IMAGES
of America

SHELBY AND
CLEVELAND COUNTY
NORTH CAROLINA

IMAGES
of America

SHELBY AND CLEVELAND COUNTY
NORTH CAROLINA

U.L. "Rusty" Patterson and Barry E. Hambright

ARCADIA
PUBLISHING

Published by Arcadia Publishing
Charleston SC, Chicago IL, Portsmouth NH, San Francisco CA

Library of Congress Catalog Card Number: 00-105332

For all general information contact Arcadia Publishing at:
Telephone 843-853-2070
Fax 843-853-0044
E-mail sales@arcadiapublishing.com
For customer service and orders:
Toll-Free 1-888-313-2665

Visit us on the Internet at www.arcadiapublishing.com

CONTENTS

ACKNOWLEDGMENTS

The authors wish to thank those who have helped make this publication possible. Many persons throughout the county have graciously and enthusiastically provided photos, names, and background information. Credit has been given at the end of each caption for those postcards and photographs from other collections. Several publications have been instrumental in confirming people, places, names, facts, and timelines, including *The Living Past of Cleveland County* by Lee B. Weathers; *The Heritage of Cleveland County* published by The Cleveland County Historical Association; *The Lawndale Railway and Industrial Company* by Bumgarner, Burn, Forney, and Walker; "History of the Cleveland County Fair" by Grace Hamrick; and *The Shelby Star* and *The Kings Mountain Herald*.

We wish to thank Boyd Hendrick; Jerry Noftsger; Harvey Whisnant; the Cleveland County Chamber; the Uptown Shelby Association; the Cleveland County Historical Museum; the Shelby City Parks and Recreation Department; Joe Goforth and the Cleveland County Fair Association; Cothenia Jolley and the Gardner-Webb University Archives; Dr. L. Steve Thornburg and Cleveland Community College; Mary Neisler and the Kings Mountain Historical Society; Gary Stewart; Nancy Carpenter; Andrew Pruett; Roby Combs; Edwin Ford; Patty Osborne Lee; Blanche Teele; Adelaide Craver; June Albright; Margaret Yarboro; Joe Southards; Libby Greenway; Steve Greenway; Severne Budd; Jean Ware; Ralph Dixon; Tom Martin; Vic McCord; Mary Sue Howard; Minnie Ann Forney; and Don Hensley for your contributions.

We could not have produced this work without access to the work of professional photographers of the past, including Floyd Willis and the Ellis Studios. Also invaluable were the postcards produced by the T.W. Hamrick Company, Austin and Clontz 5-10 & 25¢ Store, and the Asheville Postcard Company. Many images from the turn of the 20th century are from the Louis Hamrick collection.

A special thank you goes to Tommy Forney for all his assistance with the chapters on Shelby and Lawndale; Larry Hamrick for his encouragement and research; Dave and Marty Sennema, whose original conversation and encouragement helped to get this project off the ground; and Mark Berry at Arcadia Publishing for his technical support. Also thanks to Mary Emma Hambright for her patience, to Marion and Margaret Patterson for their support, and to Frankie Patterson for her moral and technical support and for her releasing the dining room table for the last three months.

A reasonable effort has been made to gather accurate information about each image within the timeline provided by the publisher. All of these people have helped make this publication possible. None of them are responsible for the errors, which are the authors' alone.

INTRODUCTION

Cleveland County lies in the piedmont region of North Carolina, along the border of North and South Carolina. In the 18th century it was gradually settled by those who were willing to move far from urban life. Land in this area was divided into large county units, and as population increased these were gradually broken into smaller counties. The land that is now Cleveland County was a part of earlier large counties, including Anson, Mecklenburg, and Tryon. By 1840 it was in Rutherford and Lincoln Counties.

In the 1840s the two larger counties gave land for the formation of a new county named in honor of Revolutionary War leader Gen. Benjamin Cleaveland. An area was selected for the county seat, and this town was named for Col. Issac Shelby, who fought in the Battle of Kings Mountain and later became governor of Kentucky. In 1887 the legislature changed the spelling of the county to Cleveland. Grover Cleveland was President of the United States and there was confusion over the two different spellings.

Cleveland County was an agricultural county, but by 1900 mills were becoming common. Small towns like Kings Mountain, Grover, and Lawndale grew around the textile industry. Shelby became the home of numerous mills and mill villages. Its growth resulted from its status as the county seat and the influx of people moving into the region to work in the mills.

The early 20th century was a time of growth for both Shelby and Cleveland County. Paved roads, electricity, automobiles, and telephones influenced the transformation of the county. Shelby grew from a town into a city. The majority of the buildings in uptown Shelby today were built in the first part of the 20th century. It is this growth and development that we seek to show through pictures. Those who are familiar with the area today will be able to see its development over time.

We will show the elements characteristic of Cleveland County early in the 20th century, such as the cotton culture, the textile mills, and the attraction of the waters of the county's springs. These gradually decreased in significance as the century has progressed. Other influences, such as the downtown churches of Shelby, have remained important in the lives of the citizens.

Cleveland County's towns have grown while retaining their individual character. We focus on three of these towns—Kings Mountain, Boiling Springs, and Lawndale. Each of these grew for different reasons. Kings Mountain's location on the main line of the Southern Railway contributed to its growth. Today, its proximity to Gastonia and Interstate 85 are significant to its future. Boiling Springs has become a fast-growing community, paralleling the growth of a small high school into a university of 3,000 students. Lawndale remains a pleasant community long after the loss of its early leader, Maj. H.F. Schenck, and his Lawndale-to-Shelby railway.

The chapter entitled "Around the County" features towns such as Grover, Earl, Patterson Springs, Lattimore, Casar, Fallston, Waco, and Mooresboro, as well as the hotels built to attract people to the healthy waters of the mineral springs. We take a look back at a time when "cotton was king" and cotton gins and mills dotted the countryside.

For 76 years the Cleveland County Fair has brought farm and city communities closer together. The annual fall event culminates the growing season and is a time for local farmers to exhibit the fruits of their labor. Readers will recall strolling down the sawdust-covered midways and remember their favorite shows in the grandstand.

People are an important part of the history of a county. Although there are photos of some famous people such as governors Gardner and Hoey, the focus of numerous photos is the everyday world of people in Shelby and Cleveland County. We hope readers will recognize friends, neighbors, ancestors, or even themselves as they view life as it was decades ago. Photos of people in another era show us the customs and habits of that time. For example, we include two pictures from a half century ago that show a group of women and a smaller group of men wearing hats in keeping with the style of the period.

This book is intended to be a reminder of places no longer in existence as well as early images of buildings and places in the community we call home. We hope we will inspire you to think "I remember when," and if we do our efforts have been successful.

One

SHELBY IN THE EARLY
YEARS OF THE
TWENTIETH CENTURY

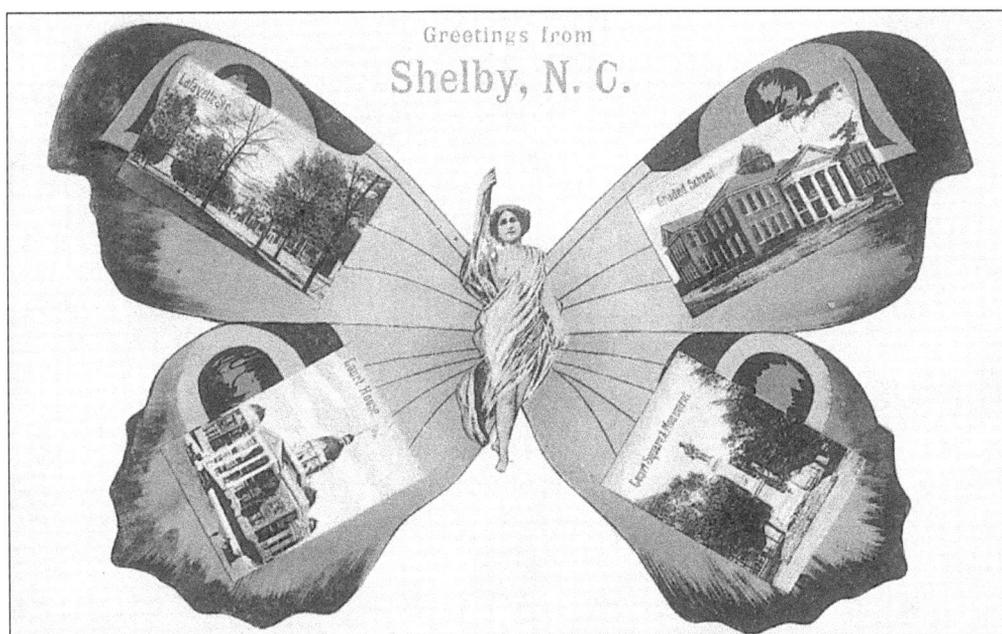

The federal government began allowing privately printed postcards to be mailed in 1898. Messages were not allowed on the back until 1907. Most pre-World War I cards were printed in Germany, as was this "Greetings from Shelby, N.C." postcard. The card was distributed by T.W. Hamrick Co. of Shelby and shows the newly built courthouse, Civil War monument, and Shelby Graded School, as well as a view of Lafayette Street. (Courtesy of Boyd Hendrick.)

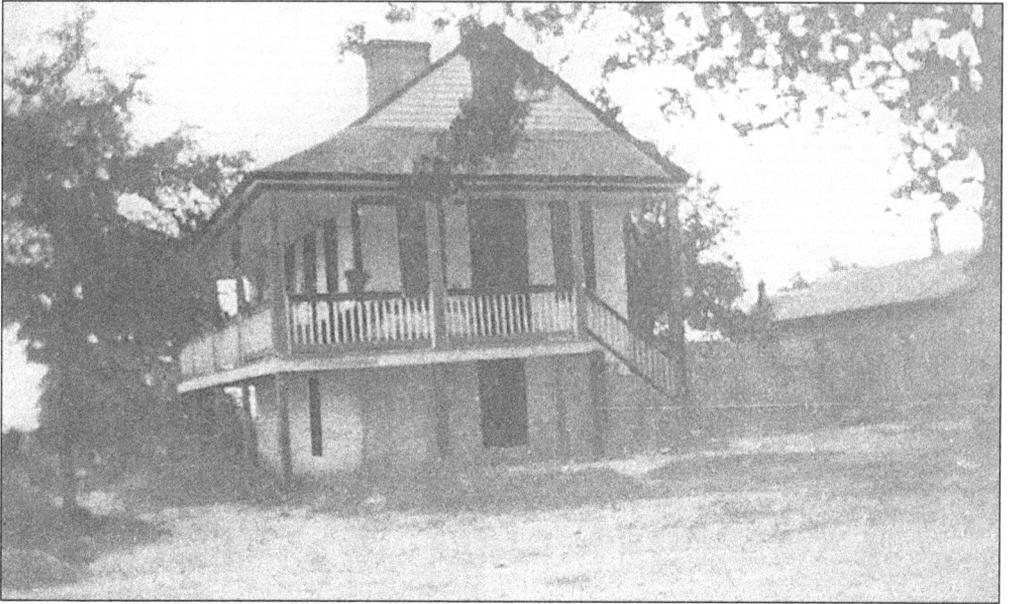

The first house built in Shelby stood on the corner of Washington and Marion Streets. Built in 1847, the house stood on this site until the erection of a new Central Methodist Church in the early 1920s. This postcard, mailed on August 9, 1907, from Shelby, shows the pre-1907-style card, which allowed messages only on the front.

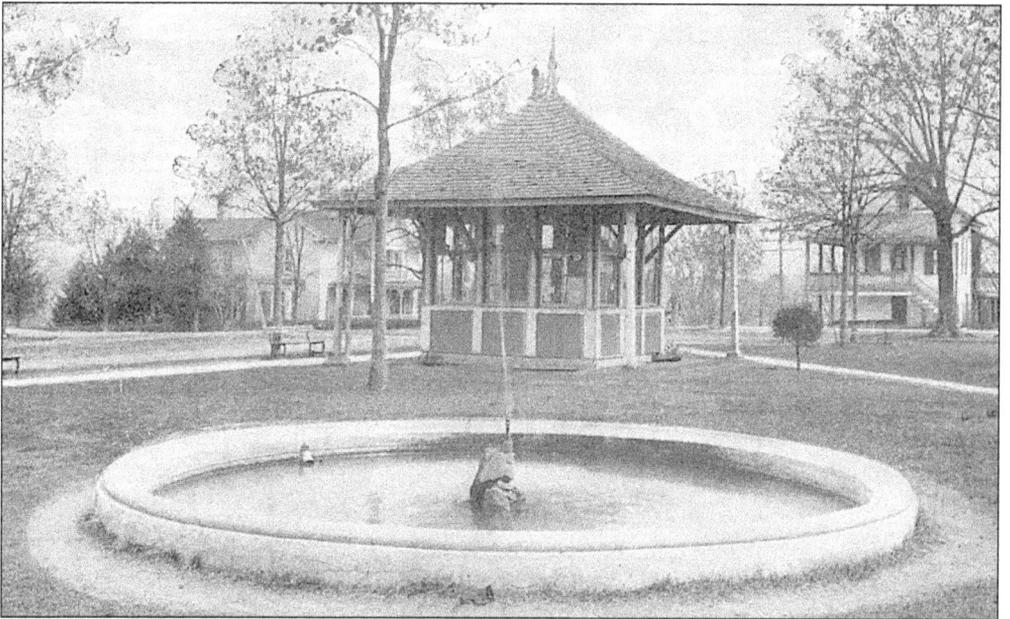

This picture was made from the north side of the court square looking east. Lithia spring waters were piped 5 miles to the square and made available to the public. The first house in Shelby is visible at the right. (Courtesy of the Cleveland County Historical Museum.)

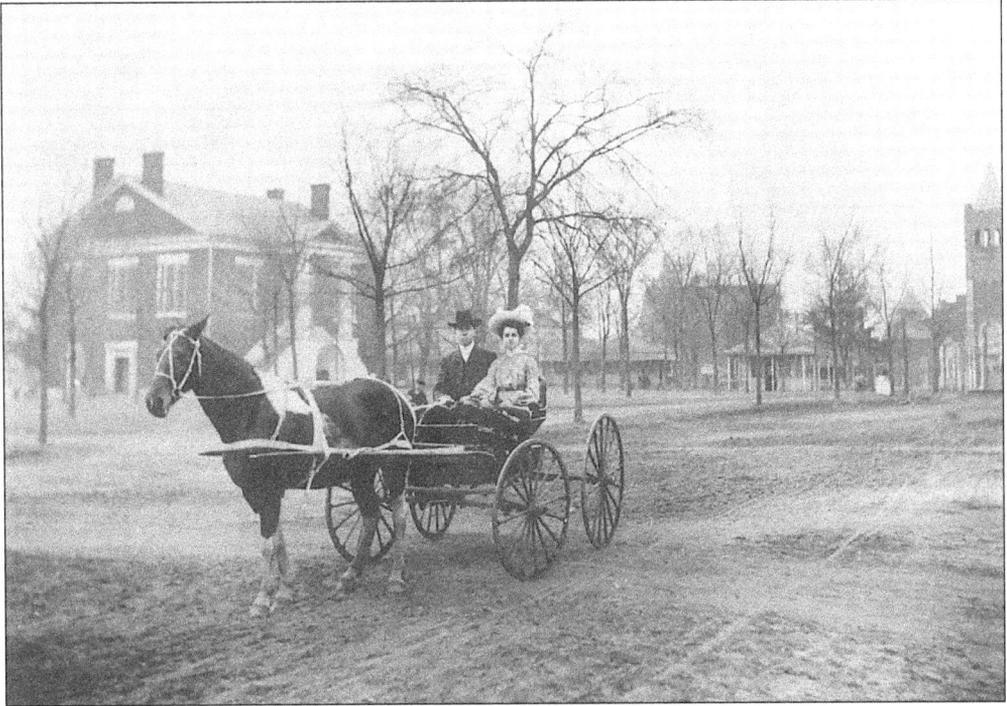

Robert Eugene Wilson and Bertha Ada Wright Wilson are pictured on the square days after their December 23, 1903 wedding. The first county courthouse, shown to the left, was built in 1845 and replaced by the current structure in 1907. (Courtesy of Mr. and Mrs. Tom Bridges.)

The United Daughters of the Confederacy led a drive to erect this monument to the Confederate dead. This is a rare picture of the monument, which was dedicated on November 21, 1906, and the courthouse, which would be razed soon after. The first house in Shelby is visible to the left of the monument. (Courtesy of the Cleveland County Historical Museum.)

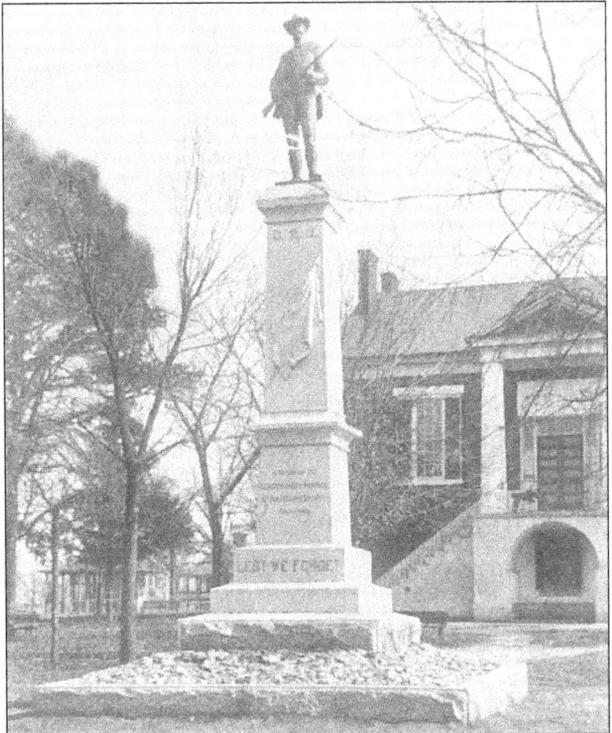

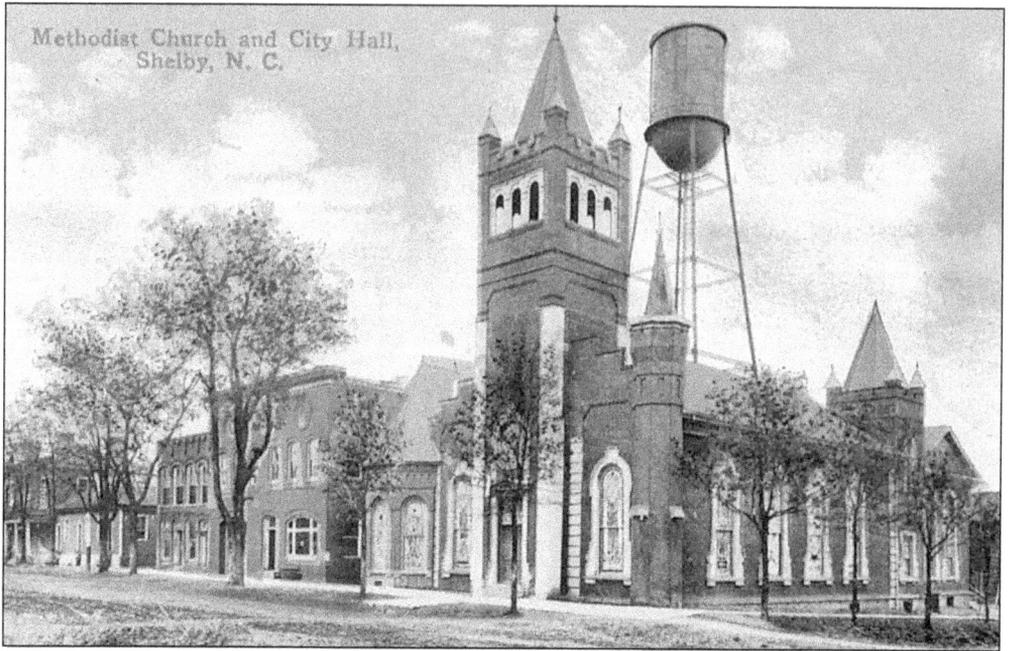

Methodist Church and City Hall, Shelby, N. C.

At the turn of the 20th century, the block on Marion Street across from the court square was a key part of the town. The Methodist church was on the corner, and around 1910 a city hall was built next to the church. A fire truck was bought in 1910 as well, and the first fire station was located in the city hall building. (Courtesy of Boyd Hendrick.)

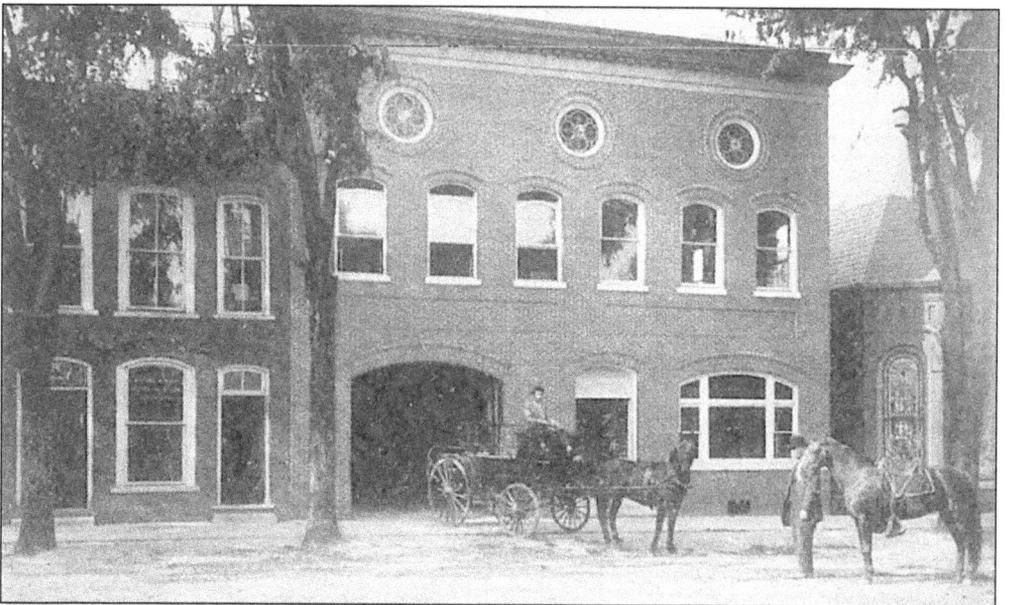

This card shows a frontal view of the city hall. The Methodist church is seen at the right. The building at the left served as the office of Shelby's main newspaper, *The Cleveland Star.* (Courtesy of Boyd Hendrick.)

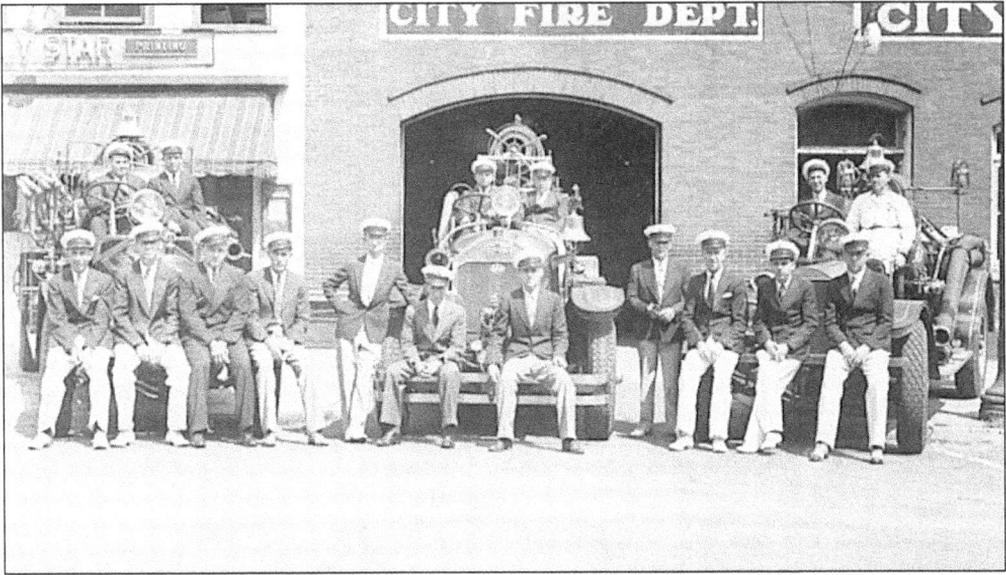

This 1931 photo shows Shelby's "modern" fire equipment. Included in the image are Chief Grady Mauney, Morris L. Lucas, Red Lankford, and Thomas Henry Lucas. (Courtesy of Tom Forney.)

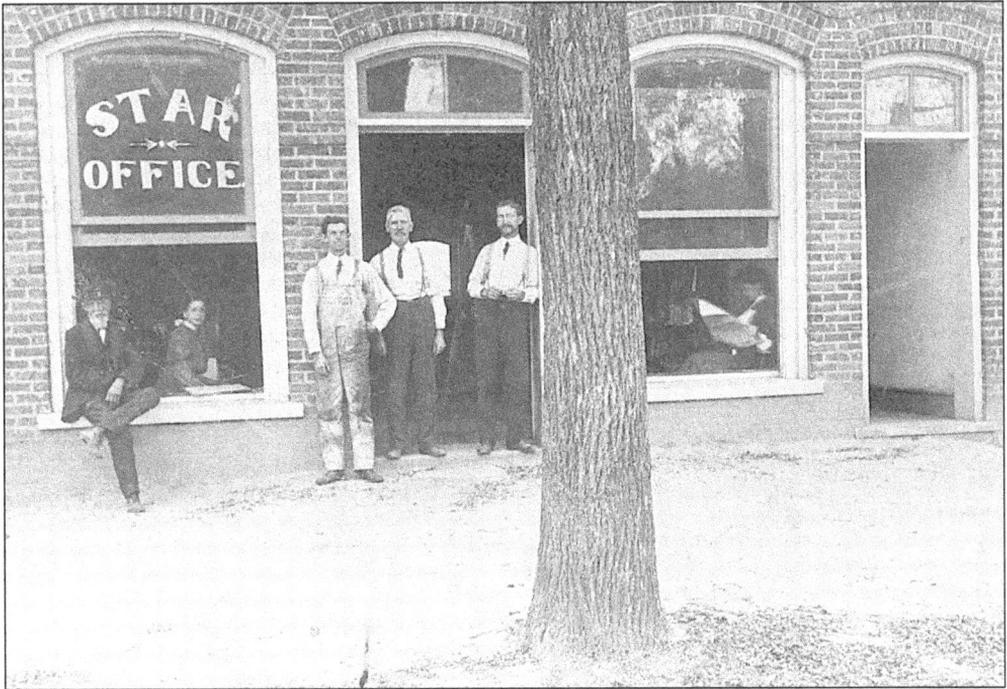

The Cleveland Star offices are seen in the early 1900s. Future governor and U.S. senator Clyde R. Hoey owned *The Cleveland Star* at that time. *The Cleveland Star* grew to a three-times-a-week paper under the leadership of Lee B. Weathers. Weathers later published the paper six times a week and changed the name to *The Shelby Daily Star*. (Courtesy of *The Shelby Star*.)

This 1910 panoramic view taken from a hot-air balloon shows the dirt streets of uptown Shelby. Most of the buildings were wooden at the time. The photo was taken from the south looking

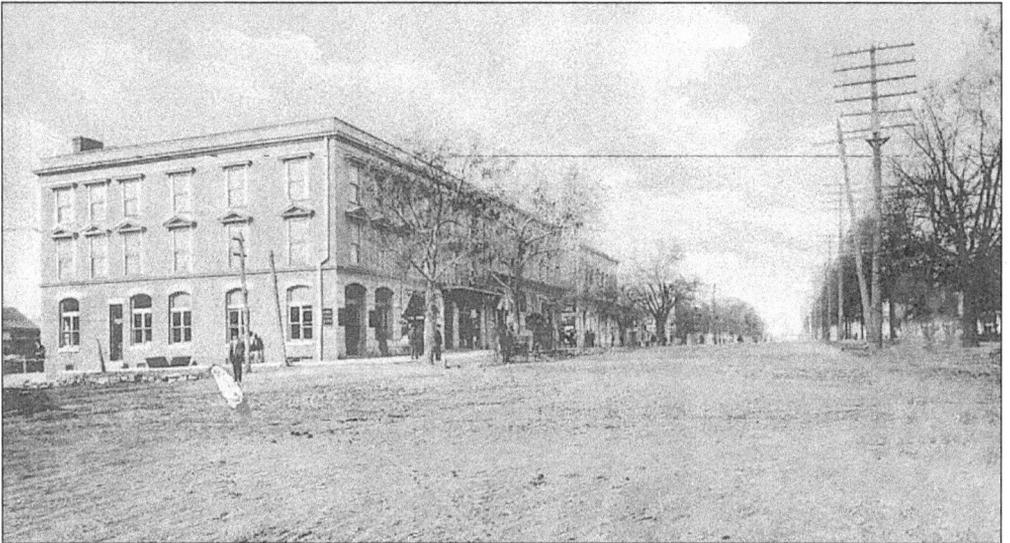

This postcard shows Lafayette Street looking north. The trees of the court square can be seen on the right. The corner building became the home of the Central Hotel. Sidewalks, which were paved around 1908, can be seen. The dirt streets would be paved during World War I. (Courtesy of Harvey Whisnant.)

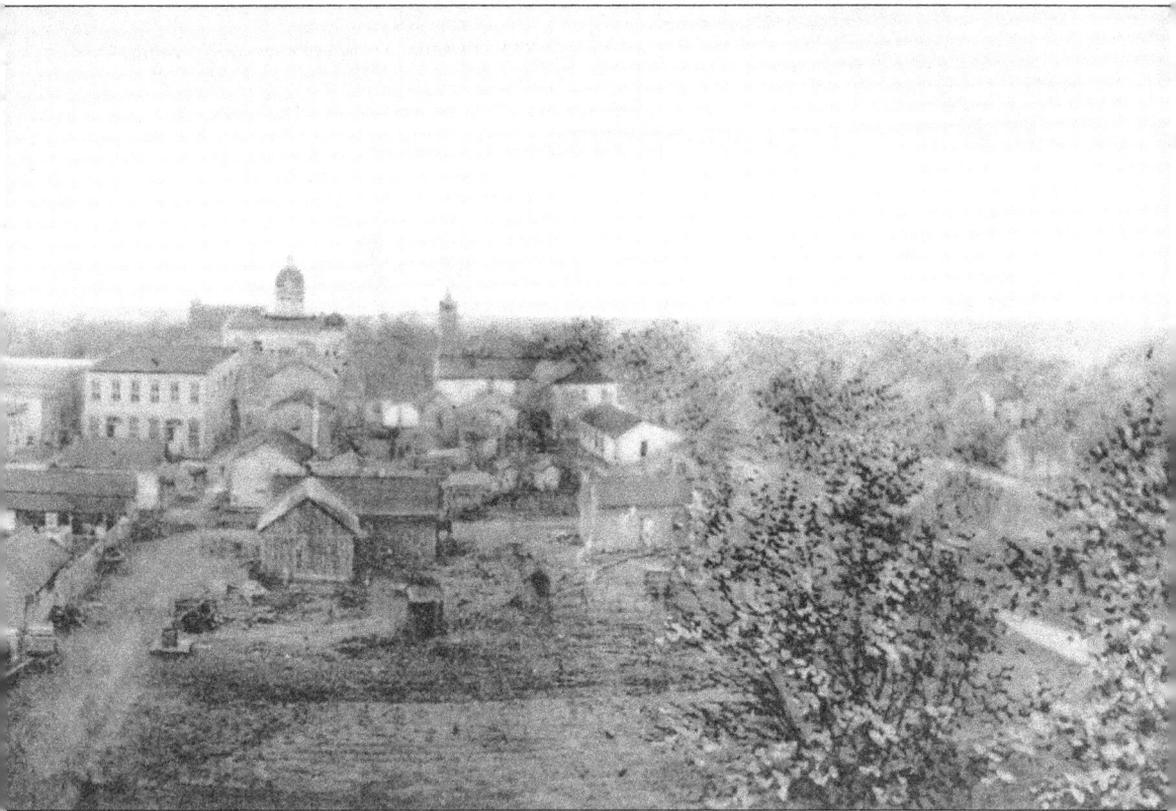

north. The new courthouse can be seen in the center; the Methodist church is visible to the right of the courthouse. (Courtesy of the Cleveland County Historical Museum.)

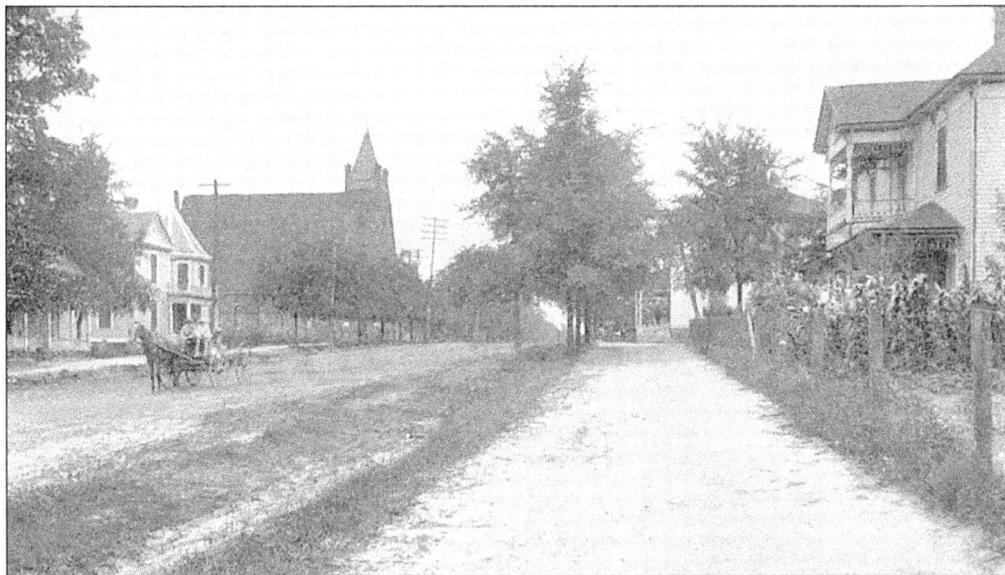

North Lafayette Street is seen in this picture, with a horse-drawn buggy on the dirt street. The building on the left is the early First Baptist Church. (Courtesy of Cleveland County Historical Museum.)

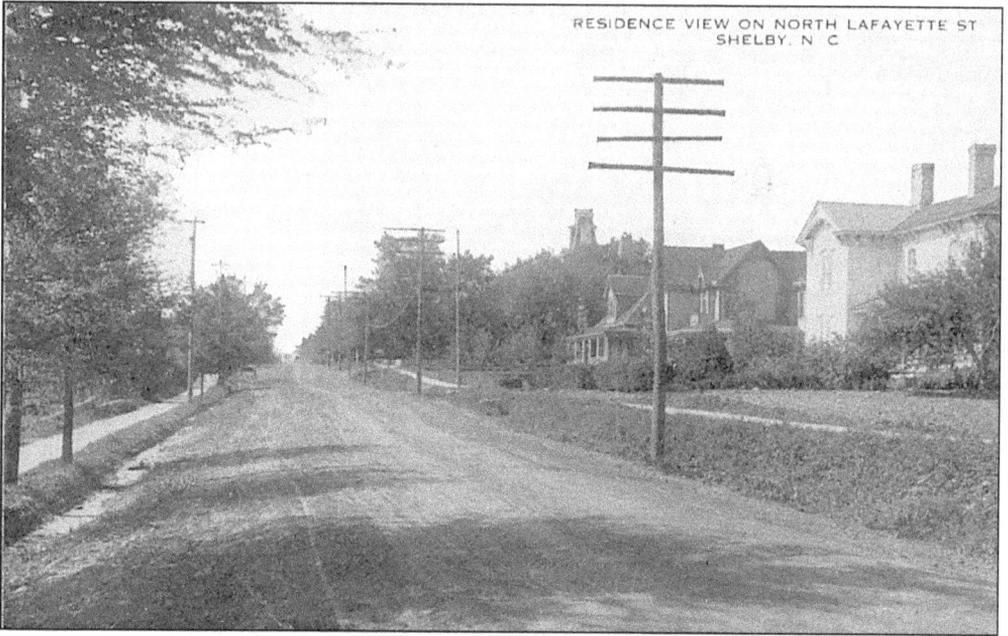

Shelby was changing as the 20th century went by. North Lafayette Street was still unpaved, but poles for electricity are visible and large homes are being built. The top of the famous "bankers house" can be seen in the center of the picture. Several bankers have lived in this house, which is an excellent example of Second Empire architecture (named for the Second French Empire, ruled by Napoleon III from 1852 to 1870). (Courtesy of Boyd Hendrick.)

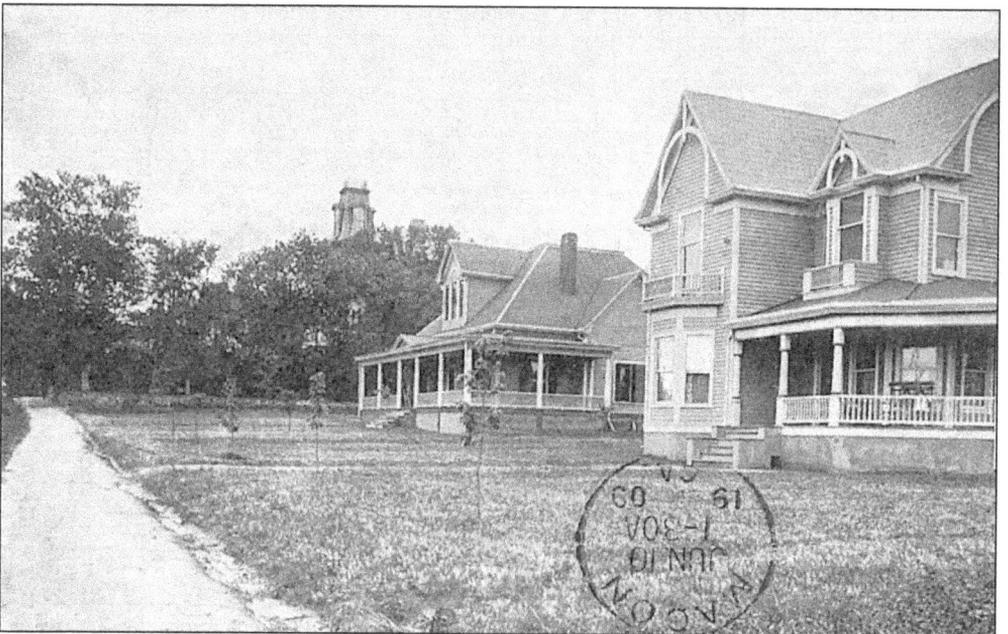

This 1909 picture shows two of the large homes on North Lafayette Street. The "bankers house" can be seen above the trees. (Courtesy of Jerry Noftsger.)

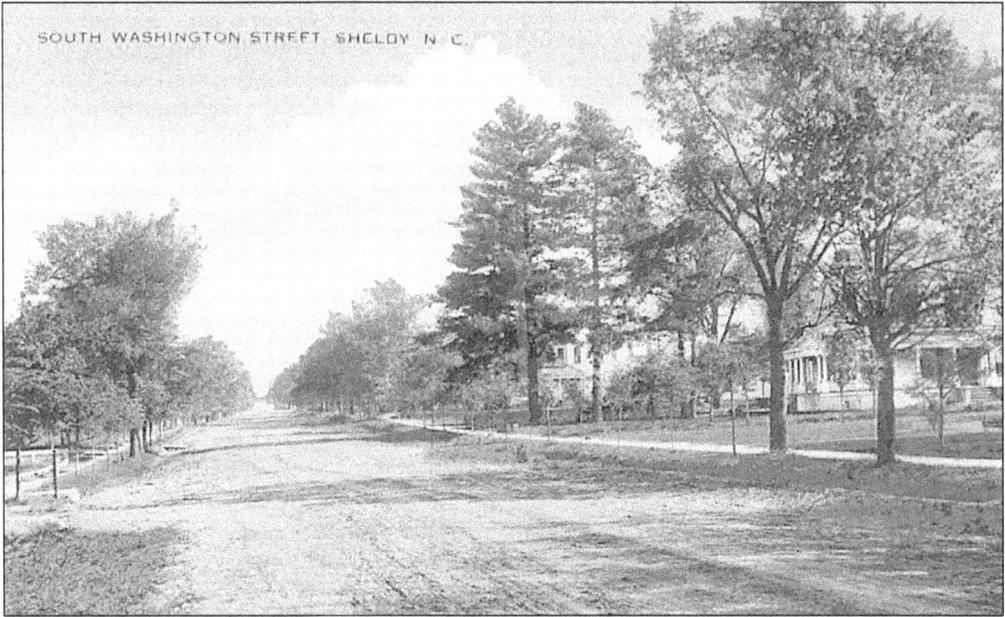

South Washington Street is seen in the days before it was paved. It was well on its way to becoming a tree-lined street with large stately homes. When DeKalb and Lafayette Streets were made into four-lane routes in later years, South Washington was preserved as a two-lane, tree-lined residential street. (Courtesy of Boyd Hendrick.)

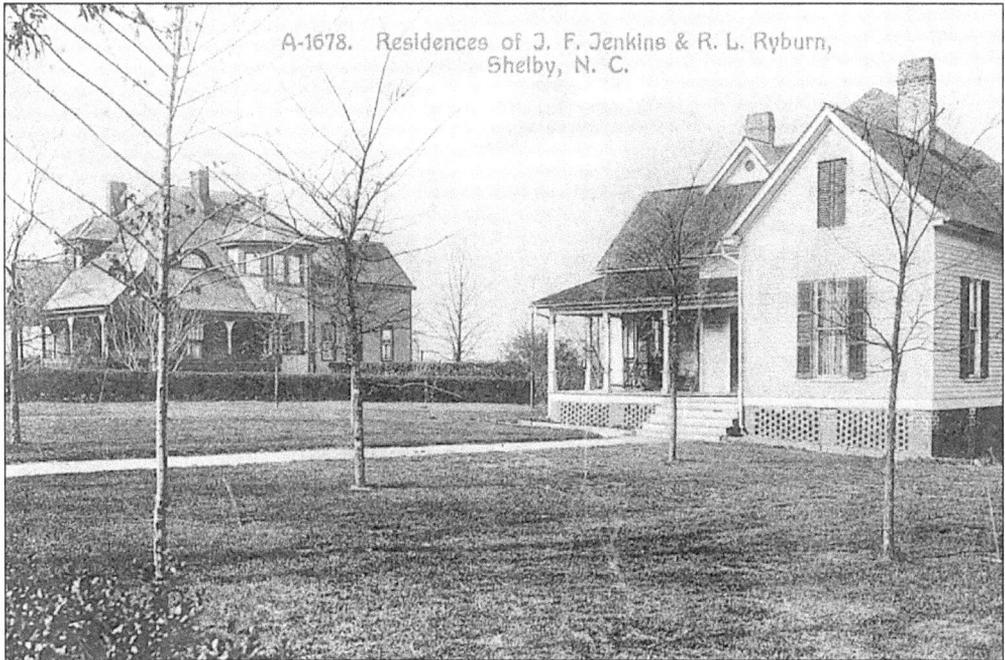

A-1678. Residences of J. F. Jenkins & R. L. Ryburn, Shelby, N. C.

Another view of Shelby, c. 1910, shows the homes of J.F. Jenkins and R.L. Ryburn. Shelby clearly followed the pattern of the era, with large houses built by affluent citizens located near the center of town. (Courtesy of Jerry Noftsger.)

17

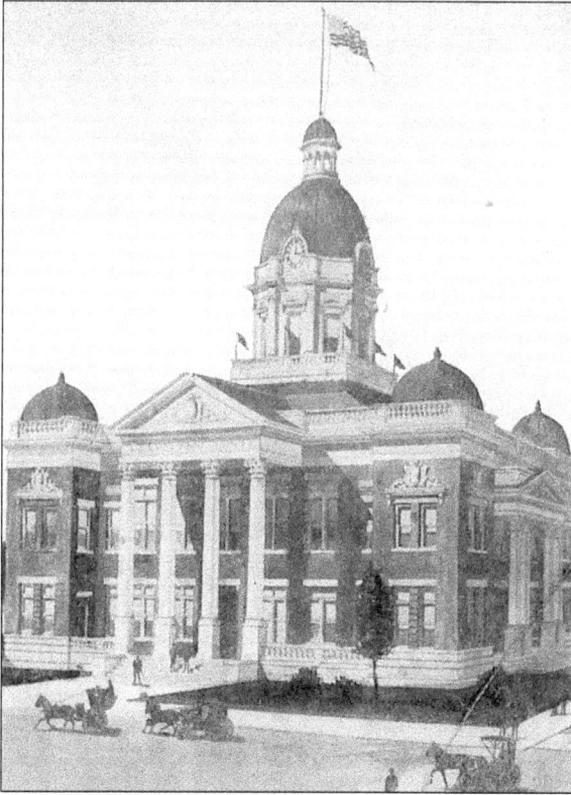

Shelby's court square changed in 1907 with the construction of the new county courthouse. This drawing of the new courthouse does not show the building in the middle of the tree-lined square. (Courtesy of the Cleveland County Historical Museum.)

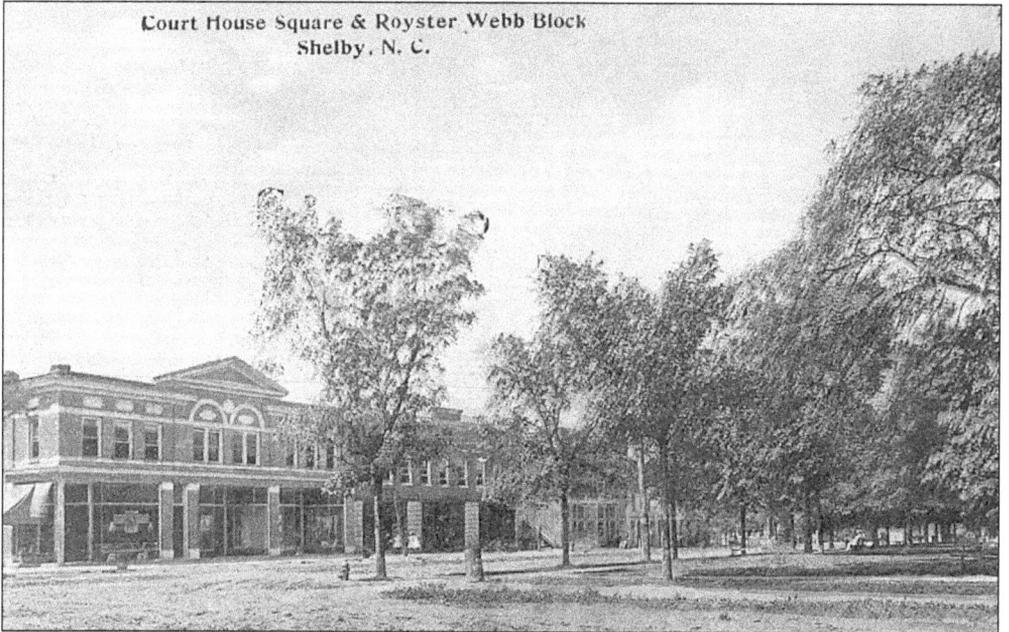

The southeast corner of the court square can be seen in this 1913 postcard. The Royster building, visible across Warren Street, has been a landmark in 20th-century Shelby. The building is still in use today. (Courtesy of Boyd Hendrick.)

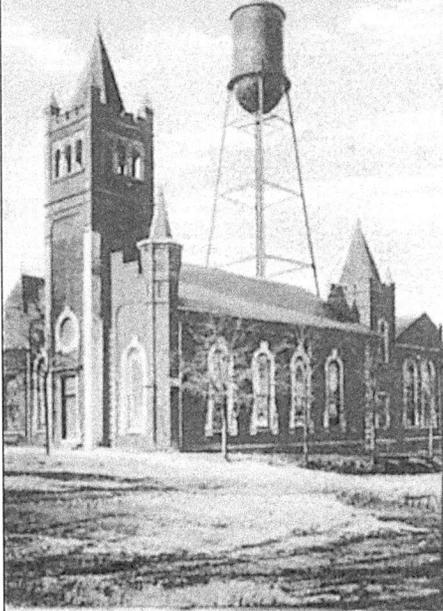

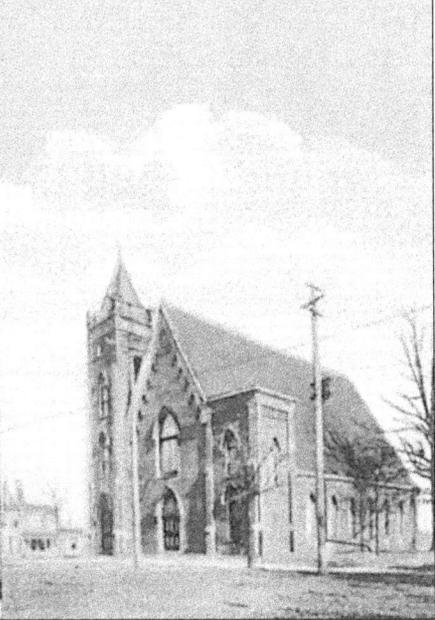

James Love's original gift of 147 acres of land for a county seat required that six one-acre lots be given to churches and educational institutions. Four churches received land. The Presbyterian and Baptist churches still occupy the same sites, but with newer buildings. The Episcopal church later moved several blocks from uptown Shelby, and the Methodist church moved across the street in 1924.

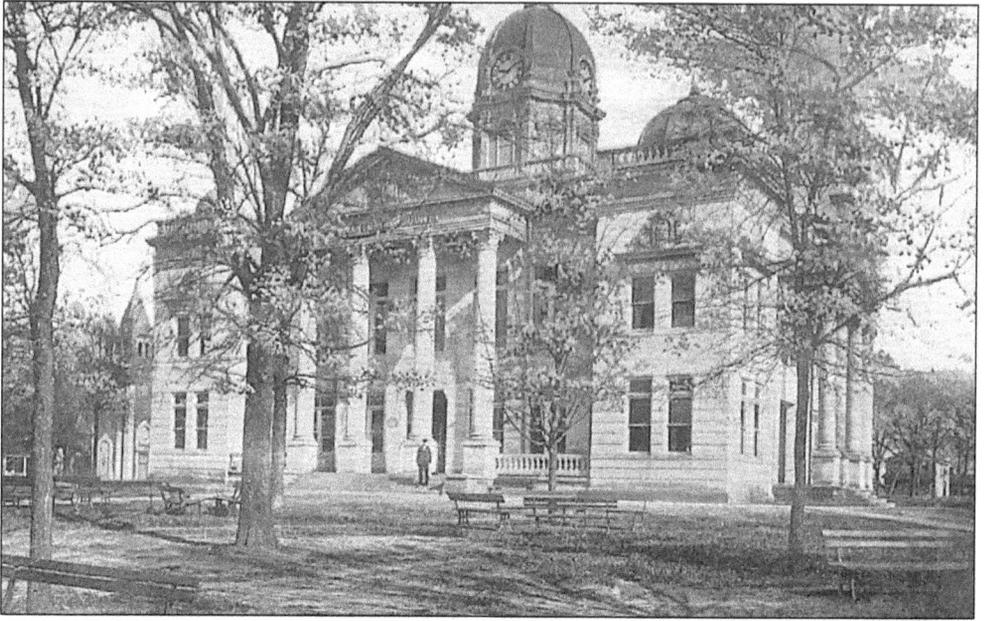

Cleveland County's new 1907 courthouse, as it appears in this postcard, was a magnificent structure. This view, c. 1910, shows the west side of the building. The old Methodist church can be seen at the left. (Courtesy of Boyd Hendrick.)

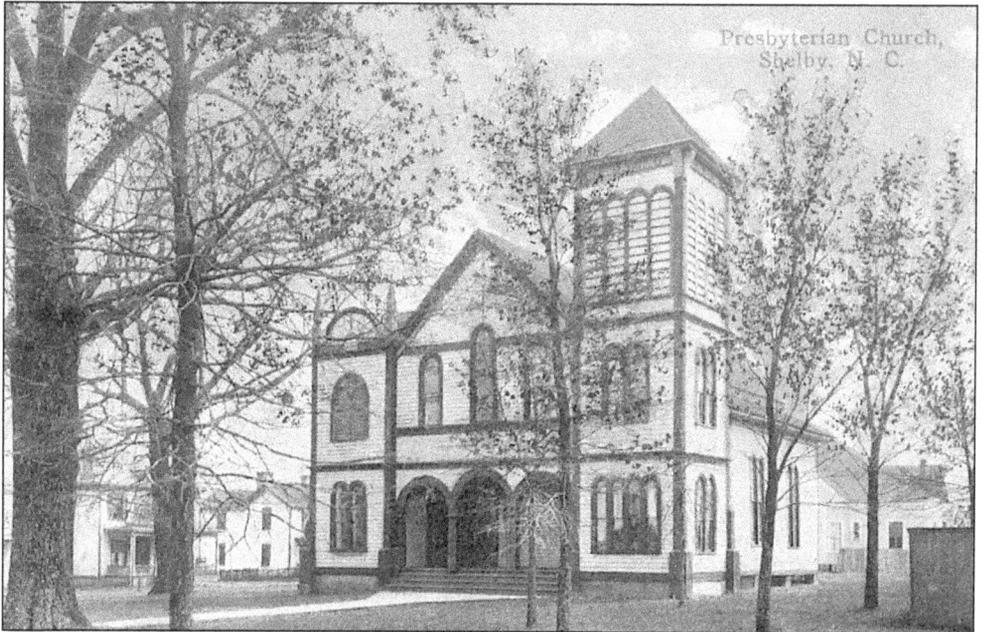

The Shelby Presbyterian Church, seen here c. 1920, was an impressive structure early in the century. Its East Graham Street location was the same as the current church. Two houses can be seen on South DeKalb Street. (Courtesy of Harvey Whisnant.)

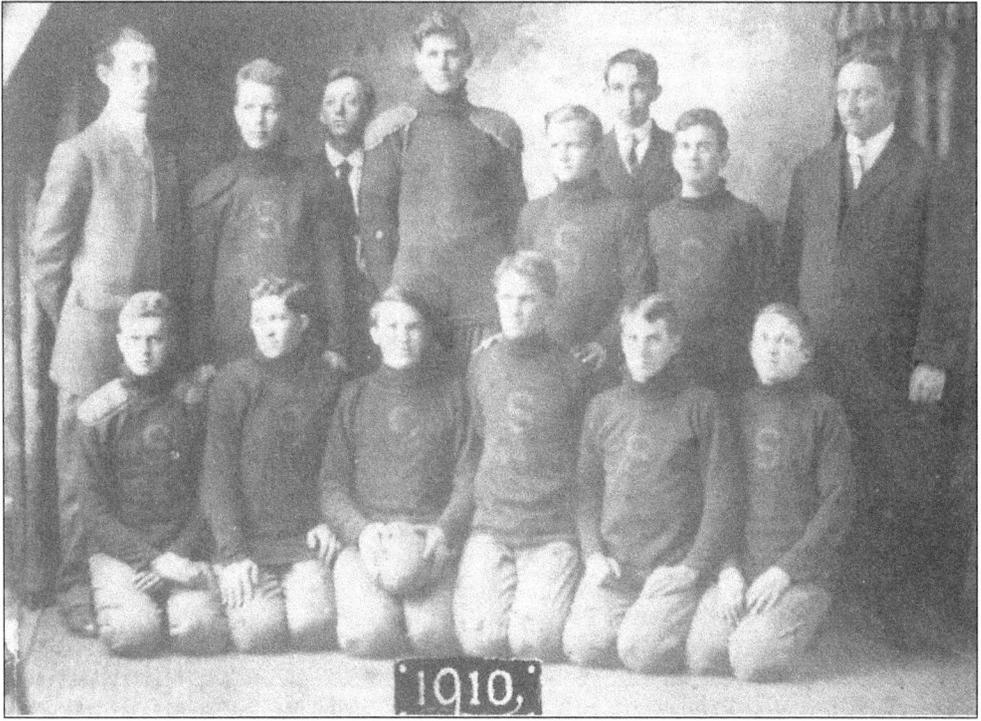

This 1910 Shelby football squad shows uniforms of the era. Oliver Anthony, the quarterback, sent this card to friends in Gastonia in January of 1911, telling them Shelby was getting their baseball team together and would beat them again. The players pictured are as follows, from left to right: (front row) Louis W. Gardner, Robert Doggett, Hilary Hudson, Ben Roberts, Harry Hudson, and Crawly Hughes; (back row) Coach R.T. Howerton, Oliver S. Anthony, Alger Hamrick, George Moore, Frank Shaw, D.W. Royster, A.W. Archer, and Coach S.N. Lattimore. (Courtesy of Jerry Noftsger.)

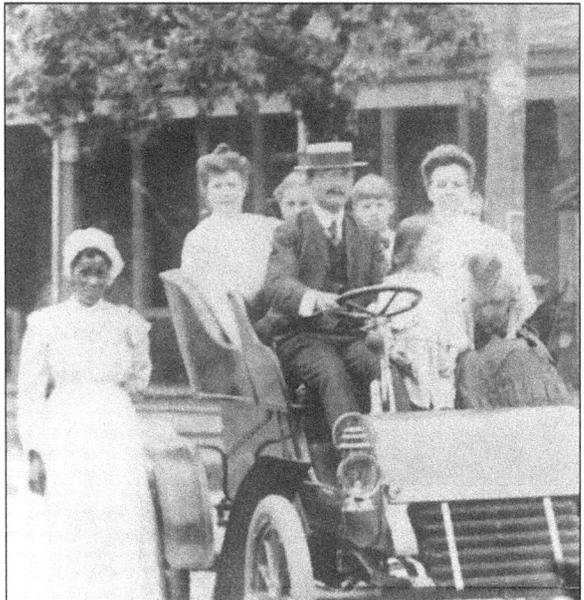

As the 20th century began, the automobile was making quite a presence. In this photo Joe Smith sits behind the wheel of an early car with Pearl Lattimore and Mildred Hull. Behind them are Mrs. L.M. Hull and Marion and Frank Hull. Lou Hull stands beside the car, c. 1902. (Courtesy of The Shelby Star.)

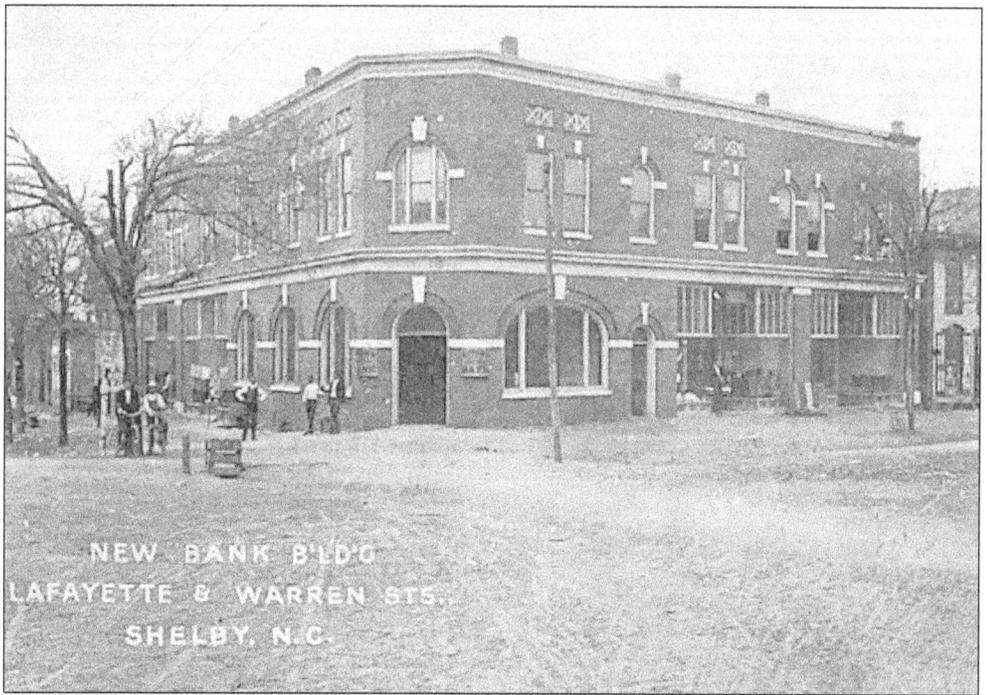

This pre-1907 postcard shows an early bank building occupying the southeast corner of Lafayette and Warren Streets. The building later housed the Union Trust Company, which had three locations across from the court square. Shelbians of the World War II era will remember Messicks Soda Shop at the front of this building. (Courtesy of Boyd Hendrick.)

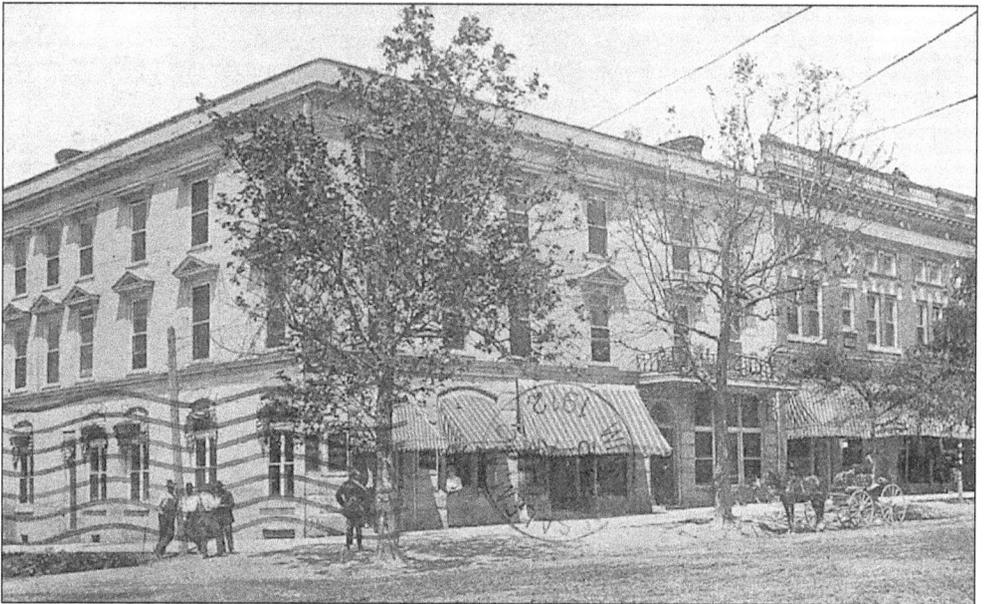

A 1909 view of the northwest corner of Lafayette and Warren shows the Central Hotel and Kendall Drug Store. The First National Bank would ultimately occupy this corner. The dark building was for decades the A.V. Wray & 6 Sons department store. (Courtesy of Boyd Hendrick.)

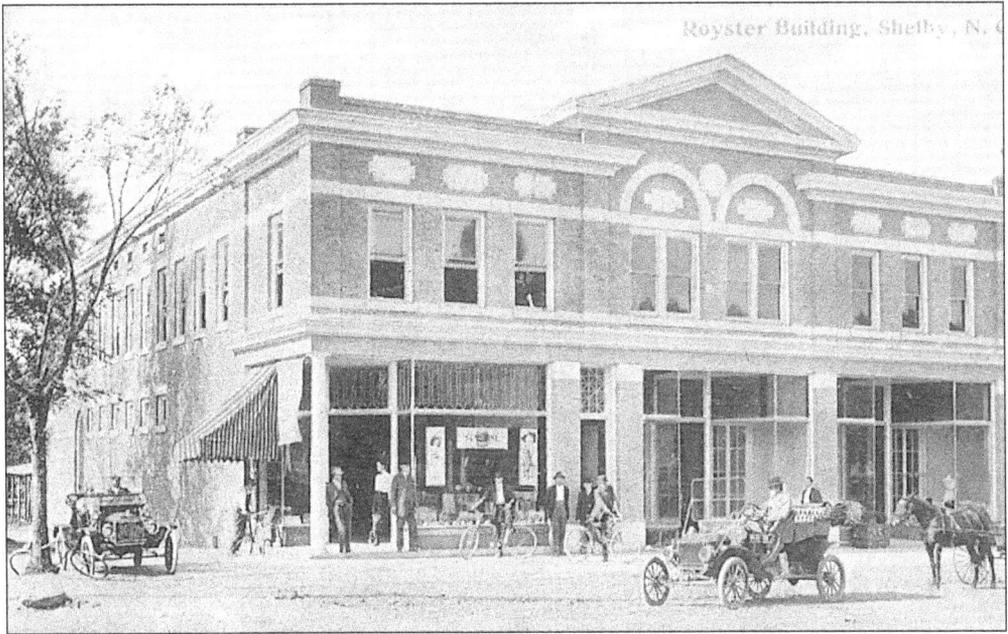

This is a great view of the Royster building in the early automobile era. Notice the horse and buggy to the right. This early card was published by Austin and Clontz 5-10 & 25¢ Store of Shelby. (Courtesy of Boyd Hendrick.)

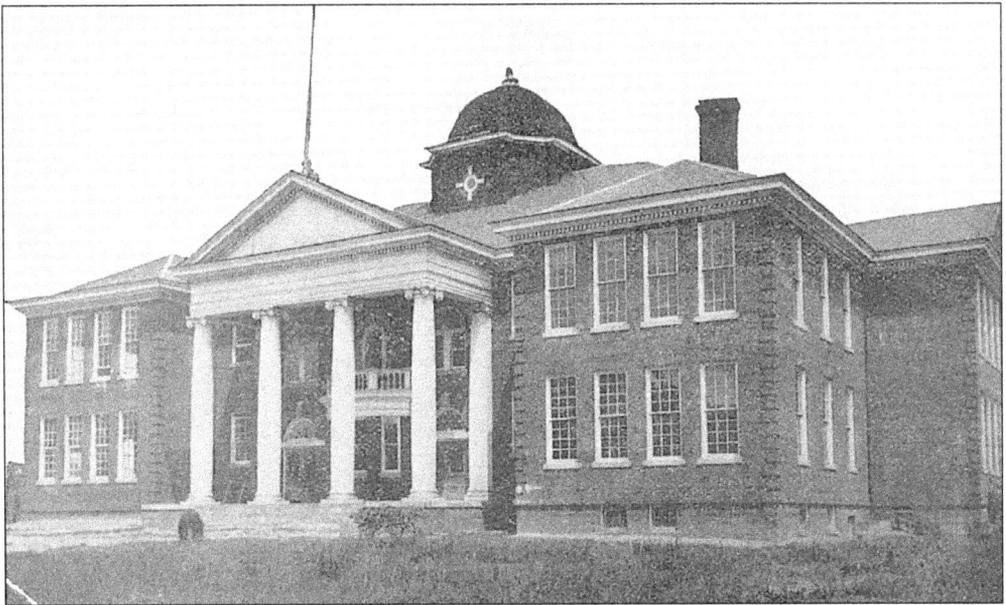

Another Austin and Clontz card shows this 20th-century landmark, which began as a graded school. It served as Shelby High School until 1937. After that it was Shelby Junior High School for over 20 years. This West Marion Street structure has been demolished. (Courtesy of Jerry Noftsger.)

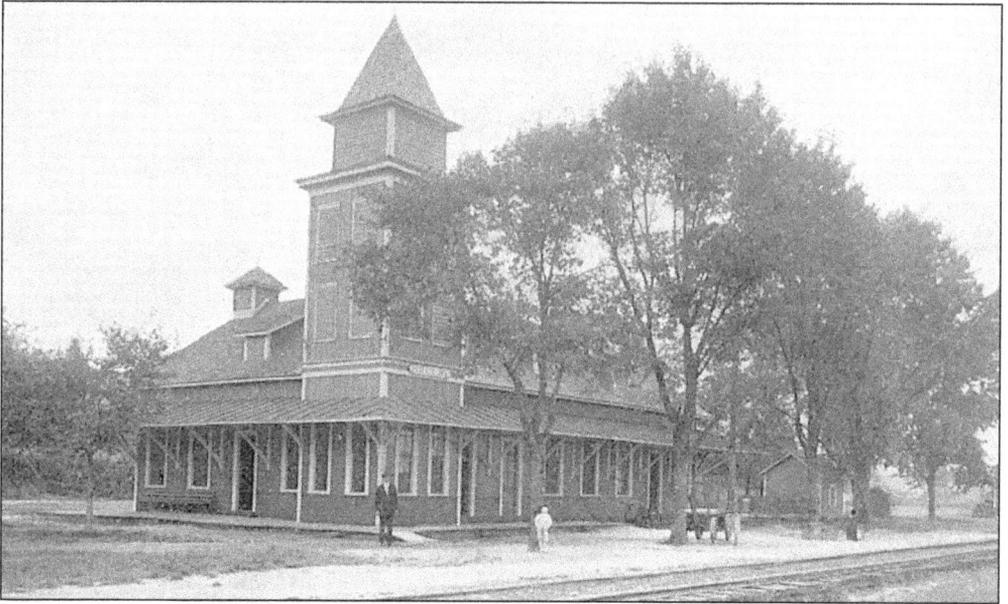

This impressive passenger station on South Morgan Street served Shelby during the days when riding the train was common. Shelby was limited by the fact that the main line of the Southern Railway went through Kings Mountain. (Courtesy of Cleveland County Historical Museum.)

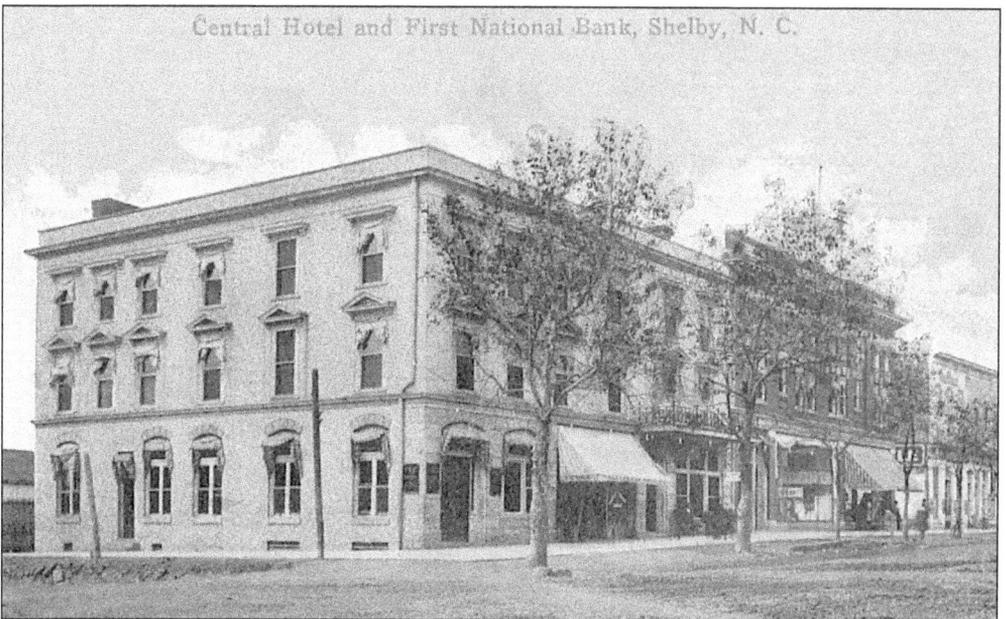

By the 1920s the streets were paved and First National Bank was established as the occupant of the northwest corner of Lafayette and Warren Streets. The Central Hotel would burn in 1928, resulting in the loss of four lives. (Courtesy of Boyd Hendrick.)

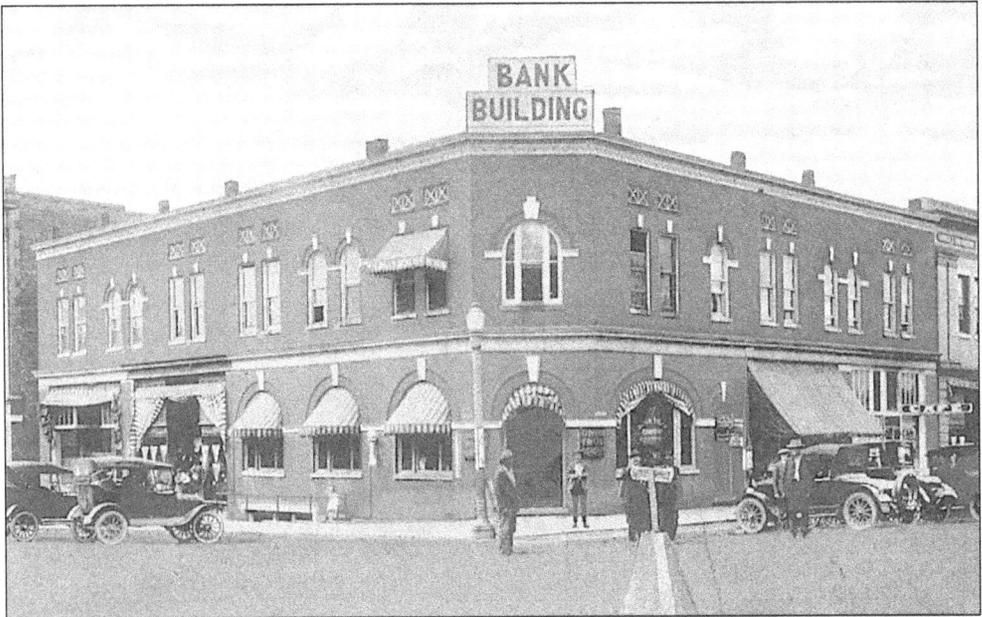

Here the bank building on the southwest corner of Lafayette and Warren Streets is occupied by the Union Bank and Trust Company. Awnings had become a common feature in the decor of buildings. (Courtesy of Boyd Hendrick.)

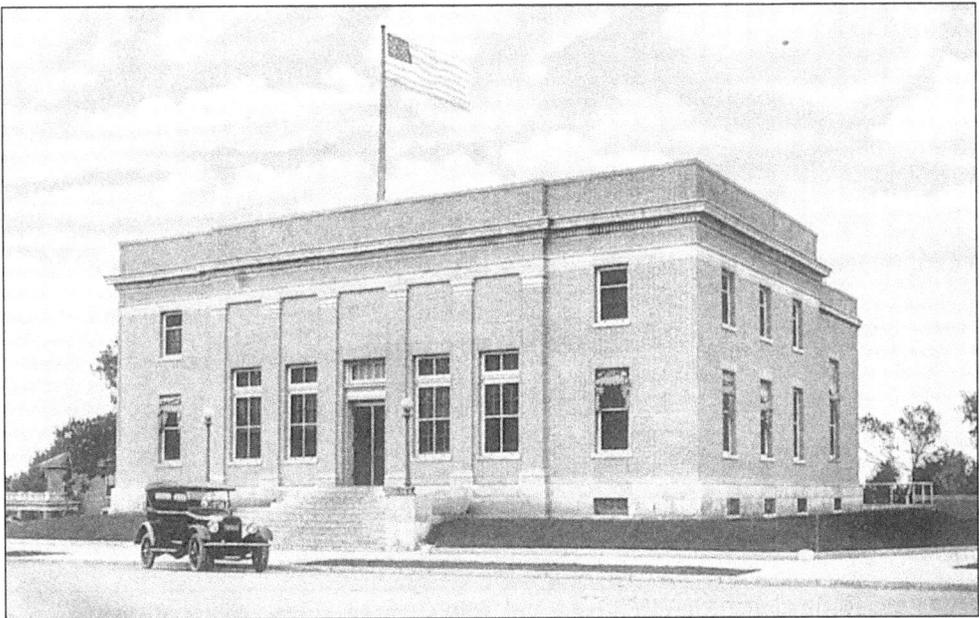

This brick structure replaced a wooden post office formerly located at this site, on Washington Street on the east side of the court square. It served as the post office until the mid 1960s, and today serves as the headquarters for the Cleveland County Arts Council.

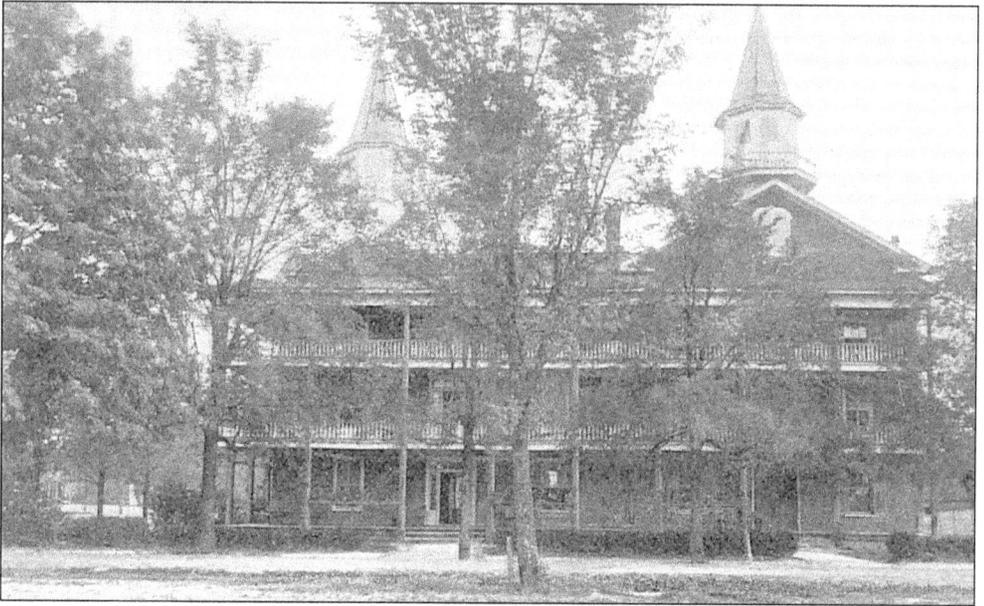

This three-story building served as the home of the Shelby Female Academy in the late 19th century. It became a hotel and later served as a hospital. The current city hall stands on this Washington and Graham Streets corner. (Courtesy of Boyd Hendrick.)

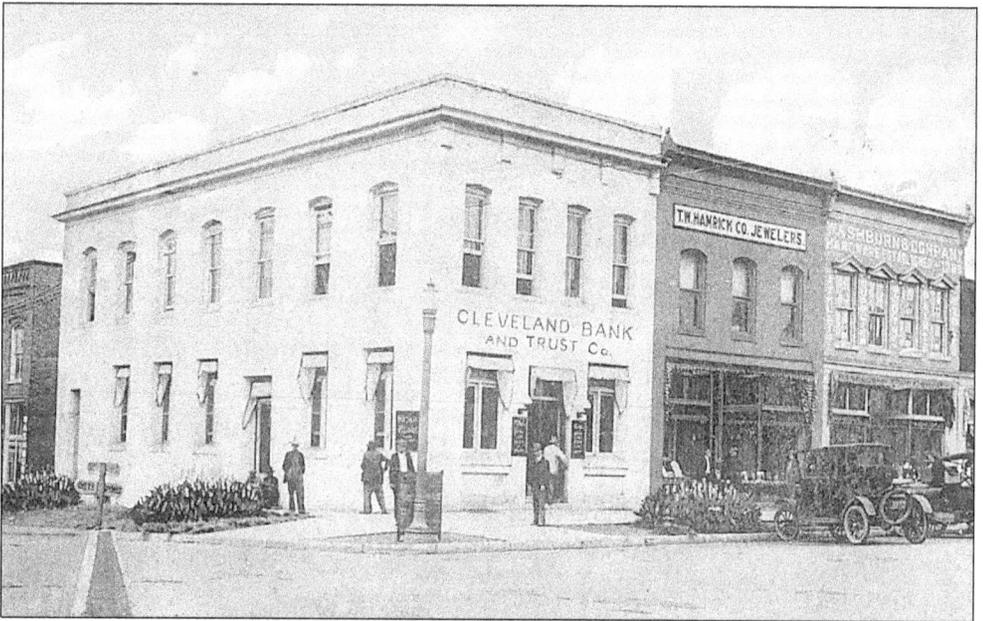

A 1920s view shows the Cleveland Bank and Trust Company on the corner of Lafayette and Marion Streets. The building, which is still occupied, was the home of Union Trust Company until the 1960s. The T.W. Hamrick Company, also visible above, produced postcards of Shelby, including this one. (Courtesy of Boyd Hendrick.)

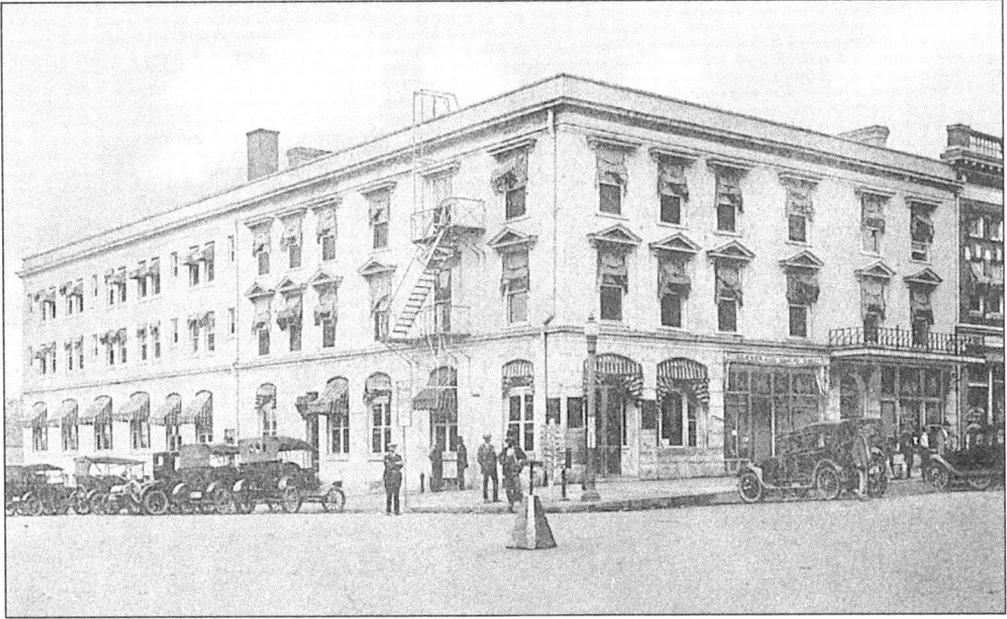

This 1920s postcard shows the Central Hotel before it burned in 1928. The age of the automobile had arrived and paved streets were common. (Courtesy of Boyd Hendrick.)

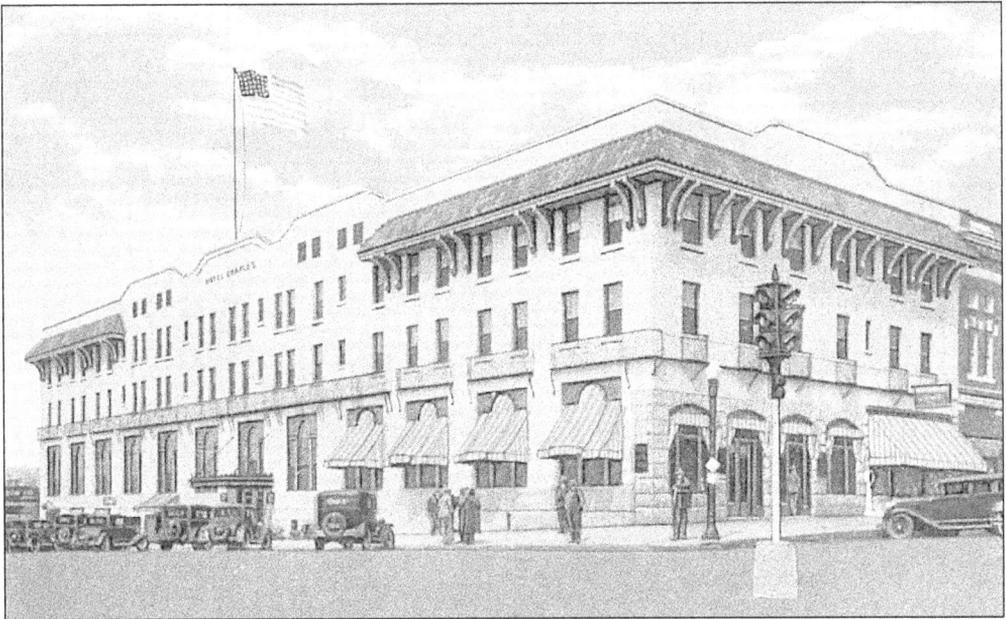

After the 1928 fire the building was repaired and the Hotel Charles became Shelby's leading downtown hotel. First National Bank occupied temporary quarters on Warren Street while this site was being repaired. Part of the Warren Street building collapsed during renovations, and six people were killed.

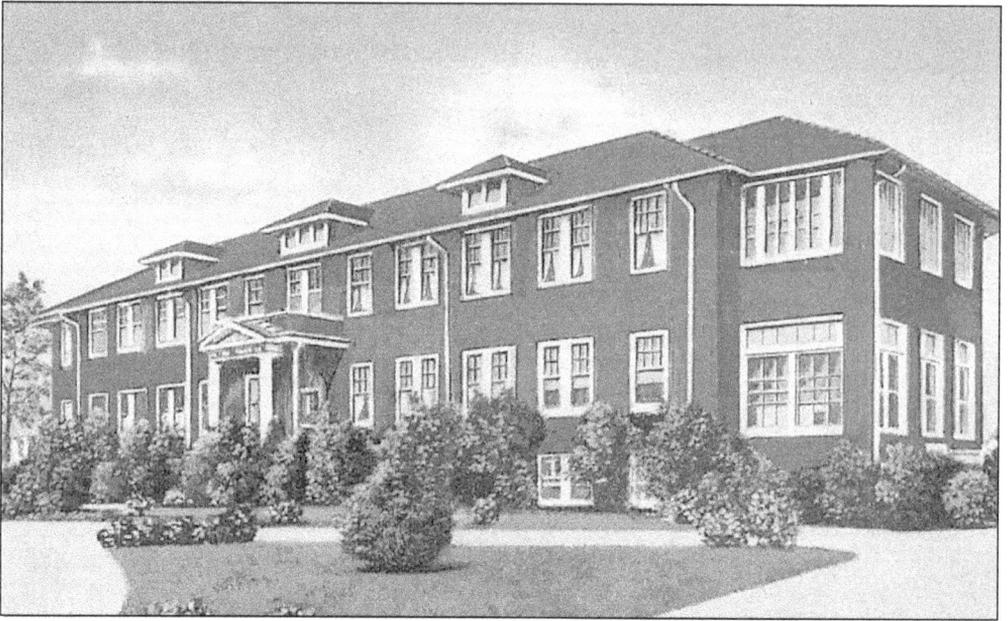

A hospital was built on Grover Street in 1924, several blocks from downtown Shelby. This building served the community until after World War II, when it was enlarged and ultimately replaced. When the Asheville Postcard Company began its Shelby series, this 1930s photo was S-1 in a series of over 20 cards.

This 1950s postcard shows the original hospital building with an entrance lobby added. New rooms have been constructed behind the original building. Visible at right is the nursing students' residence.

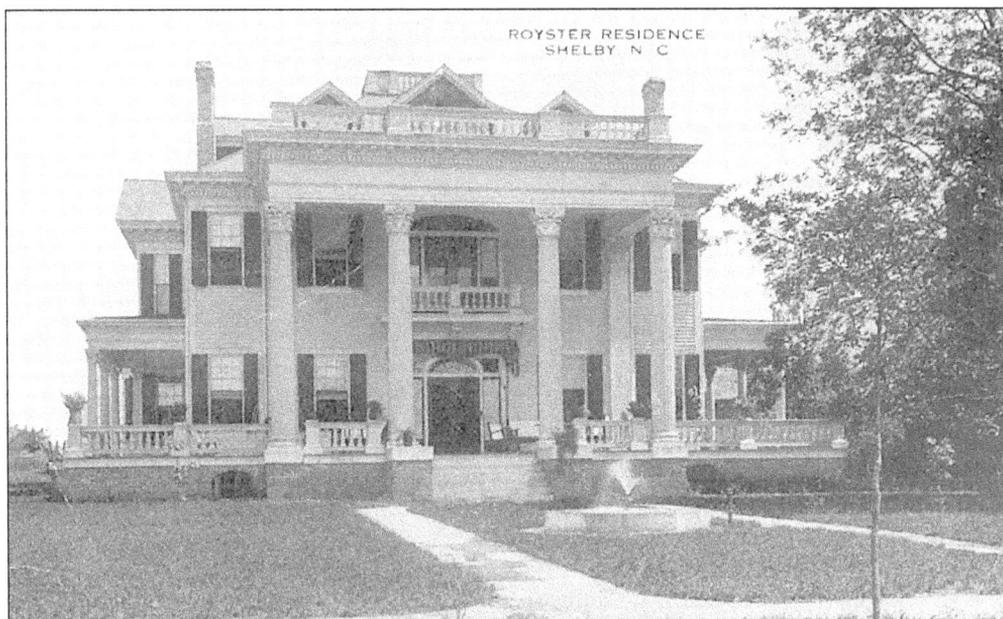

South Washington Street featured many large houses. This *c.* 1910 home at 413 South Washington Street was the Royster family residence. It still stands today, but is in disrepair. (Courtesy of Boyd Hendrick.)

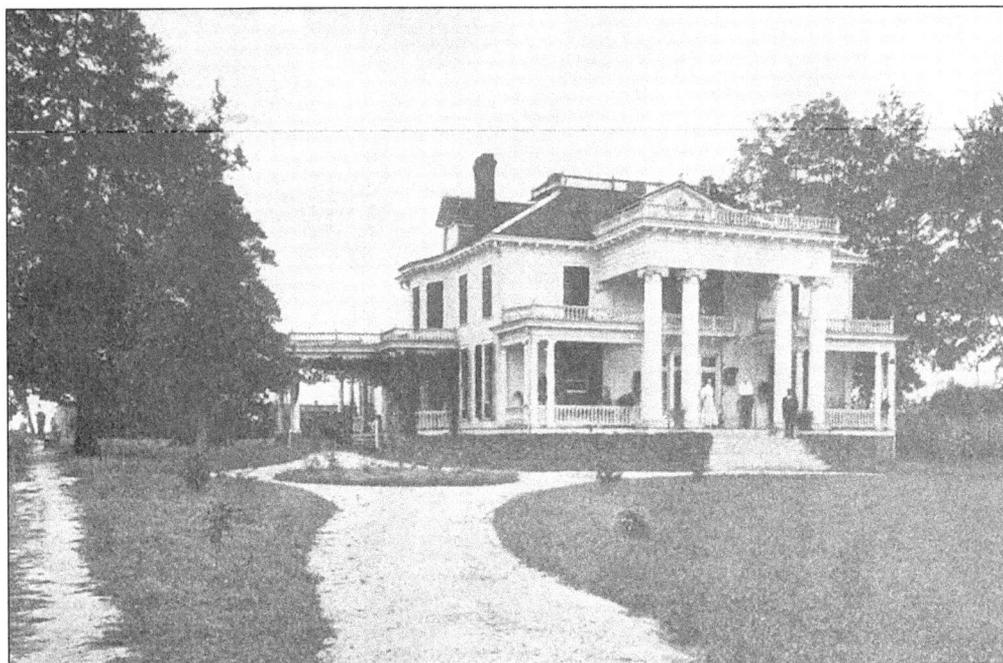

This residence of J.A. Anthony at 403 South Washington Street, pictured here in 1910, is still in use today. It was later occupied by Judge James L. Webb, and by Mrs. Fay Webb Gardner during the last years of her life. The house known as "Webbley" was a bed and breakfast in the 1990s and is listed on the National Register of Historic Places. (Courtesy of *The Shelby Star.*)

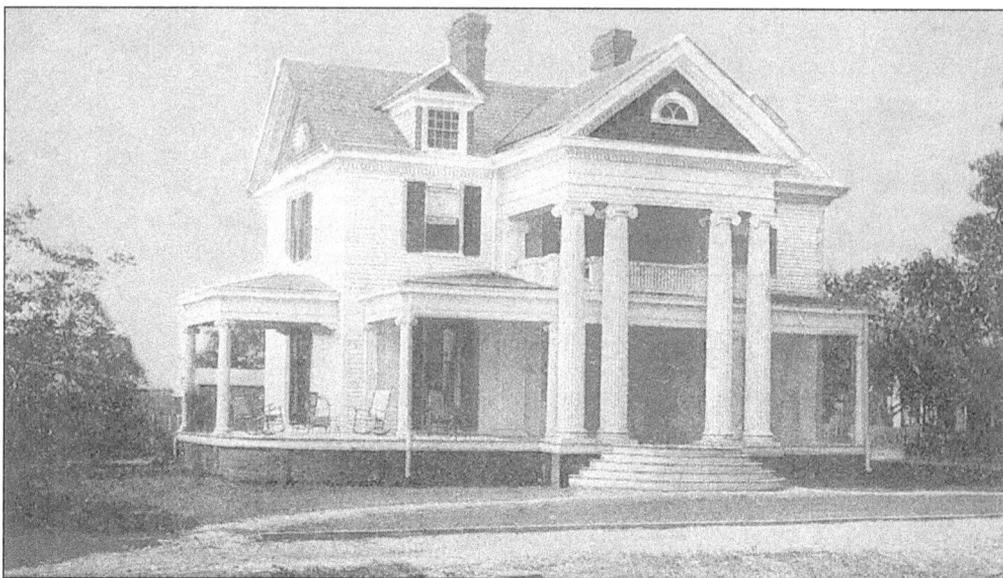

West Marion Street joined South Washington as a center of fine homes. Both streets are today a part of the Historic Uptown Shelby District. This c. 1920 photo shows the residence of J.R. Moore at 517 West Marion Street. The house still stands today. (Courtesy of Boyd Hendrick.)

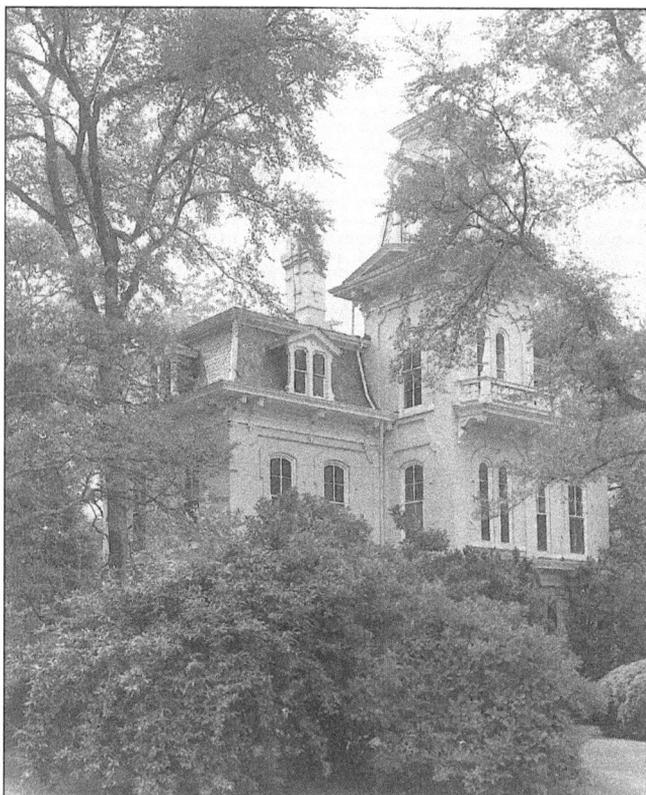

Although this is a much later photograph, it is an excellent view of the bankers house on North Lafayette Street which was only partially visible in some earlier pictures. Several bankers have lived in the house, which was built in the 1850s with the use of slave labor. (Courtesy of *The Shelby Star*.)

Two

SHELBY GROWS AS IT MOVES TOWARD THE MID-CENTURY

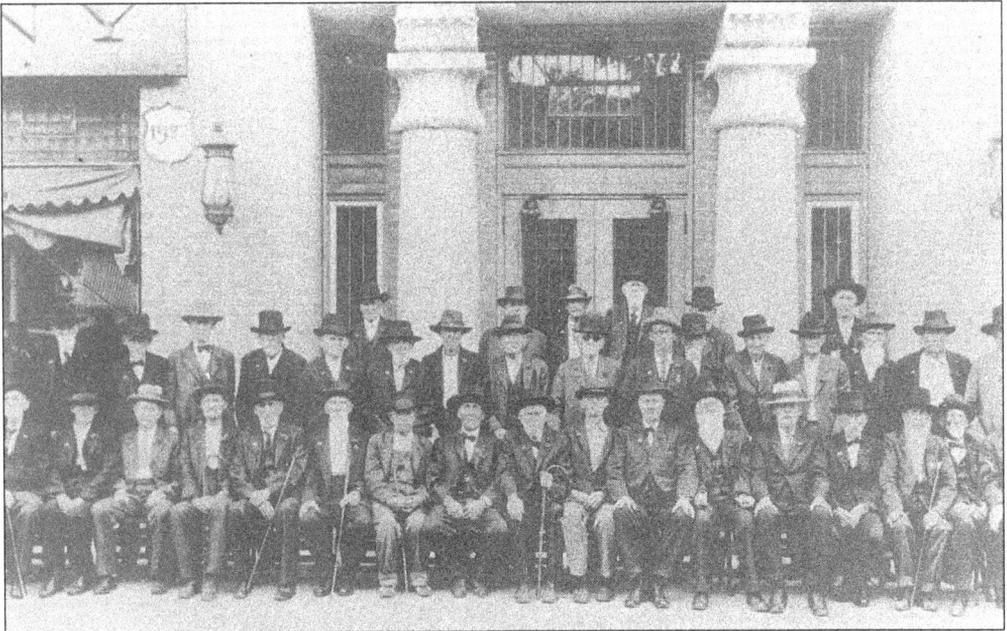

By 1927 the Confederate Veterans of the Civil War were literally a dying group. This reunion of CSA veterans shows a group of 41 men who were mostly over 80 years old. This picture was taken in front of the Masonic Building, which was built in 1924.

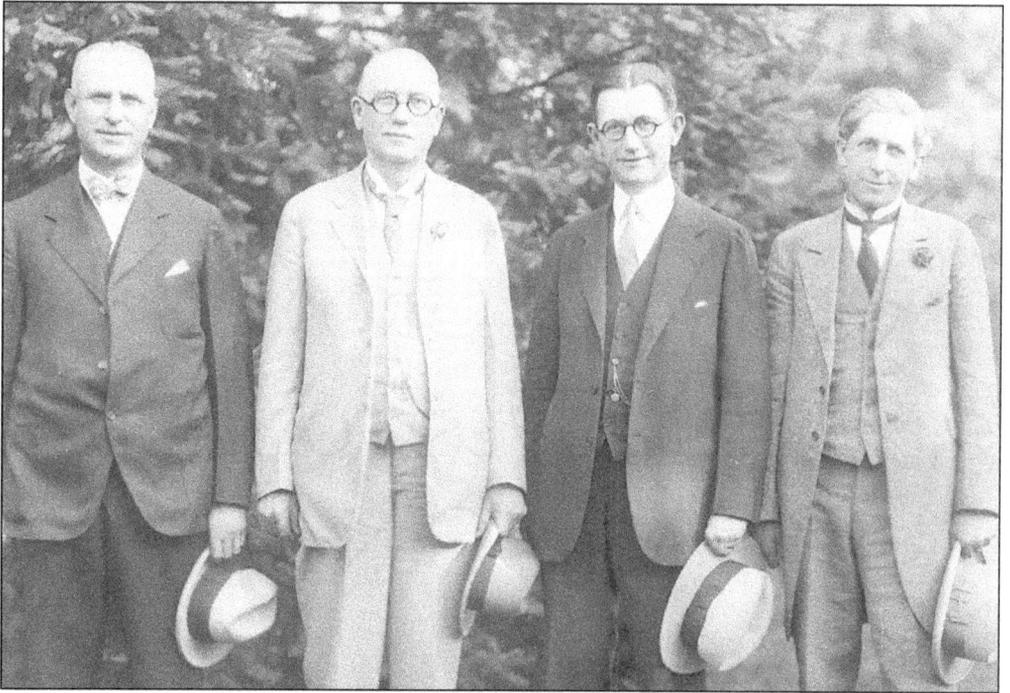

In the first half of the 20th century, Shelby was known for its outstanding political leaders. Of a group that came to be known state-wide as the "Shelby Dynasty," these four men were the most famous. They are, from left to right, Gov. O. Max Gardner, Judge James L. Webb, Judge Edwin Yates Webb, and Gov. and Sen. Clyde R. Hoey. (Courtesy of the Uptown Shelby Association.)

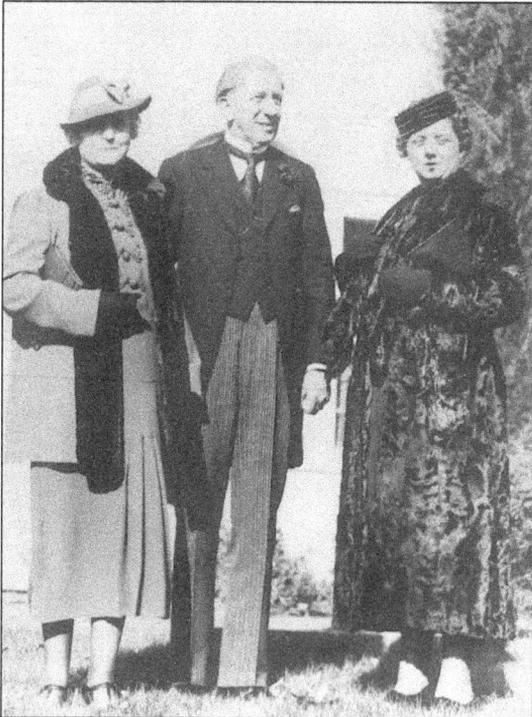

Sen. Clyde R. Hoey was known for his style of dress. He wore a high collar and always had a flower in his lapel. His wife, Bess (at right), was the sister of Gov. O. Max Gardner. (Courtesy of the Uptown Shelby Association.)

Residence of Gov. Hon. Clyde R. Hoey
Shelby, North Carolina

Senator Hoey's home at 602 West Marion Street was sold to local businessman J.L. Suttle Jr. after the senator died in 1954. Mr. Suttle and his wife, Sarah, lived in the home until their passing.

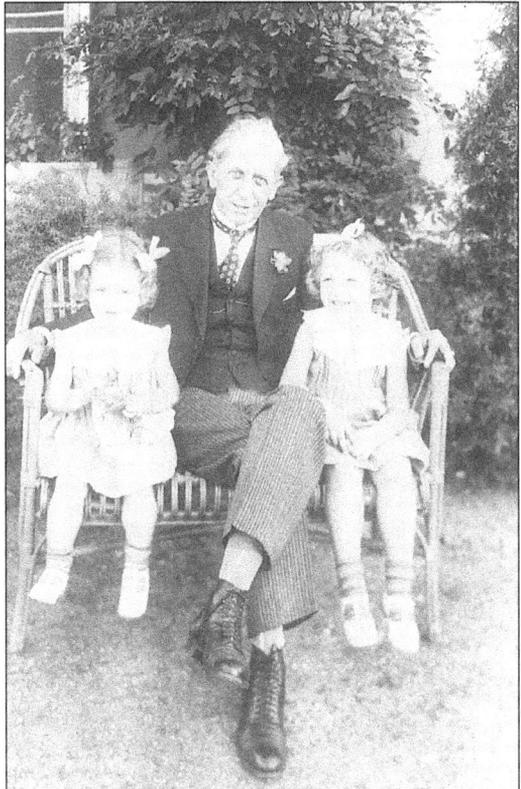

Senator Hoey was widely known and respected, and it seems he did not mind being photographed. Here he poses with two smiling young girls. (Courtesy of the Uptown Shelby Association.)

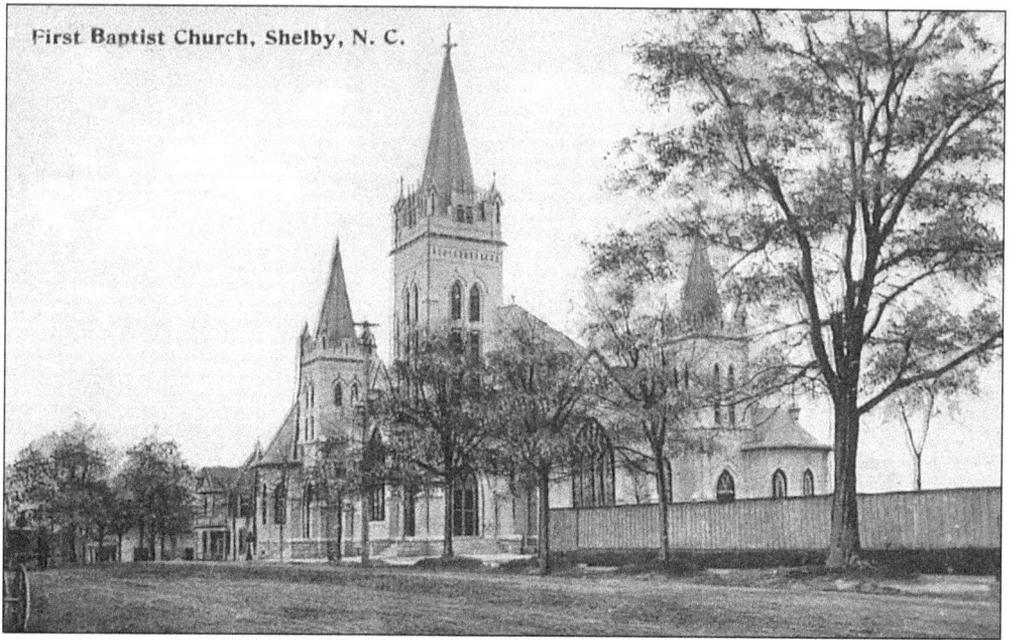

First Baptist Church, Shelby, N. C.

Shelby's largest church was the First Baptist Church at 120 North Lafayette Street. This c. 1914 photo shows a large building that would be enlarged as time passed. The lot behind the fence was the site of Campbells Department Store, which was built in 1927. (Courtesy of Boyd Hendrick.)

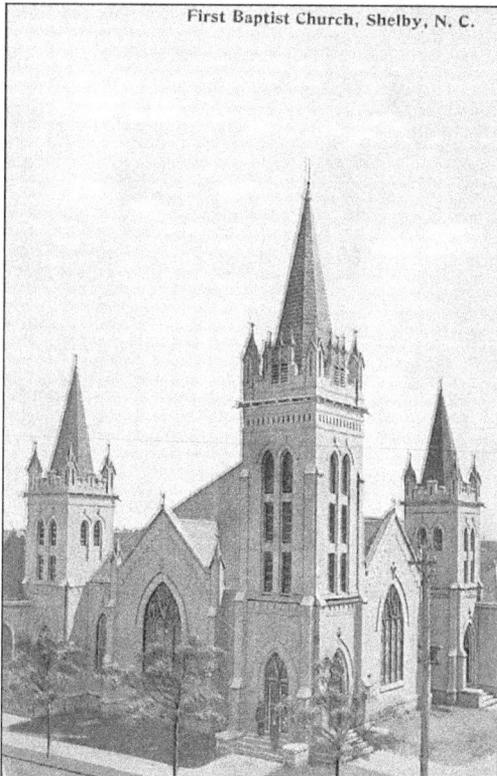

First Baptist Church, Shelby, N. C.

This 1940s postcard shows the main entrance to the church's 900-seat auditorium. Governor Gardner was a member of this congregation. The church's most famous pastor, Dr. Zeno Wall, served from 1924 to 1947. (Courtesy of Boyd Hendrick.)

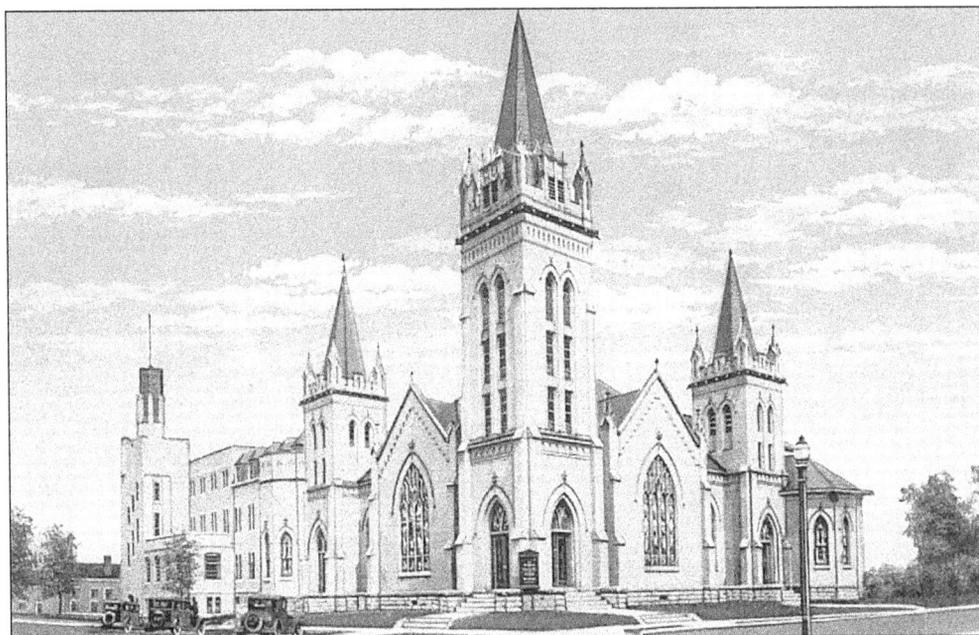

This 1930s postcard shows the church after an addition was completed. This part of the church looks the same today. Two buildings were later added behind this structure. (Courtesy of Boyd Hendrick.)

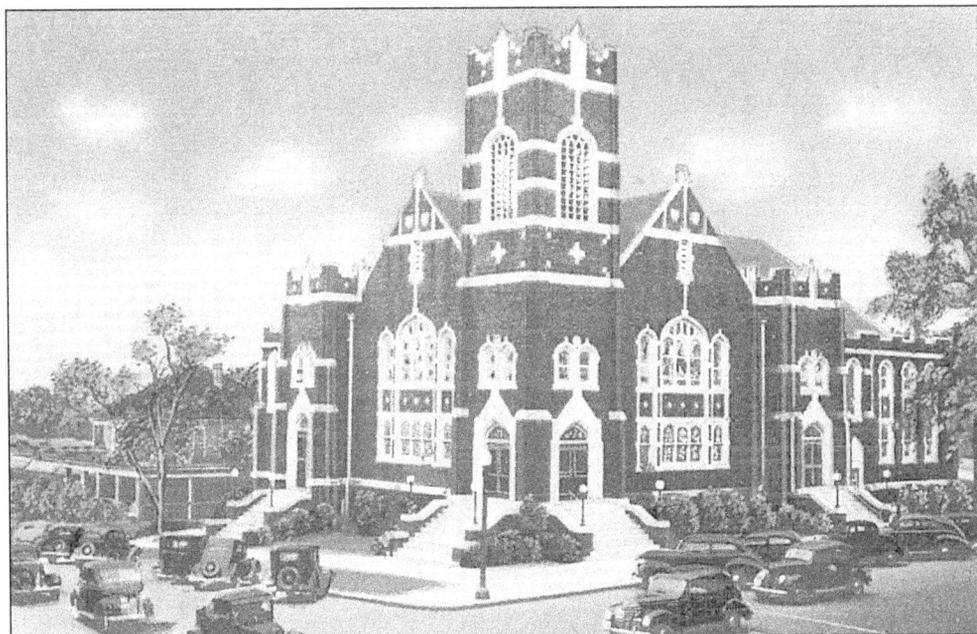

When the Methodist church moved from its Marion Street location in 1924, this structure was built on the site of Shelby's first house. Senator Hoey attended this church, which is still in use today as the Central United Methodist Church and looks much the same as this 1940s postcard.

This building was constructed in the 1930s, with the public library to the left, city hall in the center, and the police and fire departments to the right. Today the building houses city hall and looks much the same. This brick structure replaced the large building that originally served as the Shelby Female Academy.

This community building, c.1940, was located on the site of the current Cleveland County Courthouse. During its life it served in numerous capacities, including as the home of the local American Legion.

During the early years of the 20th century the post office was located in several places around the square. A wooden building stood on this site and served as the post office before the construction of this yellow brick building, c. 1930.

In this night view of the post office, the Central United Methodist Church can be seen to the left. This Washington Street landmark is the home of the Cleveland County Arts Council today.

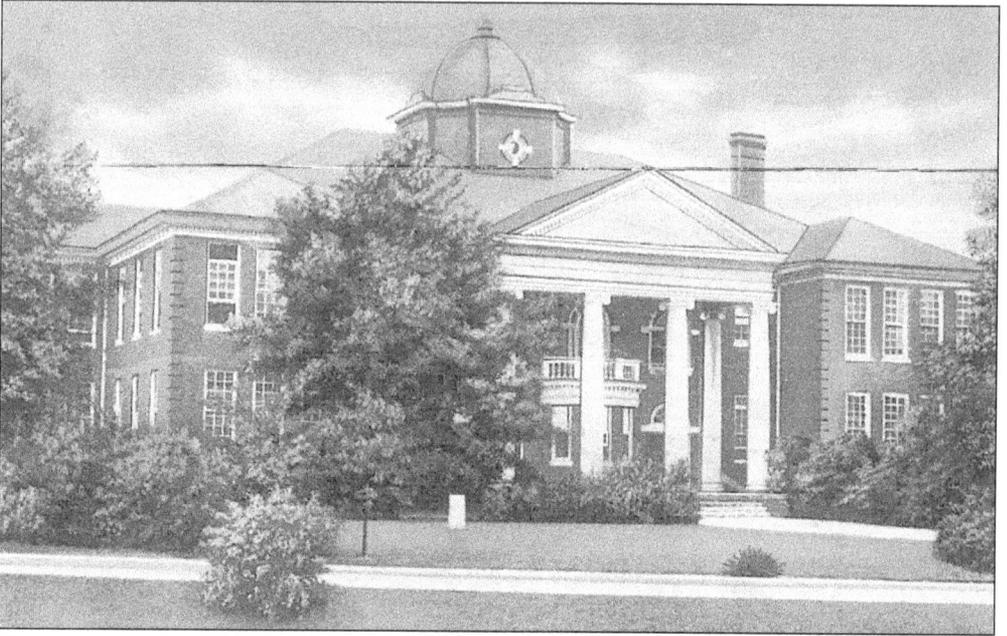

This postcard shows the graded school building as it looked during its time as Shelby High School. The structure became Shelby Junior High School in 1938 and was used for another 30-plus years.

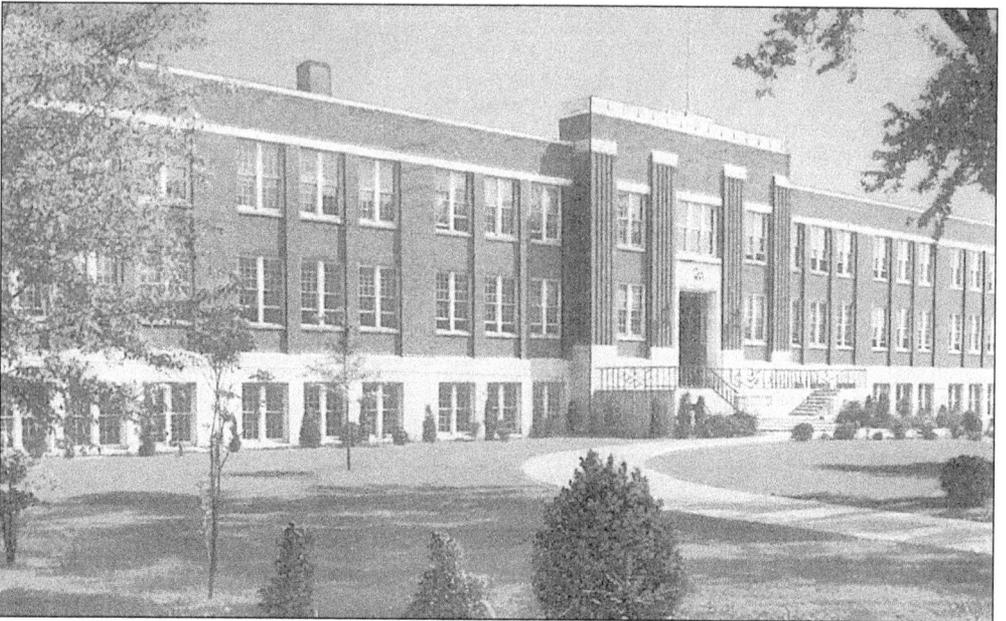

The new high school on West Marion Street was built in 1937. It served as Shelby High School for almost 25 years. Today this structure serves as Shelby Middle School. The windows have been redone, but the building stills looks much the same.

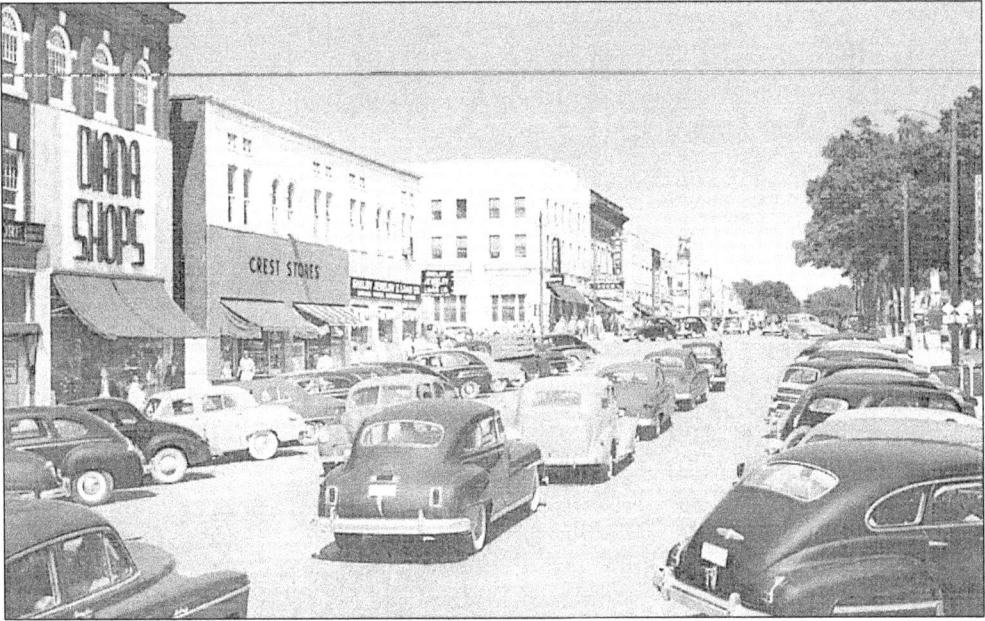

Lafayette Street looked much different near the middle of the 20th century than it did in the era of dirt streets. The building on the left, which housed the Crest Stores, is the Union Trust Building of an earlier era. Note that uptown traffic was two-lane, with angle parking.

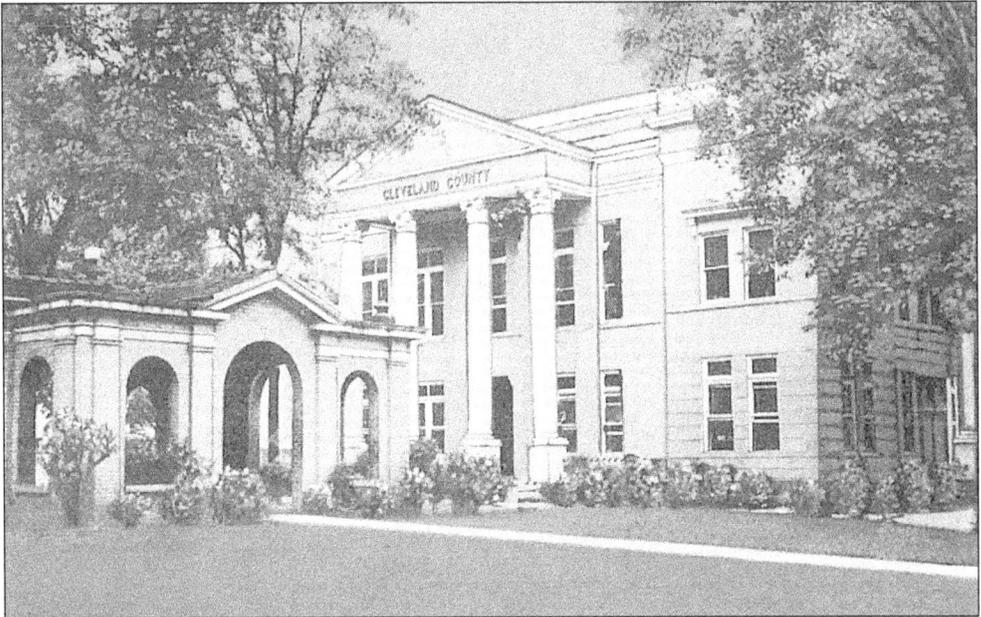

The historic Cleveland County Court House is seen on the east side. The building on the left was at one time a cover for the spring water, which was piped to the court square. Shelbians of the 1950s may remember this small building as the place to take the test for a drivers license. At one point the sheriff had an office here.

Formal Opening

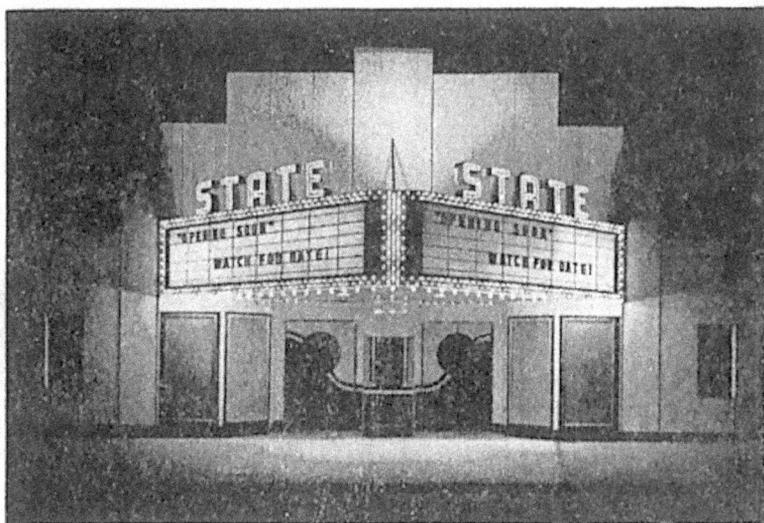

Friday, October 27, 1939

Doors Open 7 P. M.

State

A COMMUNITY ASSET

SOUTH WASHINGTON ST.

SHELBY, NORTH CAROLINA

By 1939, movies were very popular and towns the size of Shelby had more than one theater. During the World War II–era Shelby had four theaters within a block or so of the court square. The State Theater opened in the fall of 1939 and would serve as one of the two leading Shelby movie houses in the Hollywood glory days of the 1940 and 50s. Years later the State became the Flick, and today the building houses an antique market. (Courtesy of Vic McCord.)

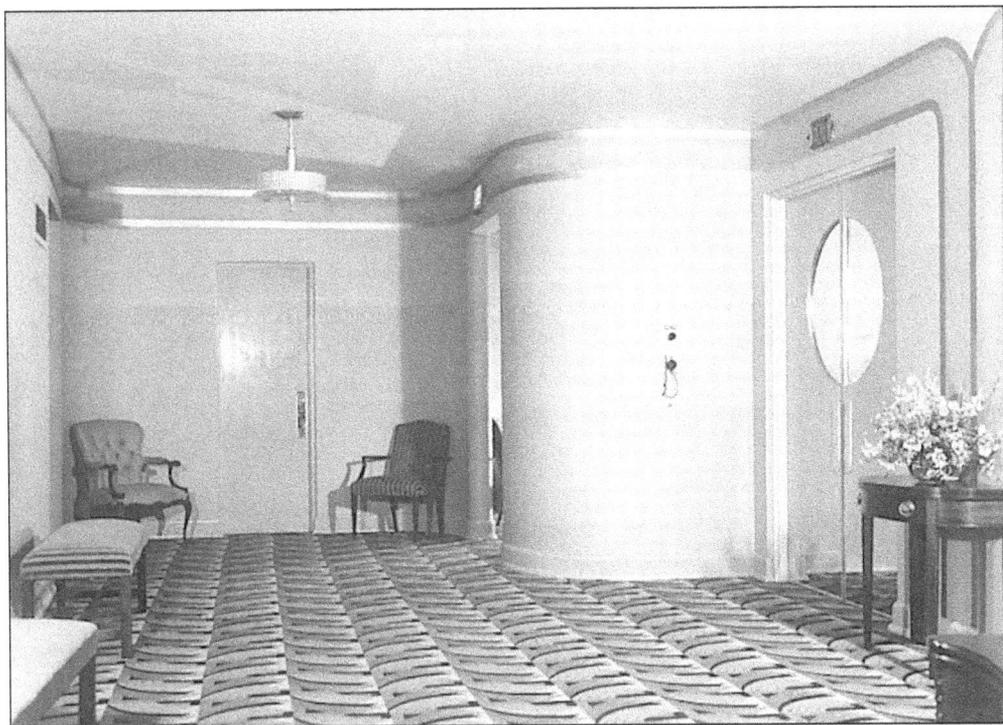

This view of the new lobby shows its stylish decor. Missing is the concession counter, which was popular with movie-goers.(Courtesy of Vic McCord.)

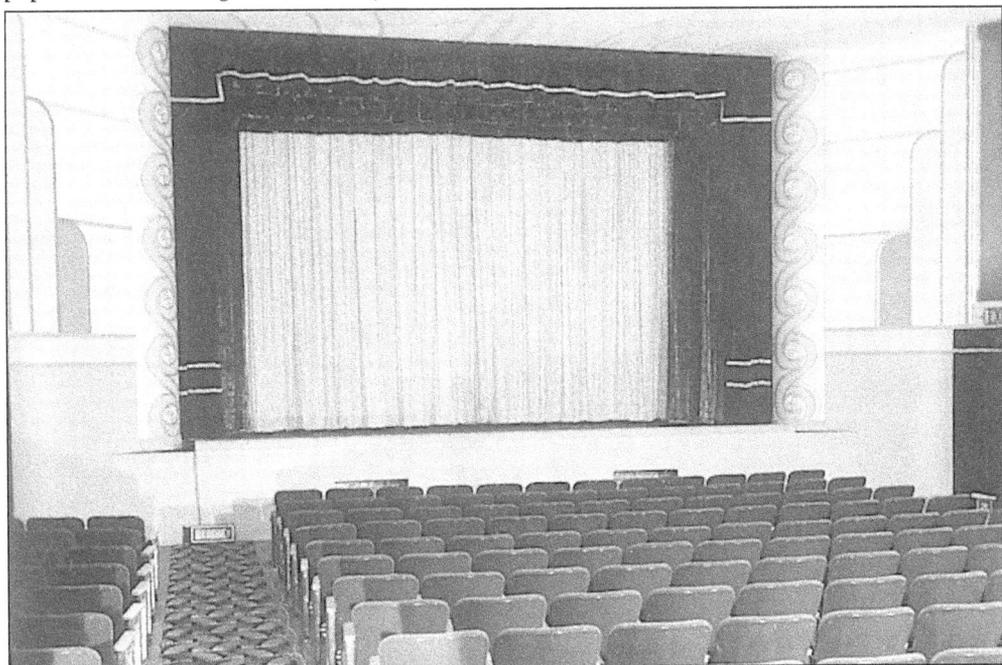

The beautiful interior of the theater was state-of-the-art in 1939, but the small screen was not made for the later cinemascope era. It was on this screen that Shelbians of the 1950s saw Charlton Heston part the Red Sea. (Courtesy of Vic McCord.)

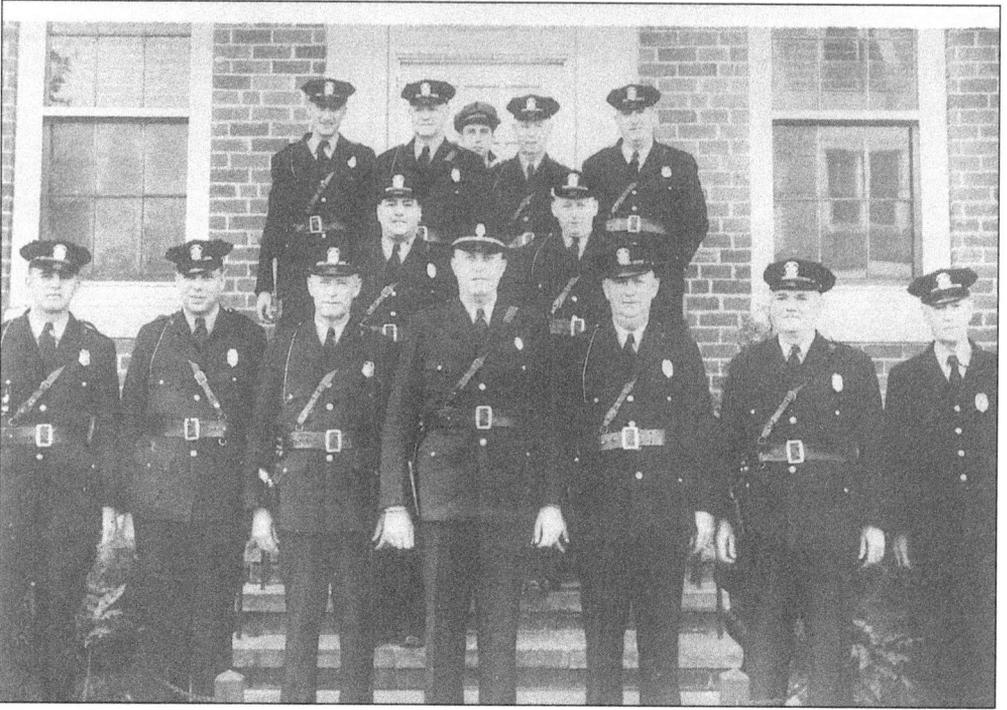

The 14-man police department posed in front of city hall for this World War II–era photo. Pictured front and center is Chief Knox Hardin, who served as Shelby's police chief for a record 28 years, from 1939 to 1967. (Courtesy of the Uptown Shelby Association.)

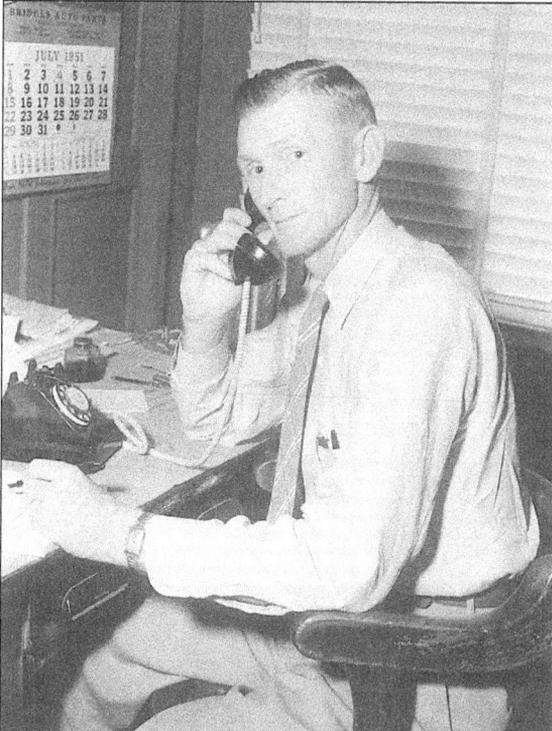

The calender in this picture reads July 1951, which was the first year Sheriff J. Haywood Allen was in office. Allen, whose father, I.M. Allen, served one term as sheriff, set a Cleveland County record by serving as sheriff for almost 30 years. (Courtesy of Uptown Shelby Association.)

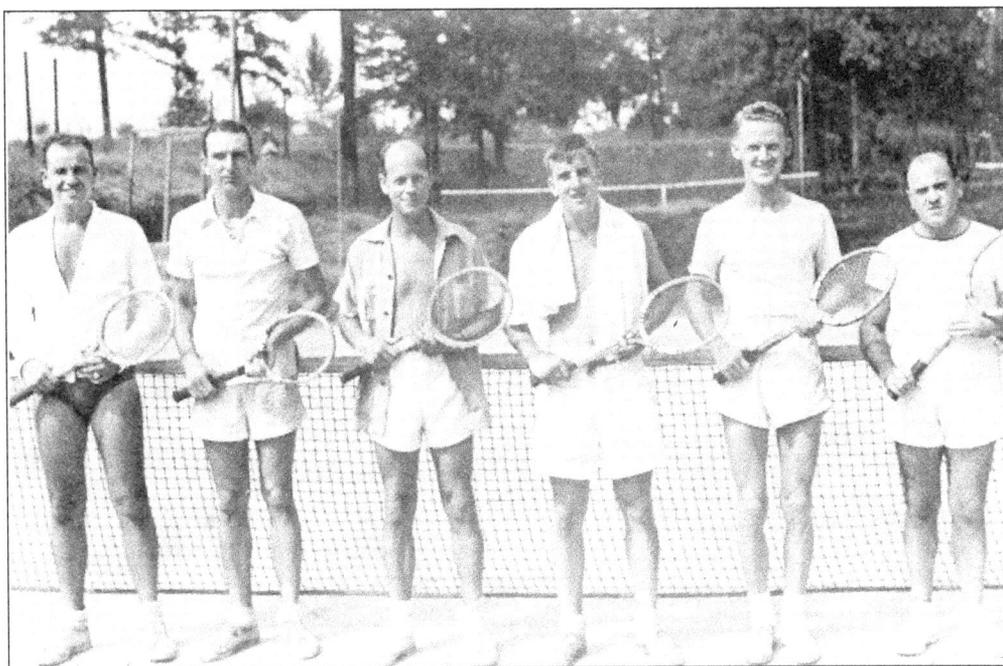

Shelby has a proud heritage of developing quality tennis players. Many have earned state and national reputations. This 1930s photo shows Shelby's first tennis team. Pictured from left to right are Dick LeGrand, Tom Gold, J.L. Suttle Jr., A.W. "Buck" Archer, Pegram "Pig" Holland, and Russell Laughridge. (Courtesy of *The Shelby Star*.)

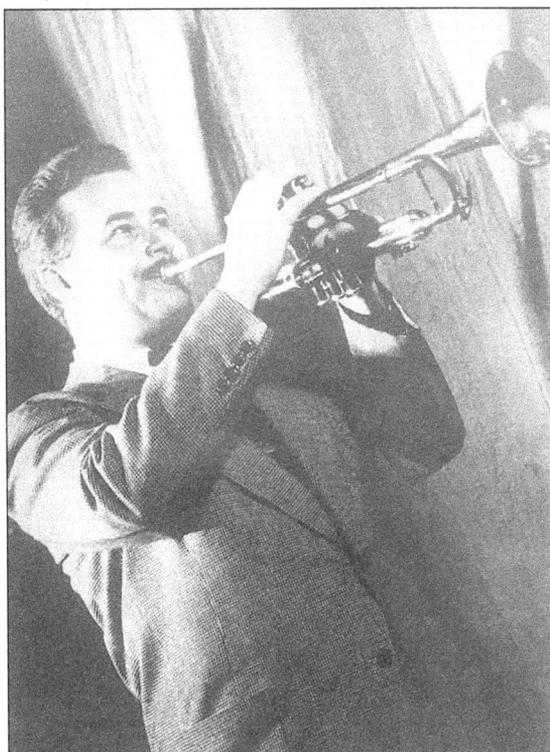

Shelby native Johnny Best played with several leading American bands. He was with Artie Shaw from 1936 to 1940, and later with Glenn Miller and Bennie Goodman. He retired to LaHoya, CA. (Courtesy of the Uptown Shelby Association.)

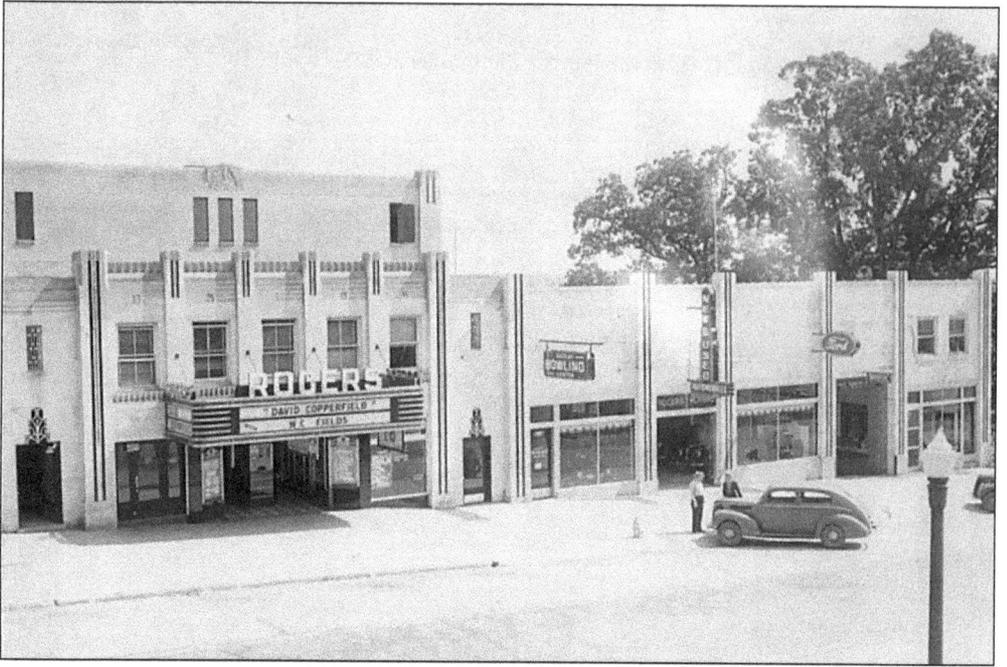

Shelby's other leading uptown theater in the 1940s and 50s was the Rogers. In the days of segregation, it had a "colored" balcony with a separate entrance. The Rogers added a cinemascope screen and was the last of the old uptown theaters to close. (Courtesy of Tommy Forney.)

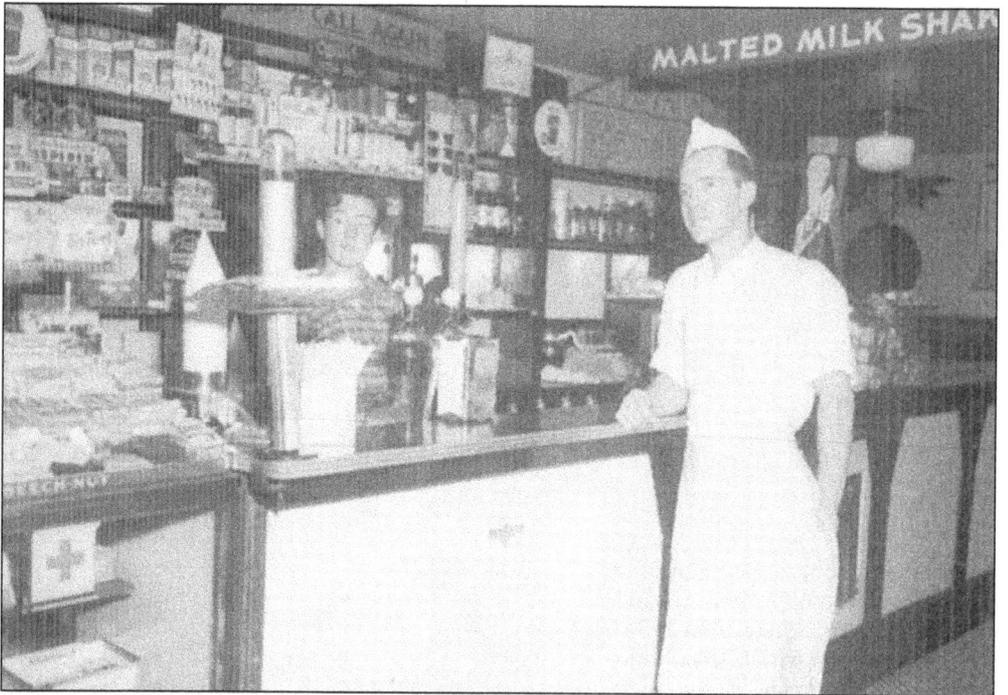

This photo, c. 1950, shows the interior of Beam's Soda Shop, which was located next to the Rogers Theater. (Courtesy of Tommy Forney.)

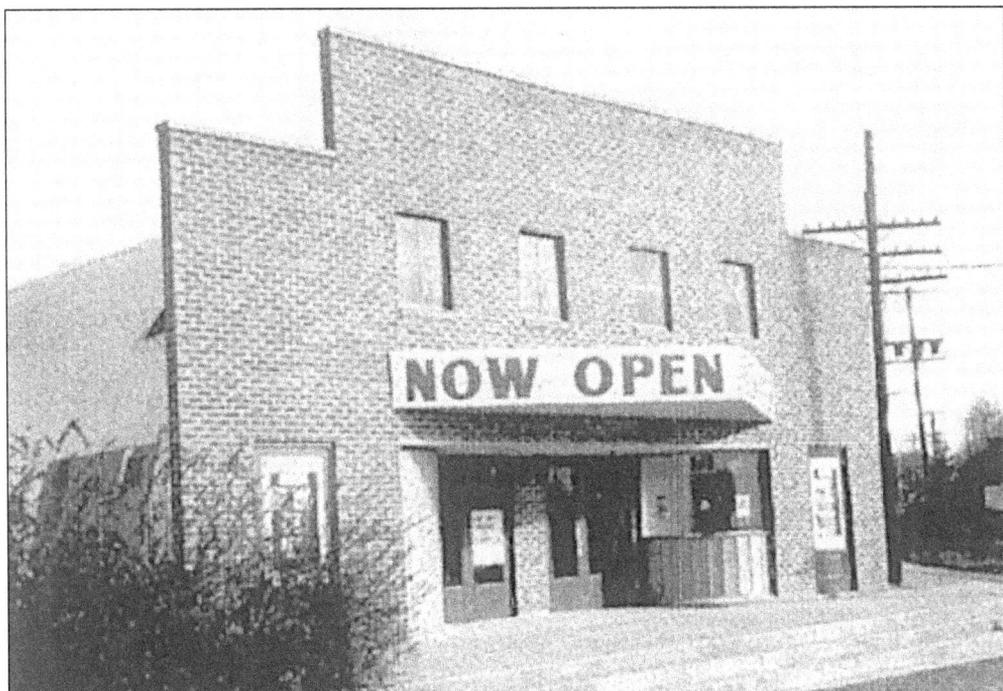

Another example of the era of segregation was the Washington Theater, which was located in the black community. The theater was on Buffalo Street, not far from the traditional black school known as Cleveland School. (Courtesy of Tommy Forney.)

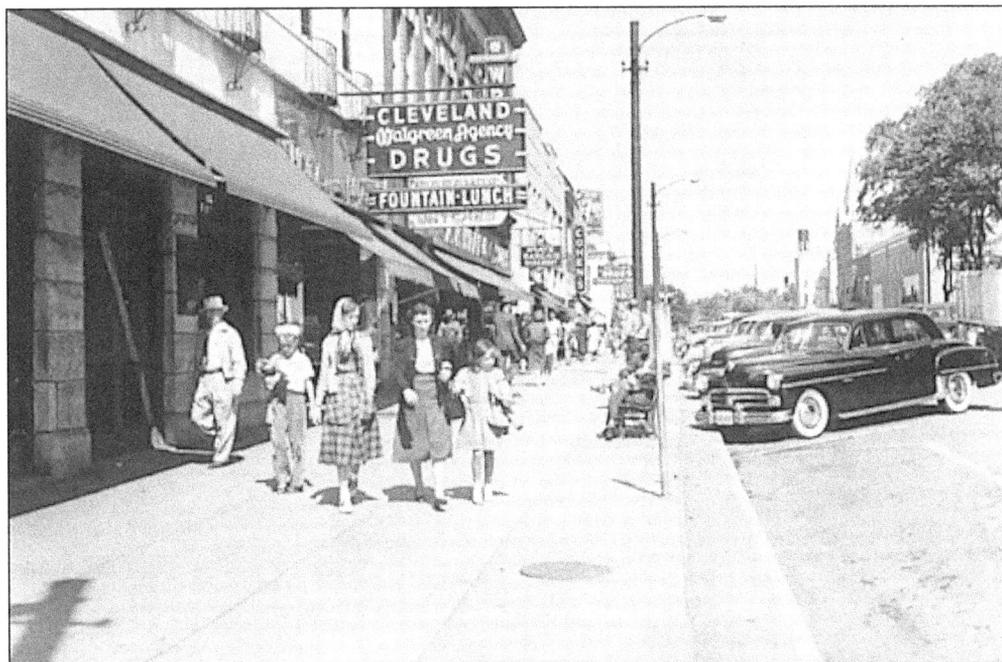

This photo, c. 1950, shows a typical day in uptown Shelby. People are seen in front of First National Bank. The Cleveland Drug Store was a popular gathering place where many political discussions were held. Notice the angle parking still in use. (Courtesy of Tommy Forney.)

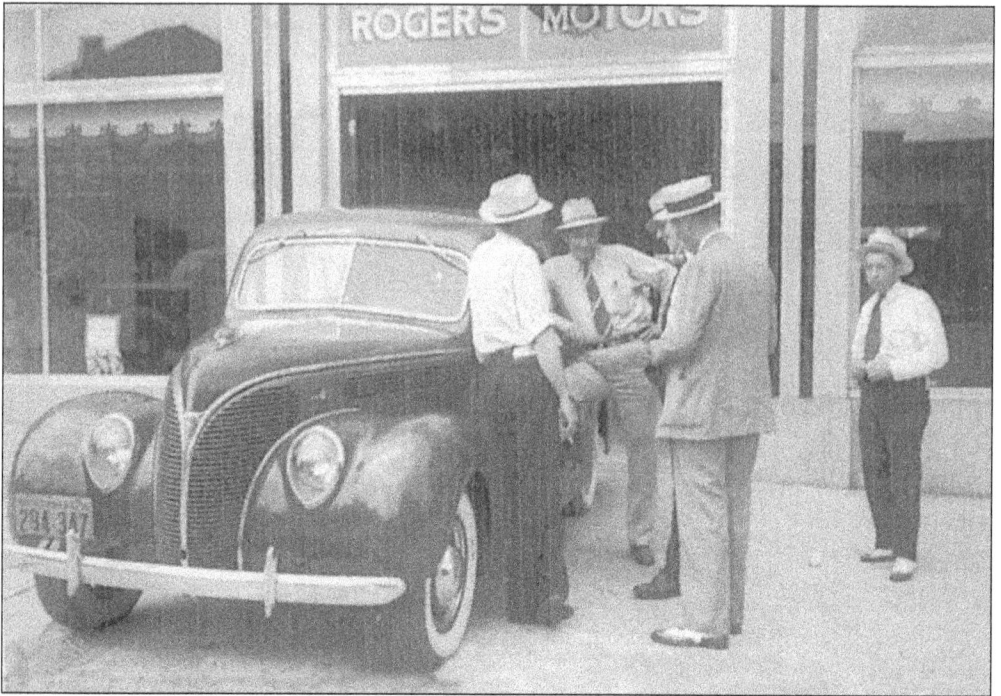

Rogers Motor was located just east of the Rogers Theater on East Marion Street. This scene shows a group of men who all were wearing hats as was common in the 1940s. The Ford car has the wide whitewall tires that were popular in the years following World War II. (Courtesy of Tommy Forney.)

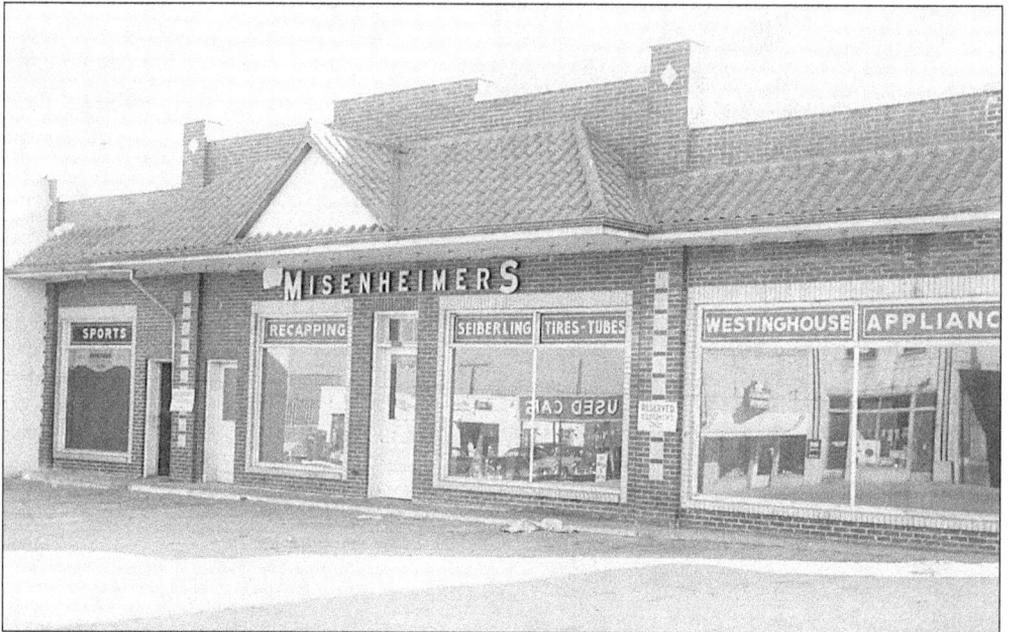

Misenheimers was located across Marion Street from Rogers Motors, just behind the Methodist church. Reid Misenheimer operated this store in the 1950s, featuring tires and appliances. (Courtesy of the Uptown Shelby Association.)

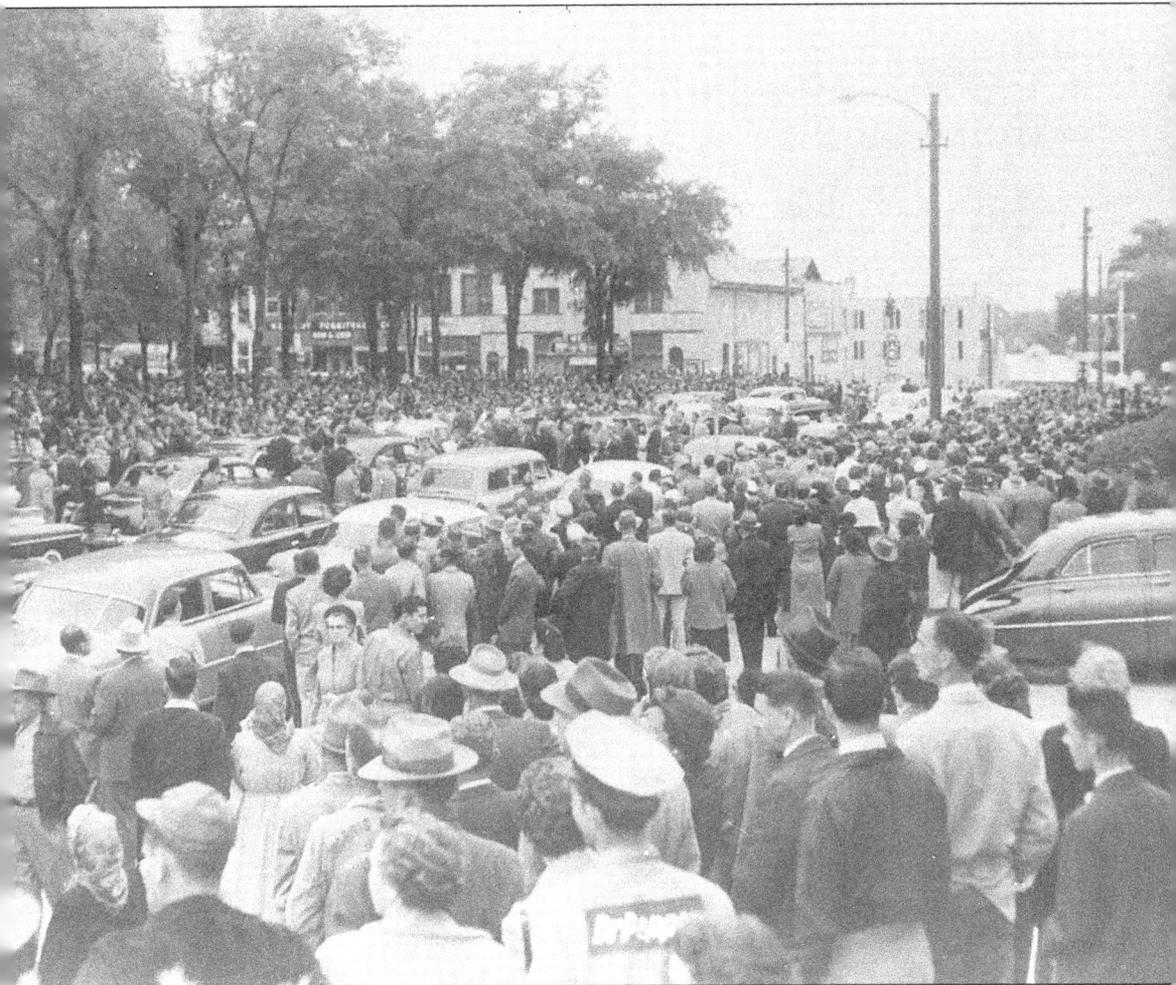

On Monday May 17, 1954, the headline of *The Shelby Daily Star* declared that the Supreme Court had found segregation of public schools to be unconstitutional. Although that decision would have long-term significance, this photograph, which appeared just below that headline, showed the concern of the moment. On Wednesday May 12, 1954, Sen. Clyde R. Hoey died in his Washington, D.C. office. Both Richard Nixon and Lyndon Johnson were scheduled to attend the funeral, but were unable to leave Washington. Sixteen senators attended the funeral at Shelby's Central Methodist Church on May 15, 1954. The crowd filled the court square and Washington Street. The church is at the right, just out of the photo.

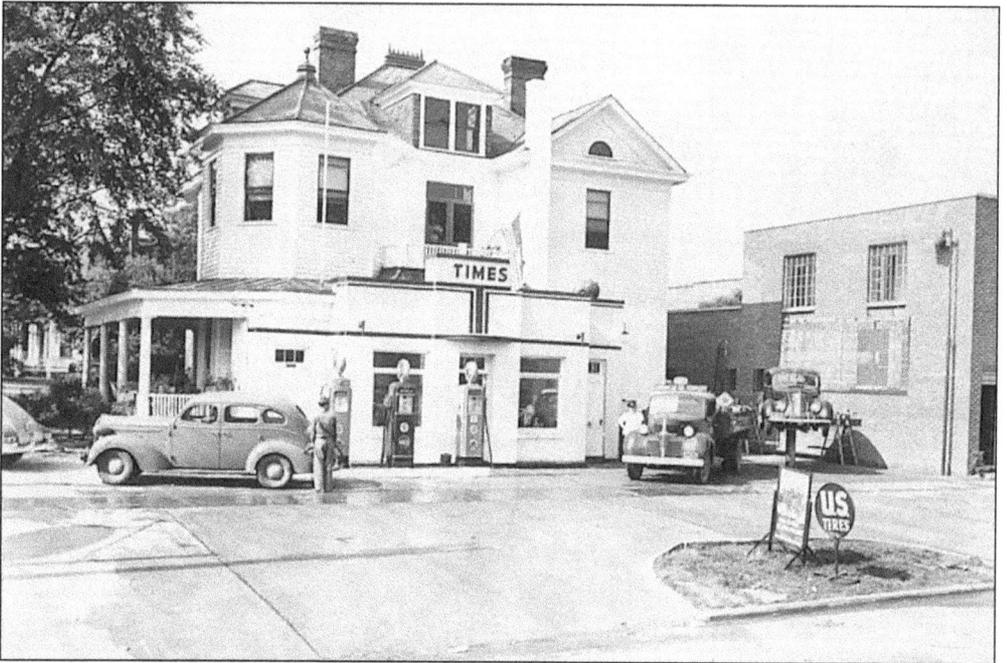

The Times Service Station was located on the corner of Warren and DeKalb Streets around 1940. The brick building next door would be the home of *The Cleveland Times* in the 1950s. (Courtesy of Tommy Forney.)

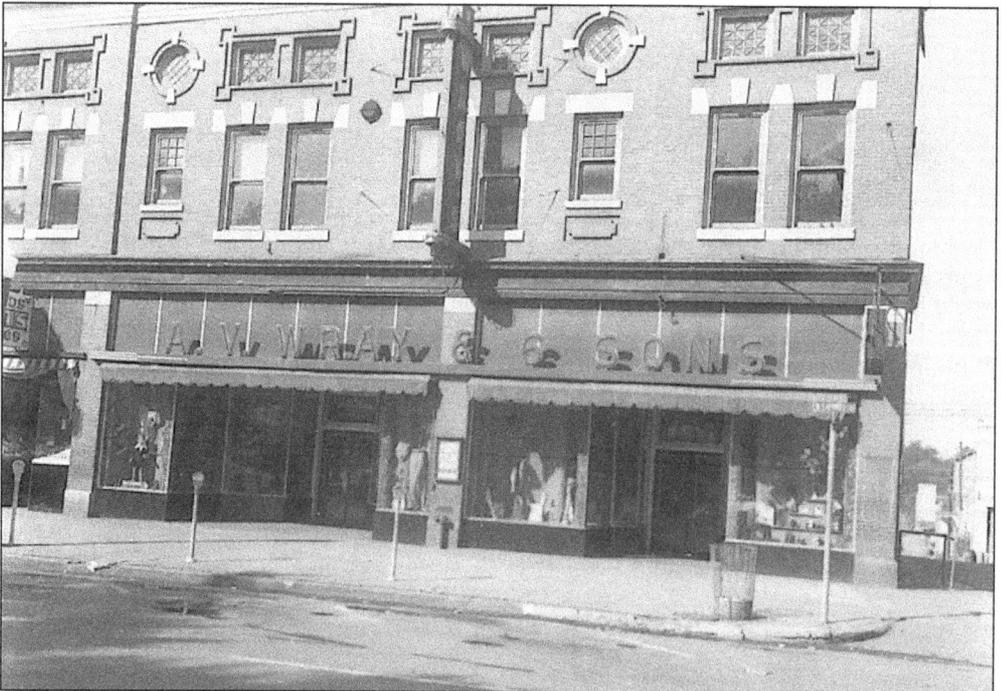

This picture, *c.* 1950, shows the building occupied by A.V. Wray & 6 Sons. Notice the era of the parking meter had arrived. The trees along the street were still a decade away. This remodeled building is now part of First National Bank. (Courtesy of Tommy Forney.)

A local supporter of Eisenhower shows off his campaign sign in front of the Oldsmobile dealership on West Marion Street in 1952. What makes this picture rare is that in heavily Democratic Cleveland County, Republicans were hard to find and never won local elections. It would be 20 years before a Republican presidential candidate carried Cleveland County. (Courtesy of the Uptown Shelby Association.)

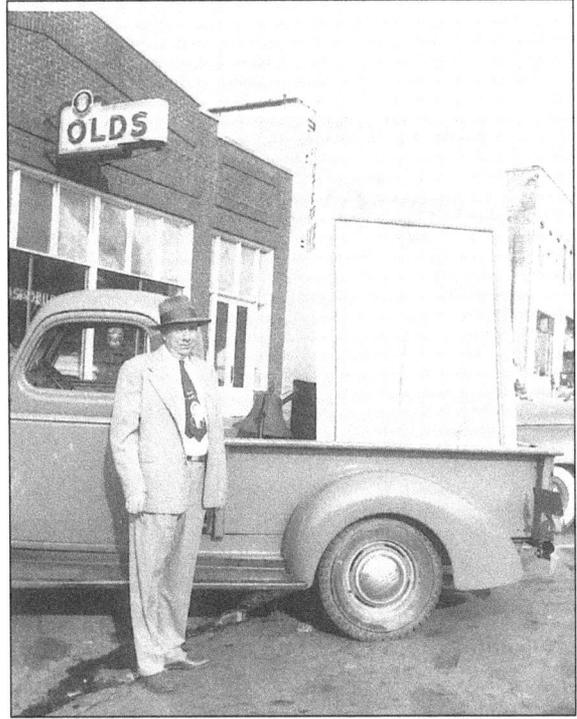

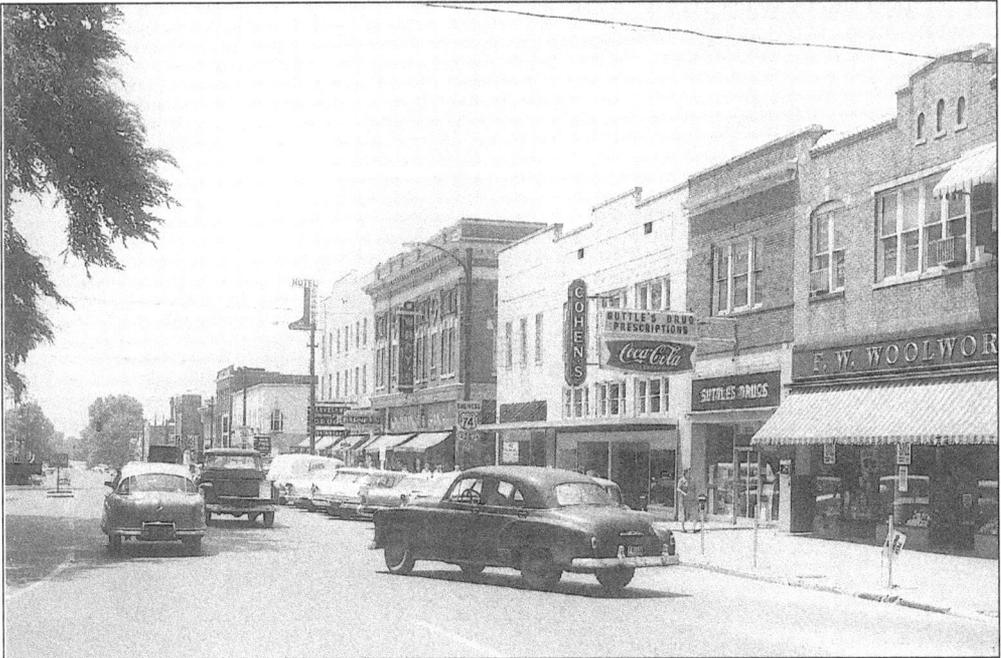

The businesses on the west side of the court square can be seen in this 1950s photograph. F.W. Woolworth's, Suttle Drug, and Cohen's Department Store were long-term occupants. However, Woolworth's moved in 1960, Suttles followed shortly after that, and Cohen's closed in the 1970s. Traffic around the court square was one-way for several years. (Courtesy of the Cleveland County Chamber.)

49

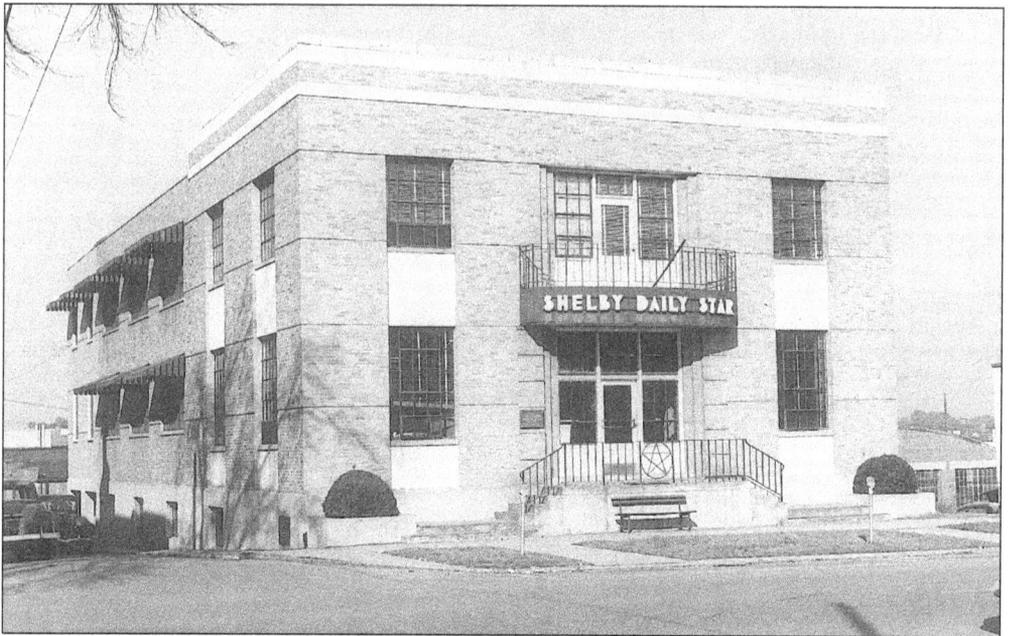

The Shelby Daily Star touched the lives of everyone in Shelby and the surrounding area. In the post-World War II era this building stood on East Warren Street, only a short block from the court square. The paper was published six afternoons a week and delivered by traditional paper boys in town and by adults in cars on the rural routes. (Courtesy of *The Shelby Star*.)

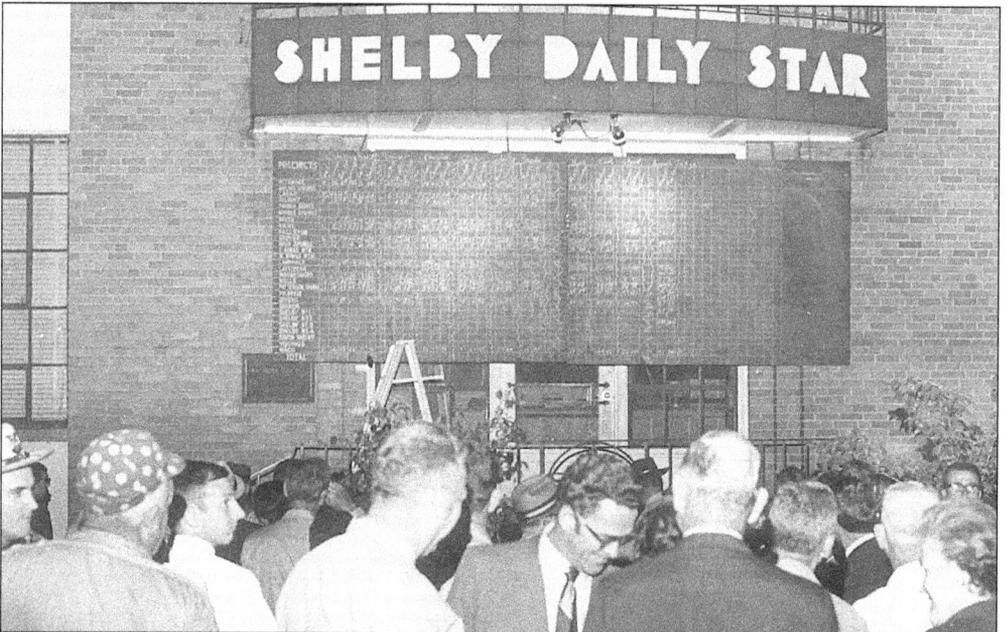

On election night it was common for large crowds to gather in front of the offices of *The Shelby Daily Star* to watch election results as they were posted by hand on the board. Since ballots were counted by hand, this often lasted into the morning hours. Lee B. Weathers, who ran the paper for over four decades, was a confidant of the Shelby Dynasty leaders and served four terms in the state senate. (Courtesy of *The Shelby Star*.)

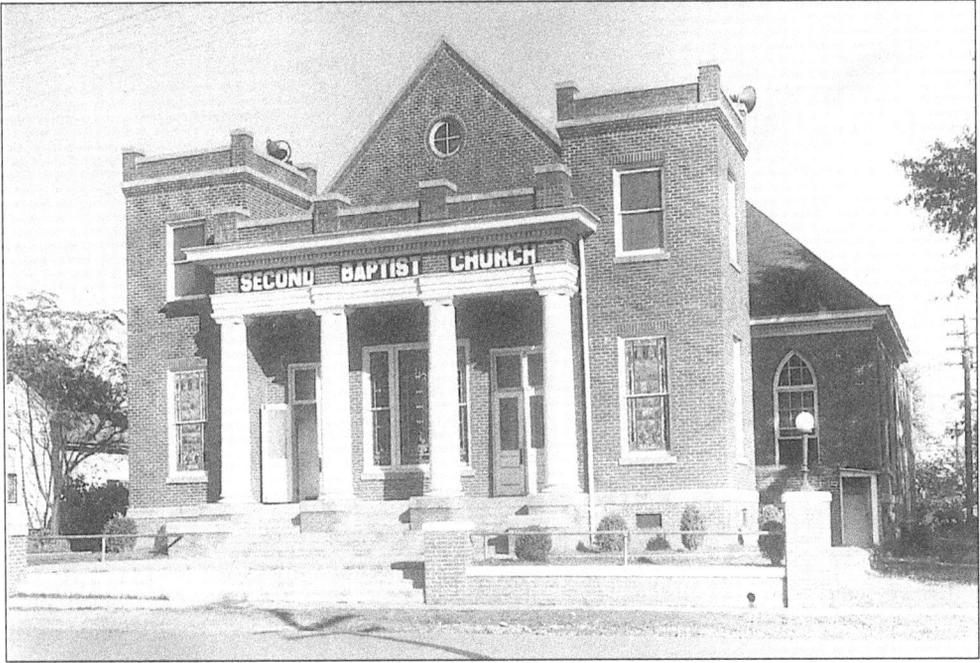

The Second Baptist Church was located on South Morgan Street just beyond where it crossed South Lafayette. This is one of the churches Rev. John Suttle helped start. This structure was razed after the church built new facilities on South Lafayette Street. (Courtesy of the Uptown Shelby Association.)

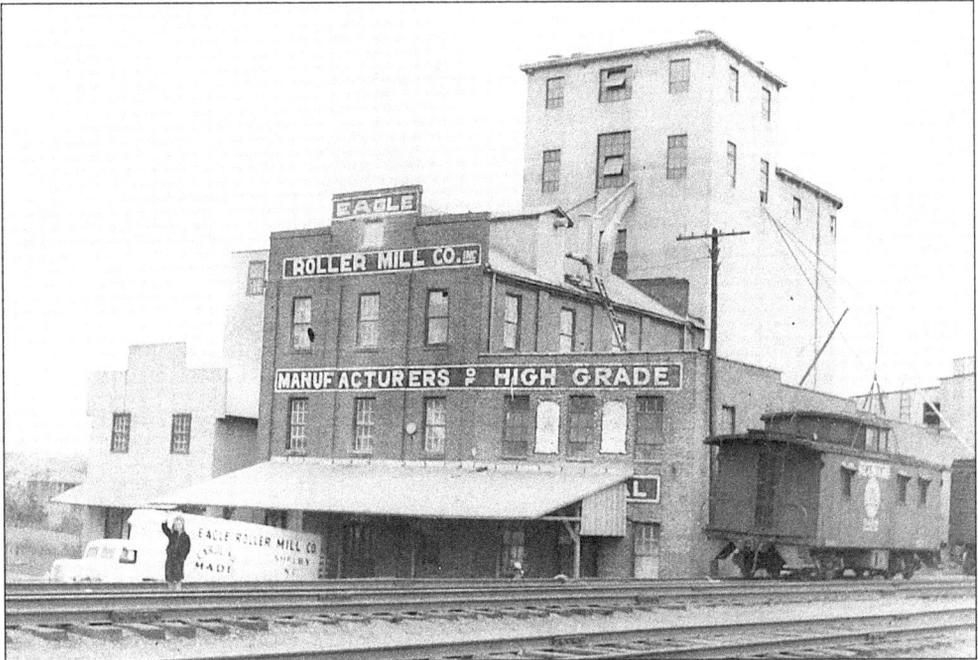

The Eagle Roller Mill Company has been located at the old Seaboard Railroad tracks for much of the 20th century. Years ago people could take their corn to the mill and have it ground into cornmeal. (Courtesy of the Cleveland County Chamber.)

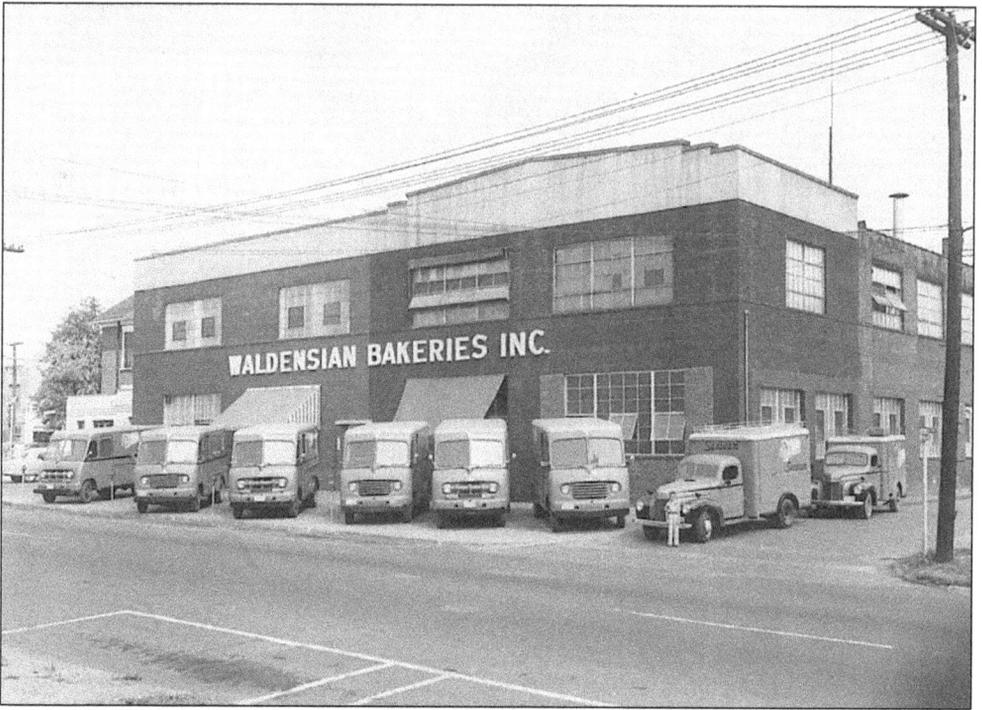

For years Waldensian Bakeries of Valdese operated a plant in Shelby on the site of the current Shelby Police Department. In the years after World War II, Athos Rostan and Ben Shytle were well known as leaders in this business. The orange trucks were common sites as they supplied stores with one of the two largest-selling breads in Shelby. (Courtesy of the Cleveland County Chamber.)

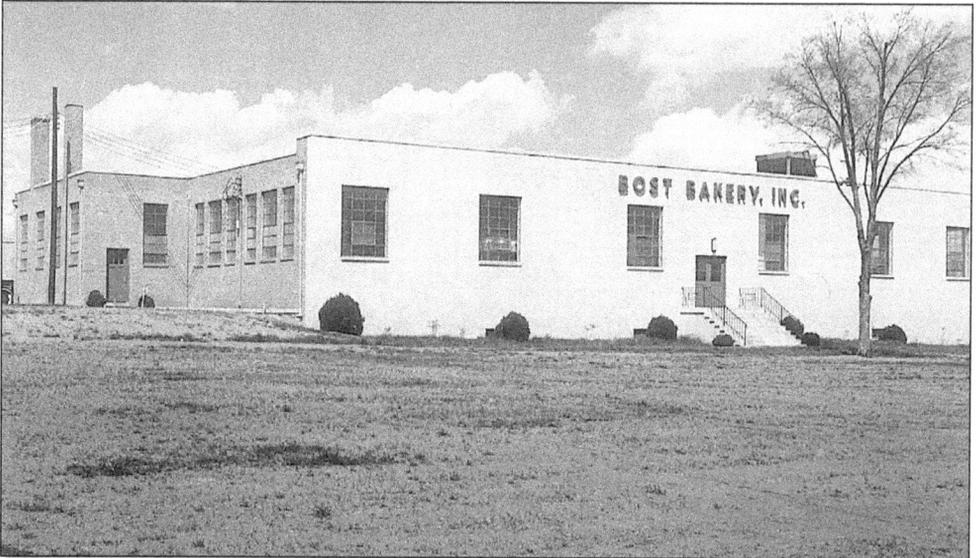

L.C. Bost Sr. established a bakery which grew into a leading Shelby business. The business was continued by his sons, Lloyd, Floyd, Bennett, and Ned. This plant, c. 1950, was located on East Marion Street just beyond the Coca-Cola bottling plant. (Courtesy of the Cleveland County Chamber.)

U.L. Patterson Sr. was a pioneer in the flower industry, being the first "grower" in the southeast to flower the chrysanthemum year-round. In 1929, U.L. and his wife, Edna, founded Patterson's Flowers, which would become one of the largest commercial greenhouse operations in the nation.

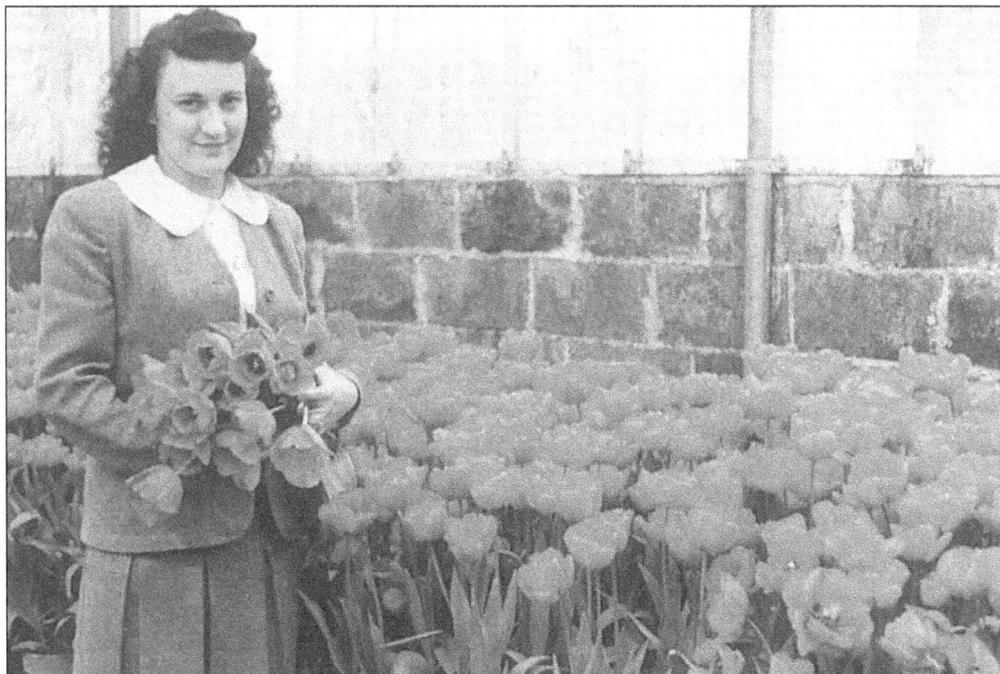

Blanche Teele, who was a cornerstone at Patterson's Flowers, stands beside a bed of tulips, c. 1950. She worked her way up to the position of general manager during her 44 years at Patterson's.

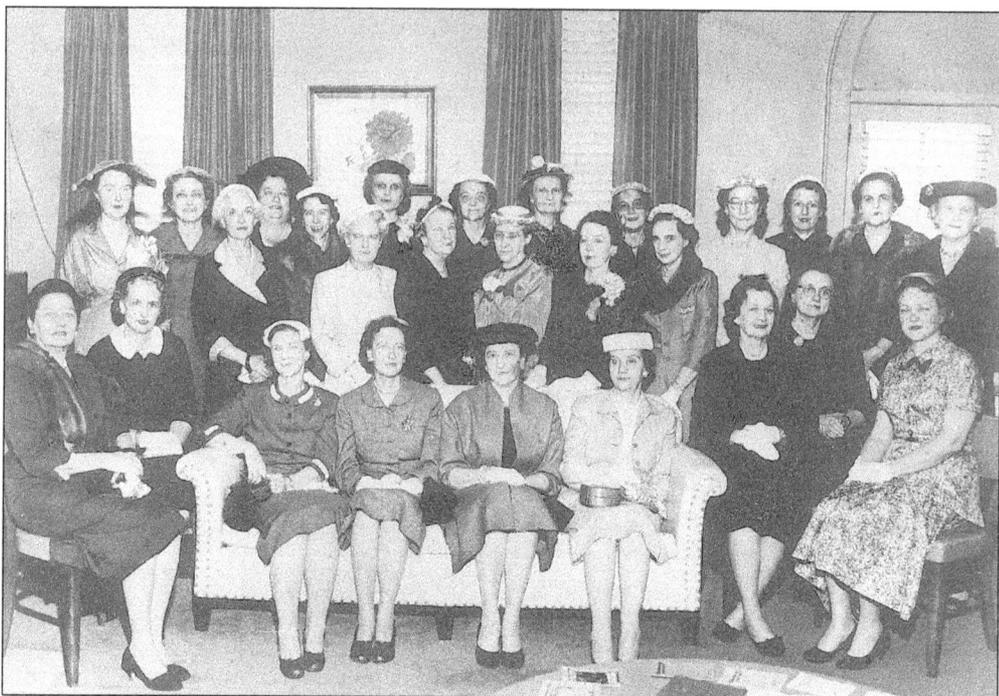

Shelby's women have long been involved in numerous cultural activities, including book clubs. Here the Contemporary Book Club celebrates its 30th anniversary with a luncheon. The picture emphasizes the the dress style of the 1940s, as the women are all wearing hats. (Courtesy of the Uptown Shelby Association.)

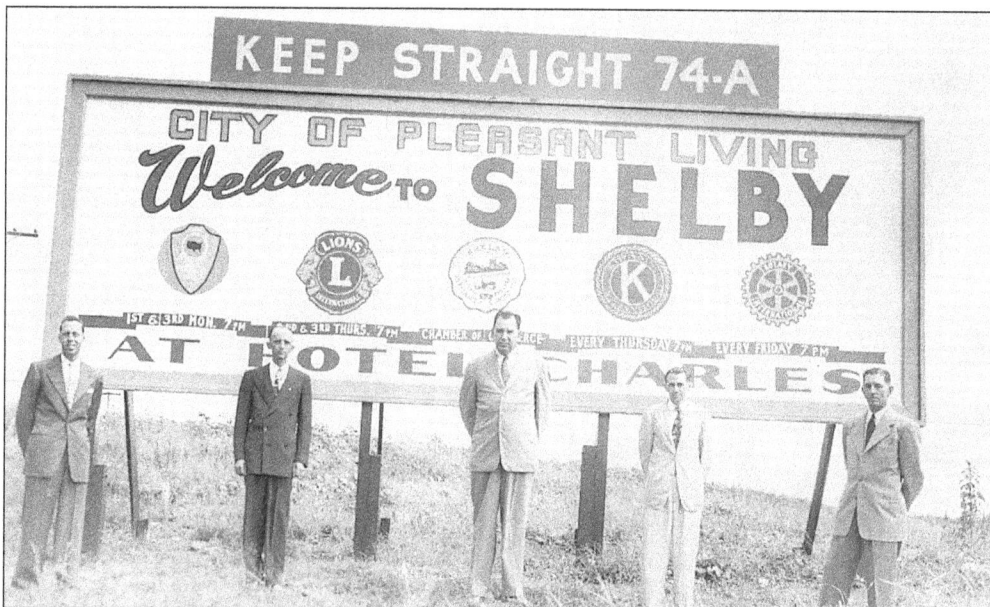

"The City of Pleasant Living" was proud of its civic clubs. This sign encouraged visitors to stay on US 74-A to see Shelby in 1951. The men pictured are, from left to right, Lloyd Bost (Jaycees), John Ed Davis (Lions), W.W. Crawley (Chamber of Commerce), Gene LeGrand (Kiwanis), and Dr. D.F. Moore (Rotary). (Courtesy of *The Shelby Star*.)

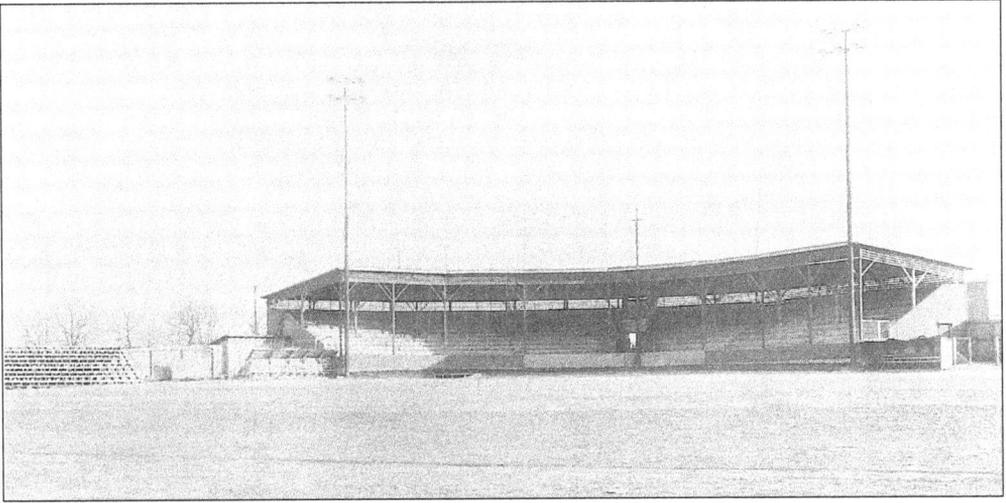

Baseball was a favorite pastime in the 1930s. Many mills had baseball teams, and the city often had a professional team. This park was Shelby's main stadium, located near the Esther Mill in the east side of the city. The park was ultimately surpassed by the Shelby High ballpark on West Sumter Street, which can be seen in the following photo. (Courtesy of Harvey Whisnant.)

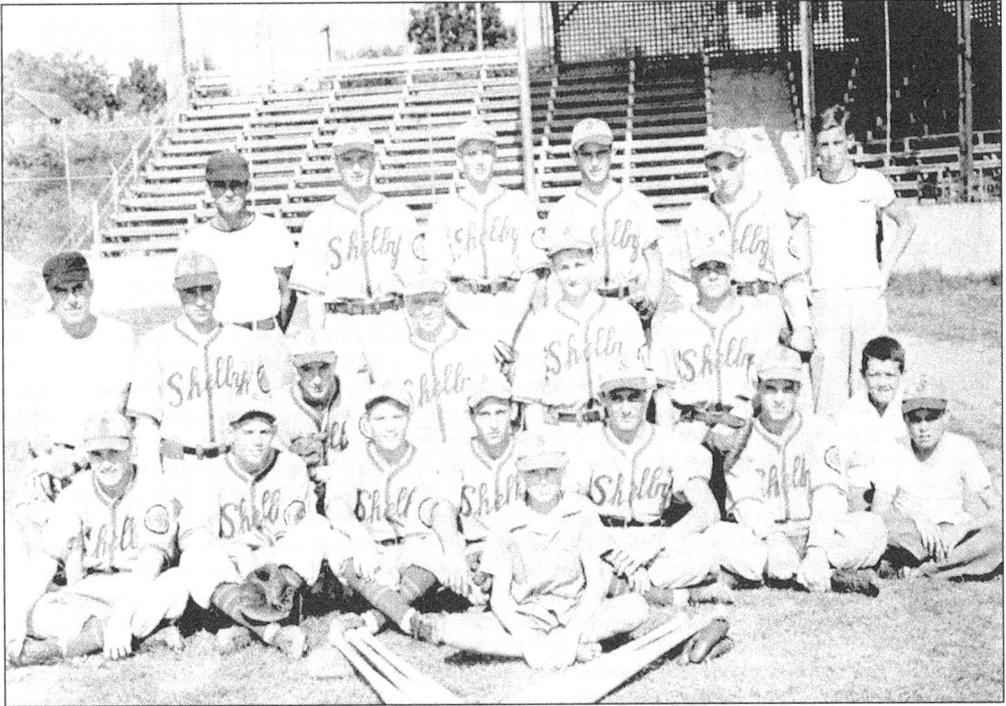

B.E. "Pop" Simmons managed this 1942 American Legion baseball team to the first of five state championships. Pictured from left to right are the following: (front row) Bobby Lane, Manley Runyans, Stanley Runyans, Floyd Brooks, Wallace "Wham" Carpenter, Bud McSwain, "Babe" Hamrick, and Dub Hardin; (middle row) Coach Simmons, Hedrick Powell, Roger McKee, "Pearly" Allen, Gilbert Jones, and Jim Patterson; (back row) Coach A.M. Troiano, Sam Green, Ben Suttle, Gene Kirkpatrick, Bobby Lail, and Bill Weaver. Chief batboy Russell LeGette is pictured in front. (Courtesy of *The Shelby Star*.)

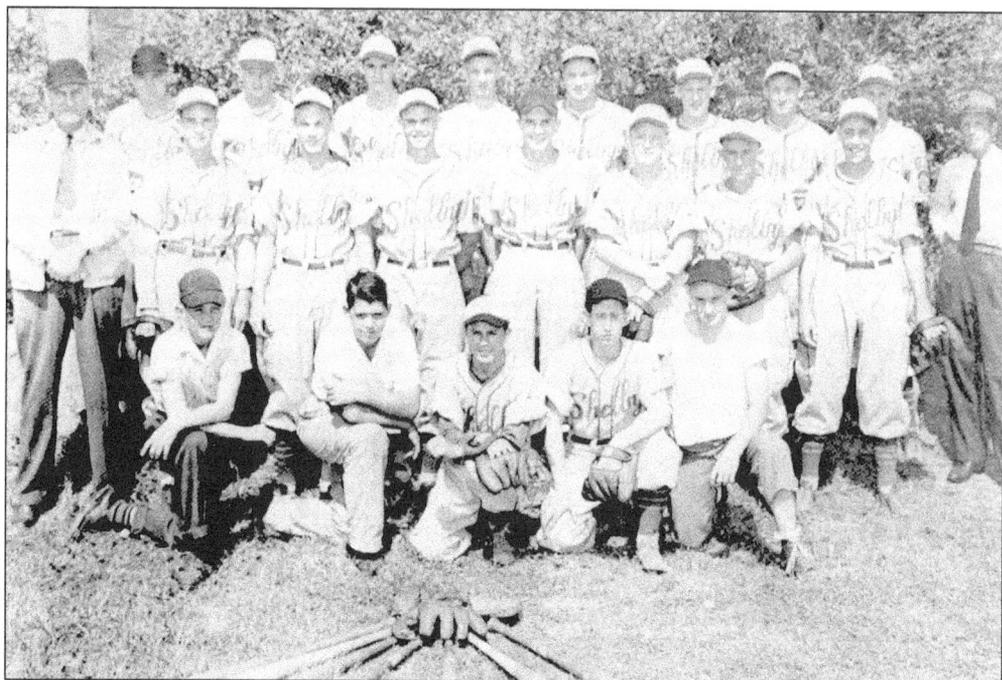

In 1945 the Shelby Juniors won the Legion Little World Series, played in Charlotte. Pictured from left to right are the following: (front row) "Babe" Hamrick, Benny Allen, B.C. Wilson, Furman Webber, and Norris Jones; (middle row) Lefty McGraw, Boots Kent, Jack Bridges, Allan Washburn, Bill Megginson, Floyd Cook, and Mack Poston; (back row) Coach Simmons, Al Bumgardner, Charlie Hutchins, Loy Paige, Don Cheek, Bill Weaver, Gene Hastings, Harvey Brown, Bob Cabaniss, and Coach Lloyd Little. (Courtesy of *The Shelby Star*.)

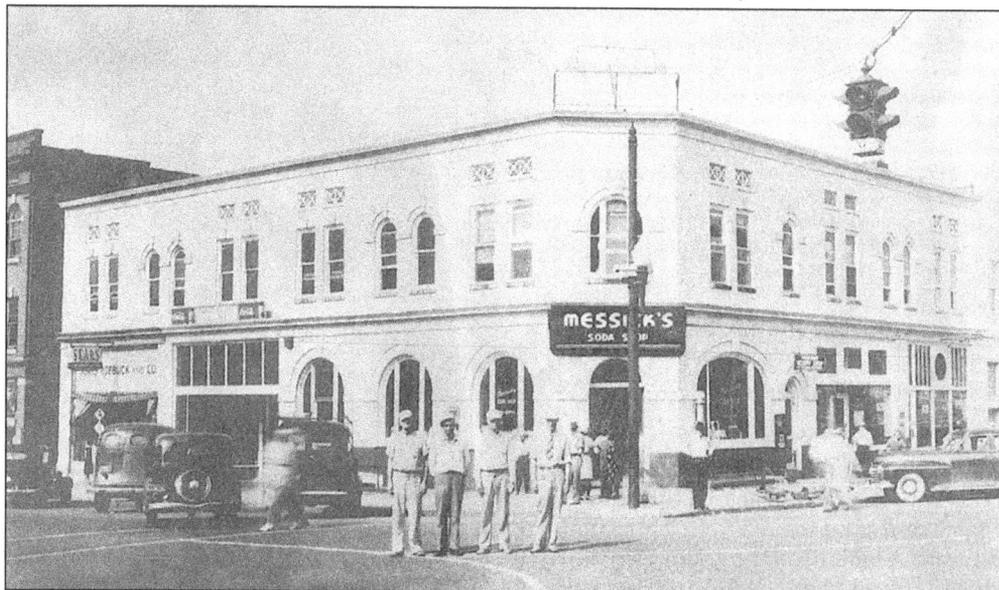

Baseball, politics, weather, and life in general were topics of discussion in Messicks Soda Shop, a popular meeting place around 1940. The building no longer has the sign on top that once proclaimed the bank building. (Courtesy of *The Shelby Star*.)

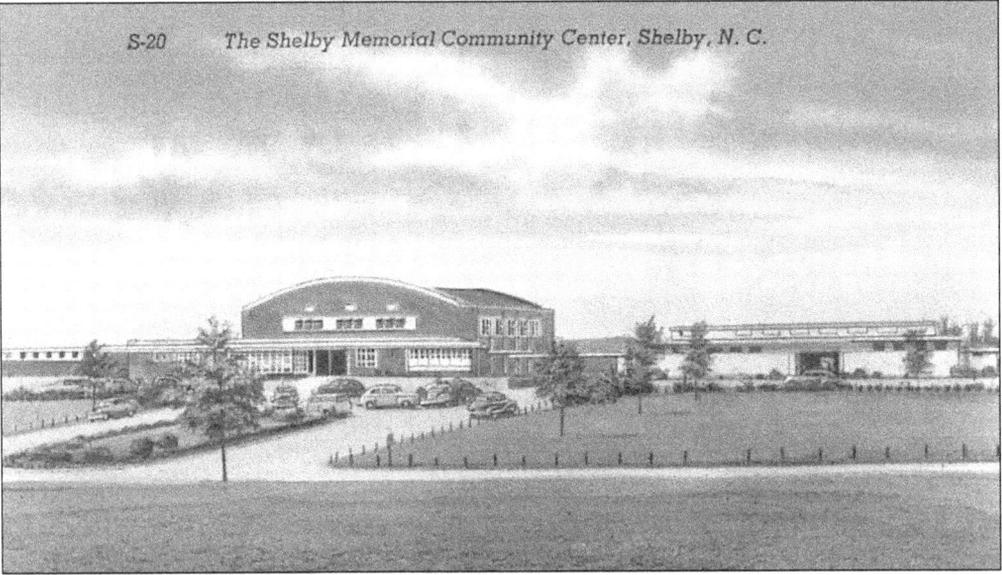

Following World War II Shelby built a large city park on West Sumter Street. This postcard shows the main building and the building that housed the dressing rooms for the swimming pool. The main building has been the home of a bowling alley, a golf pro shop, the Shelby High basketball teams, and the park offices, as well as a meeting place for the boys club, a coin club, a deaf club, dance groups, and numerous other groups.

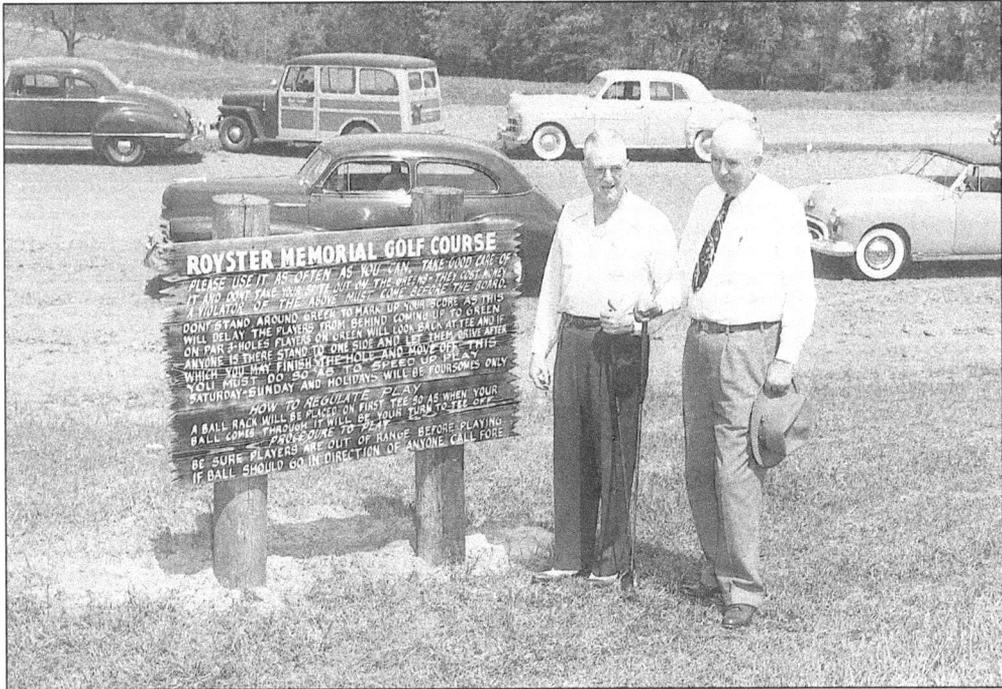

Here Mayor Harry Woodson and local businessman D.W. Royster pose at the instruction sign for the nine-hole Royster Memorial Golf Course that was built at the city park. The instructions of 50 years ago may seem obvious to the modern golfer. The course is still open today. (Courtesy of Shelby City Parks.)

57

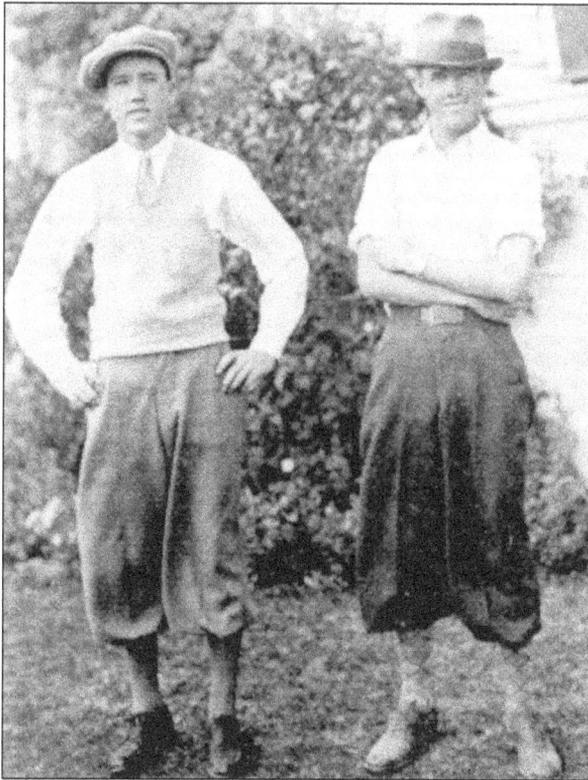

Shelby produced a pair of famous brothers who made their mark in golf. Pete Webb (left) and his brother Fred posed at the Miami Country Club in the 1930s. Pete played in two United States Opens. (Courtesy of *The Shelby Star*.)

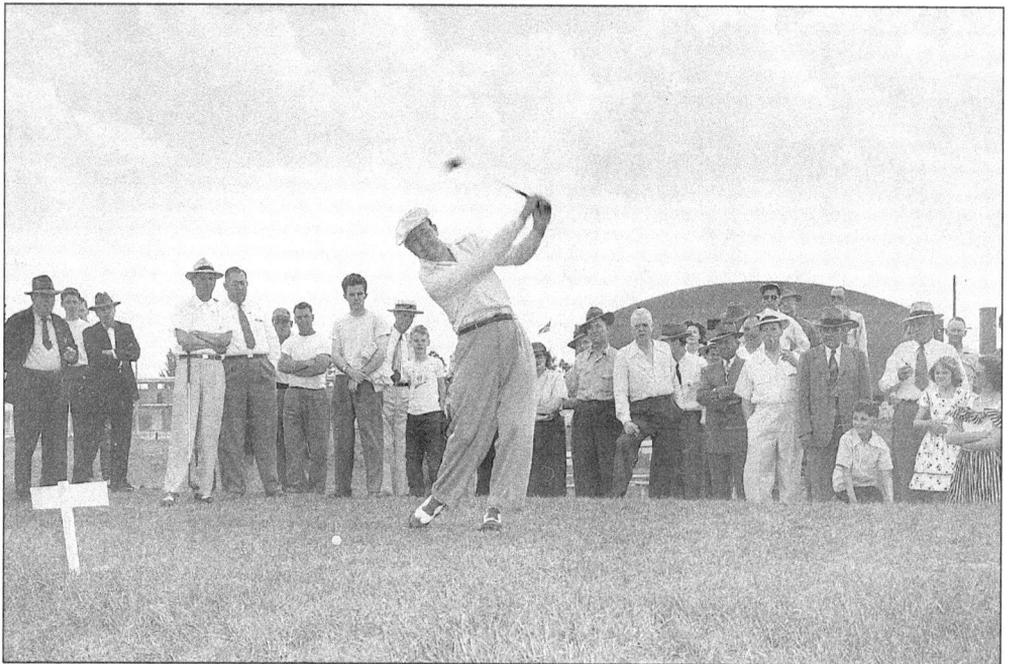

This picture around 1950 shows Pete Webb exhibiting his driving skills from the first tee of the Royster Memorial Golf Course. Today, the Cleveland Country Club hosts a golf tournament in his name. (Courtesy of Shelby City Parks.)

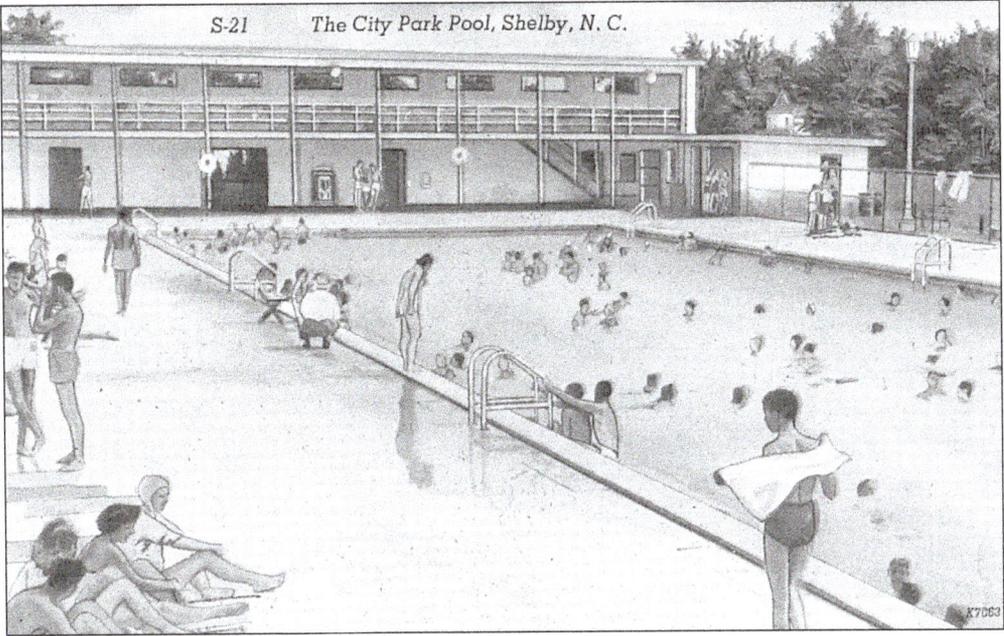

The City Park Pool, Shelby, N. C.

In the simpler times of the 1950s, a generation of Shelby kids and teenagers spent long hours at the city park pool. The pool also served as the home of early swim teams.

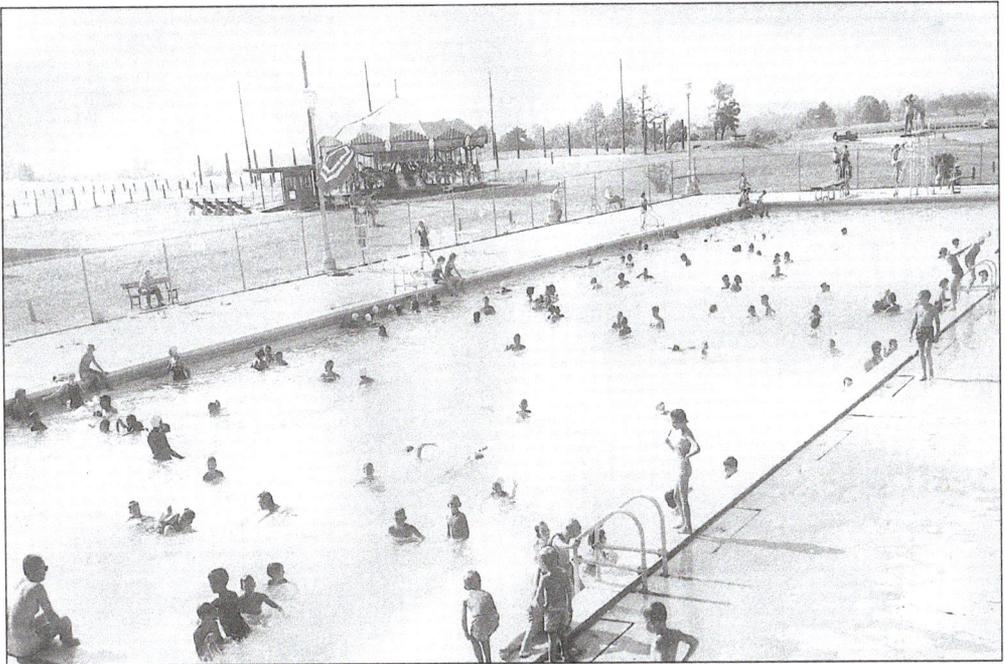

In this early 1950s view of the city park pool, one can see diving boards at the deep end (11 feet) of the pool. In the center was a high diving board, which was popular in the pre-lawsuit era. Beyond the fence the carousel can be seen in its original location. (Courtesy of Shelby City Parks.)

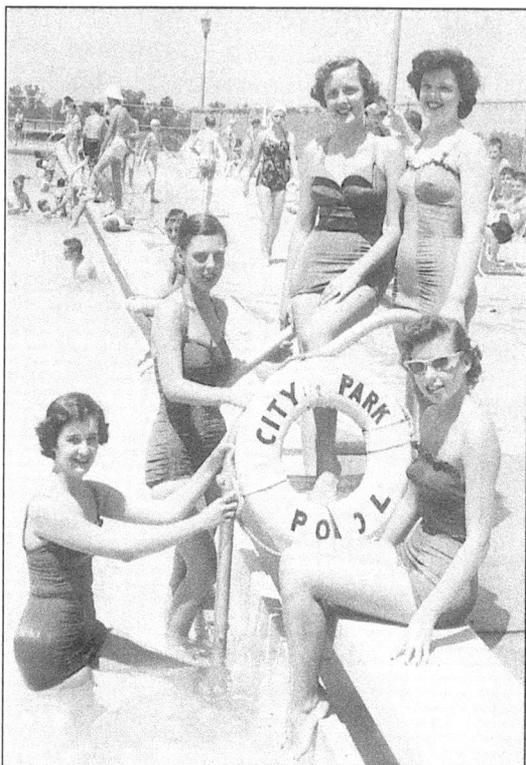

This 1950s picture shows five bathing beauties in the more conservative bathing suits of the era. (Courtesy of Shelby City Parks.)

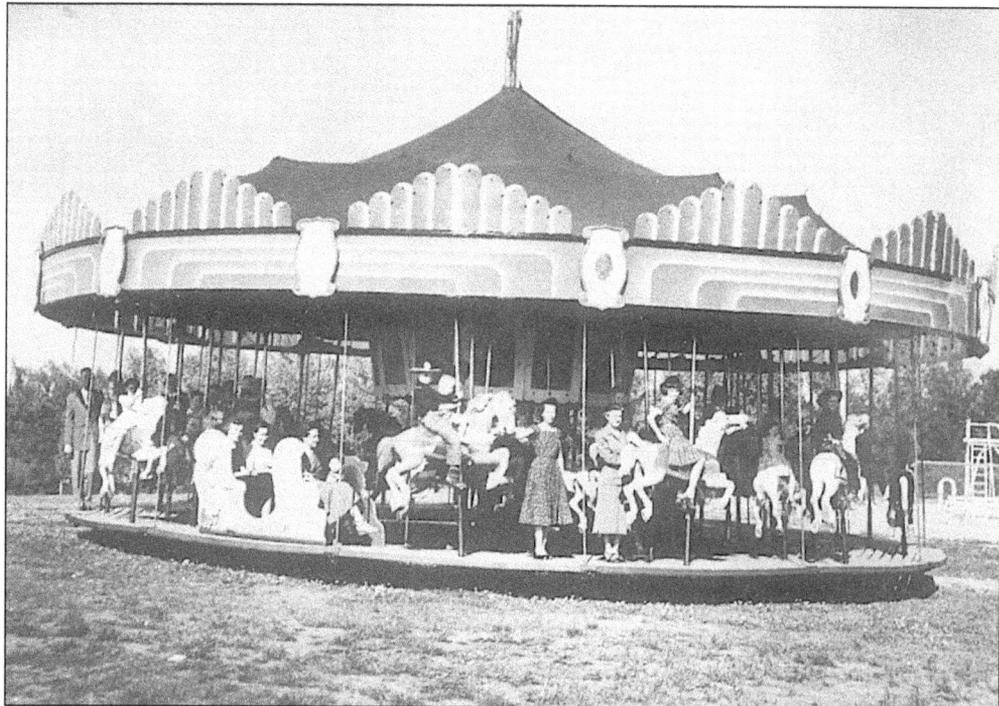

The original carousel was located near the swimming pool. The diving boards are visible at right. After one year it was relocated to its current site. (Courtesy of Shelby City Parks.)

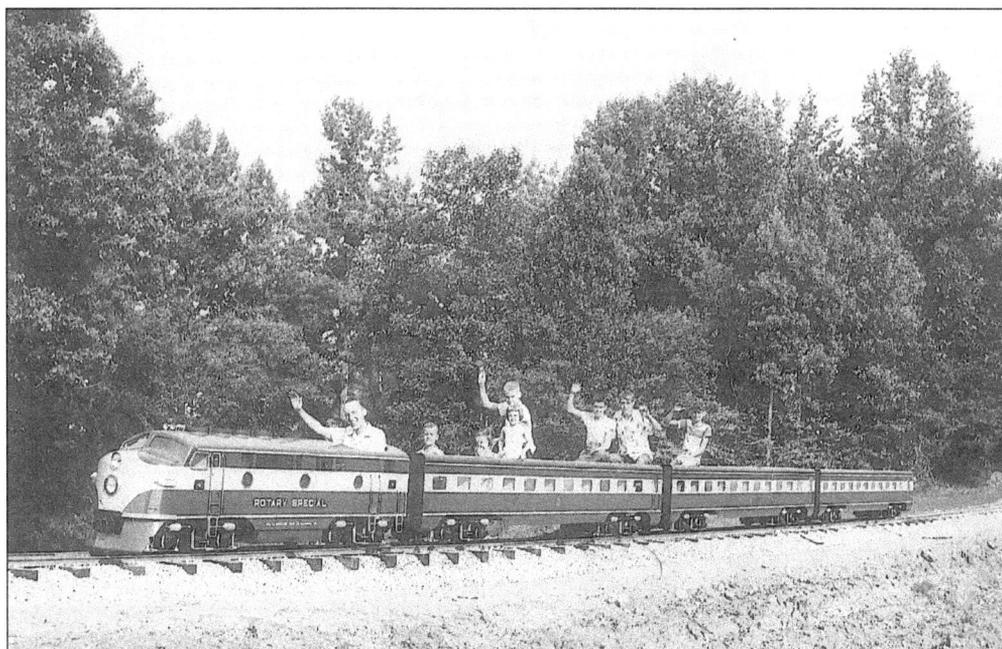

The original *Rotary Special* was a hit with children of the 1950s. Shelby City engineer Robert Van Sleen is serving as train engineer, and young Clark Ford sits just behind him. (Courtesy of Edwin Ford.)

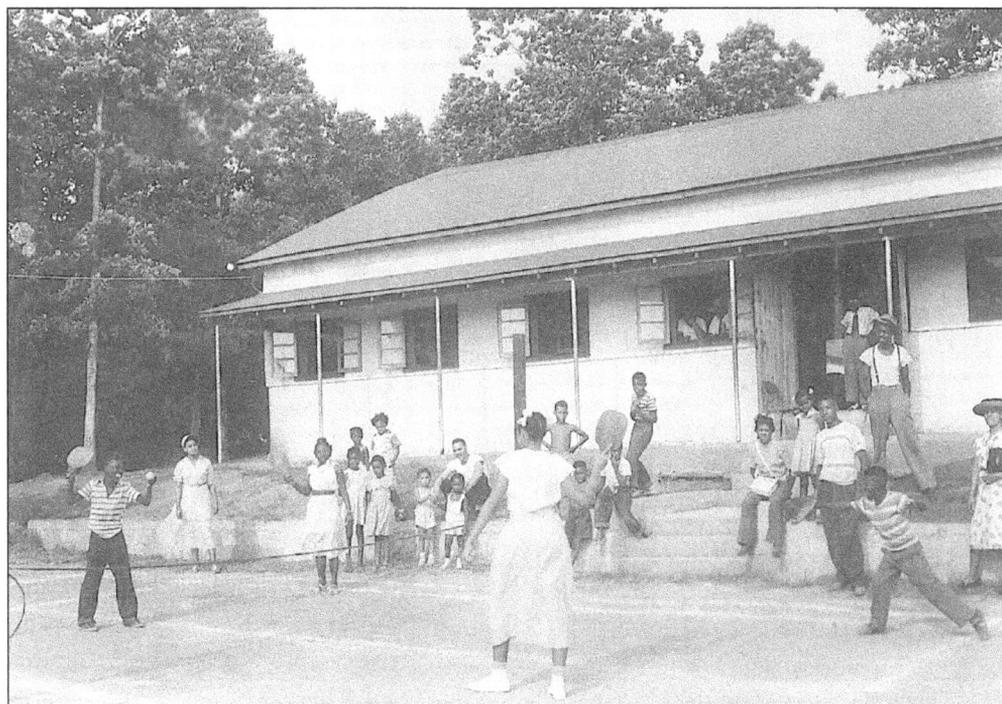

Holly Oak Park served as a park for citizens in the black community in the days of segregation. This building was once a stable on the Arey horse farm. It has been renovated and is still in use today. (Courtesy of Shelby City Parks.)

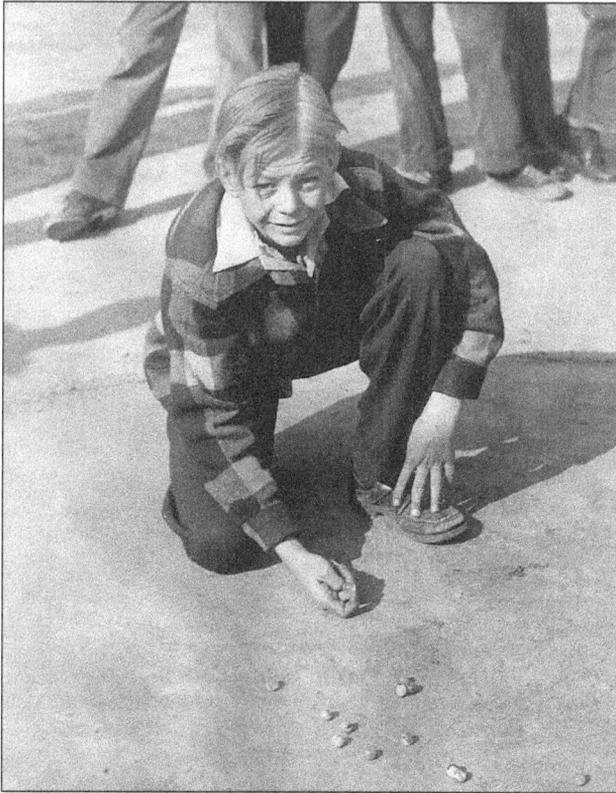

Another popular activity of the 1950s for boys was shooting marbles. Some mothers thought it was gambling if the boys played "for keeps." Don Poteat is showing the form that won him a marble shooting championship. (Courtesy of Shelby City Parks.)

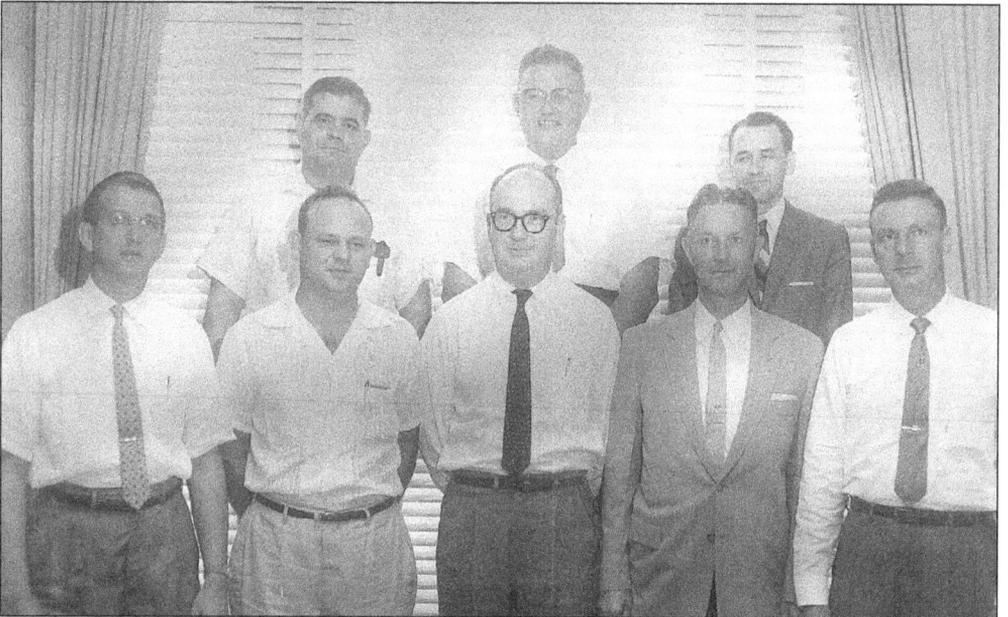

These eight men served on the city park board in the 1950s. They are as follows, from left to right: (front row) Lamar "Buddy" Young, Gene LeGrand, Hugh Wells, Henry Edwards, and Park Superintendent Robert Hartley; (back row) unidentified, J.L. Wilkie, and unidentified. (Courtesy of Shelby City Parks.)

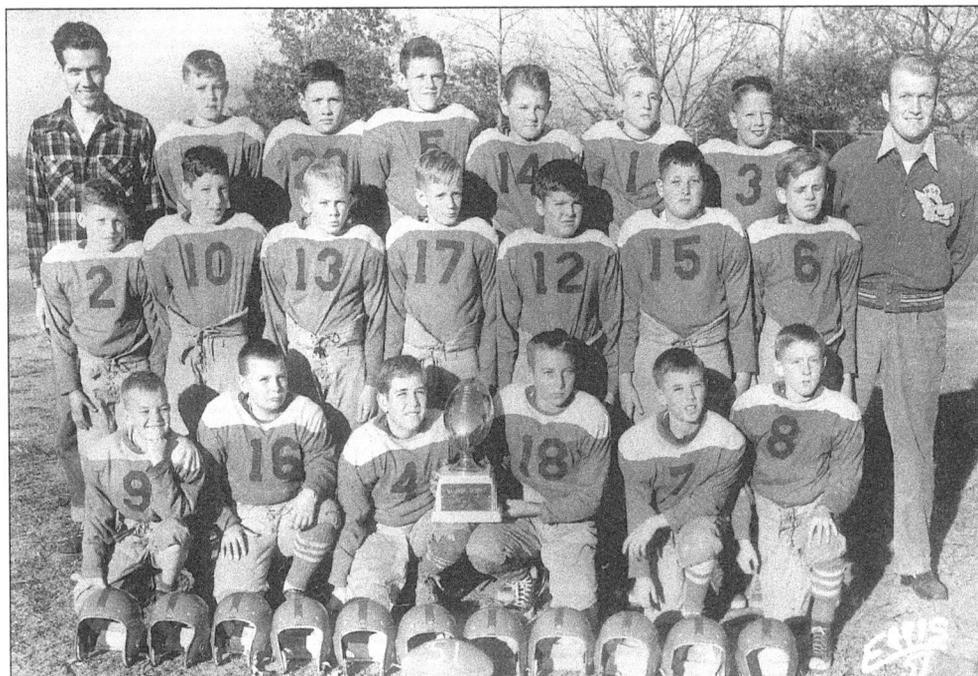

In this 1950s photo, the Dover Midget League football team proudly poses with the championship trophy. The coach is local businessman Hoyt Bailey. (Courtesy of Shelby City Parks.)

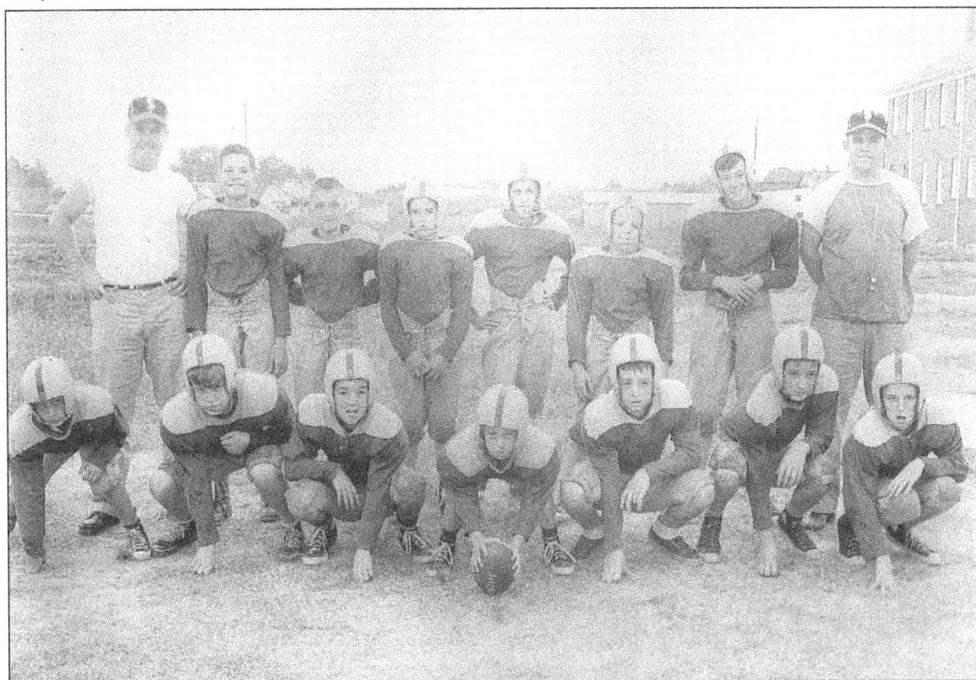

This picture from the 1950s shows that young football players found it hard to be totally serious about a team photo. This was a time when a few good men helped boys have fun and learn football. The uniforms were not always state-of-the-art. (Courtesy of Shelby City Parks.)

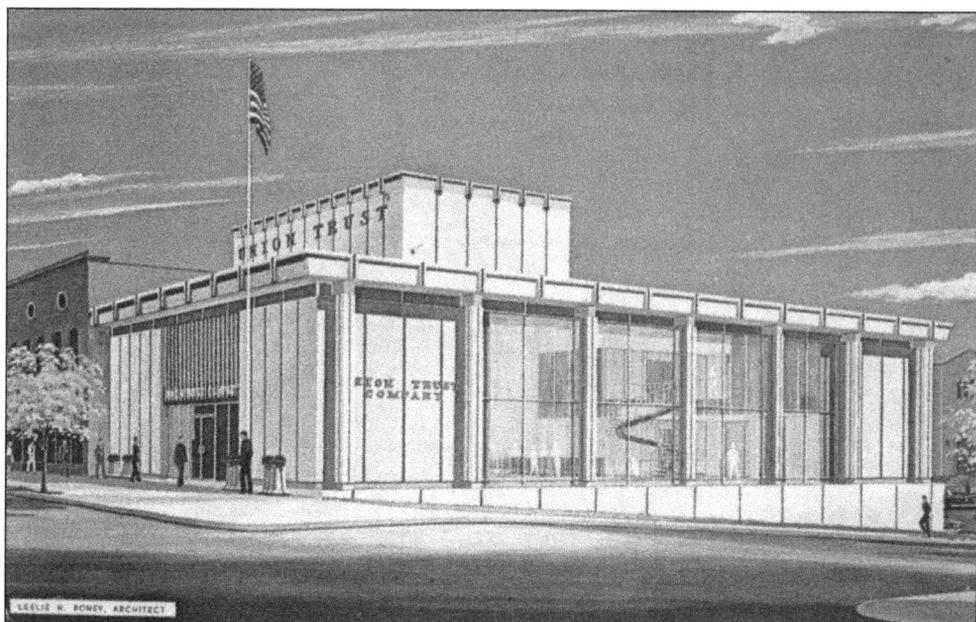

In the 1960s, Union Trust moved once again. The corner of Marion and Washington was its third location on the square. This is the architect's drawing of the proposed building. Since then Union Trust became Independence National and later was acquired by BB&T. (Courtesy of Libby Greenway.)

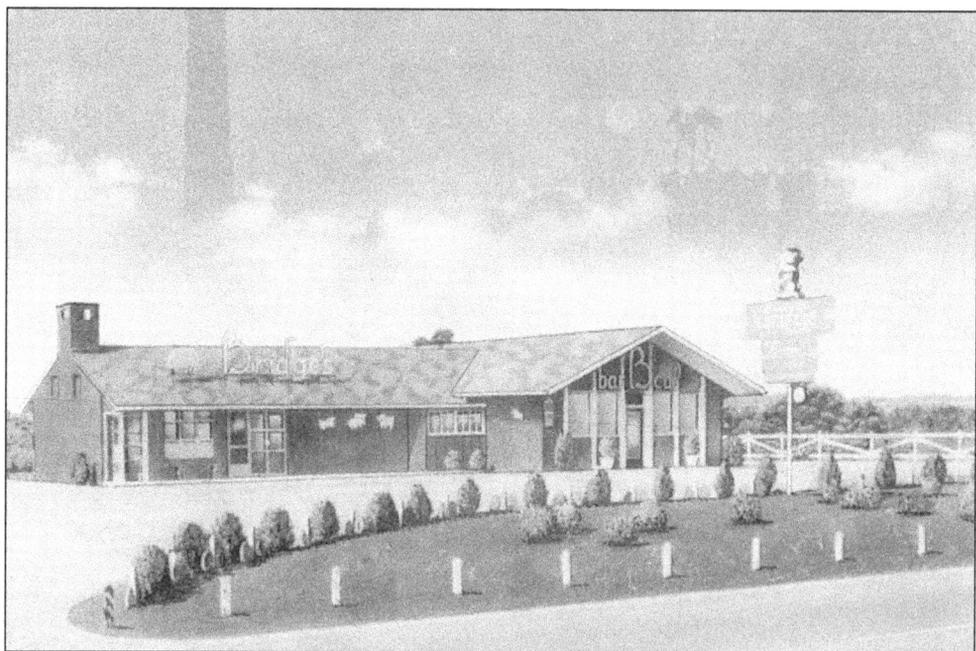

Pictured is Bridges Barbecue Lodge on US 74. For a half a century people have traveled to Shelby to eat at Bridges. This photo shows the newly built restaurant in the 1950s. (Courtesy of Jerry Noftsger.)

Three

KINGS MOUNTAIN

Originally named White Plains, the city of Kings Mountain was chartered on February 11, 1874. The beginning of the city can be attributed largely to the gold rush of 1834 and the beginning of rail service by the Charlotte-Atlanta Airline (Southern Railway) in December of 1872. The train depot was built and railroad officials asked Mrs. J.W. Tracy, the local postmistress, to name the new train station. She chose Kings Mountain in honor of the 1780 Revolutionary War battle fought on Kings Mountain, five miles to the southeast of the city in South Carolina.

In 1888, brothers J.S. and W.A. Mauney formed the Kings Mountain Manufacturing Company, the city's first cotton mill. In the summer of 1900 the Bank of Kings Mountain received its national charter, becoming the first national bank to be chartered in Cleveland County.

The Battle of Kings Mountain is considered to be the turning point of the Revolutionary War. Much like the revolutionists who fought the battle the city is named for, the people of Kings Mountain possess a hardy spirit of pride, independence, and determination.

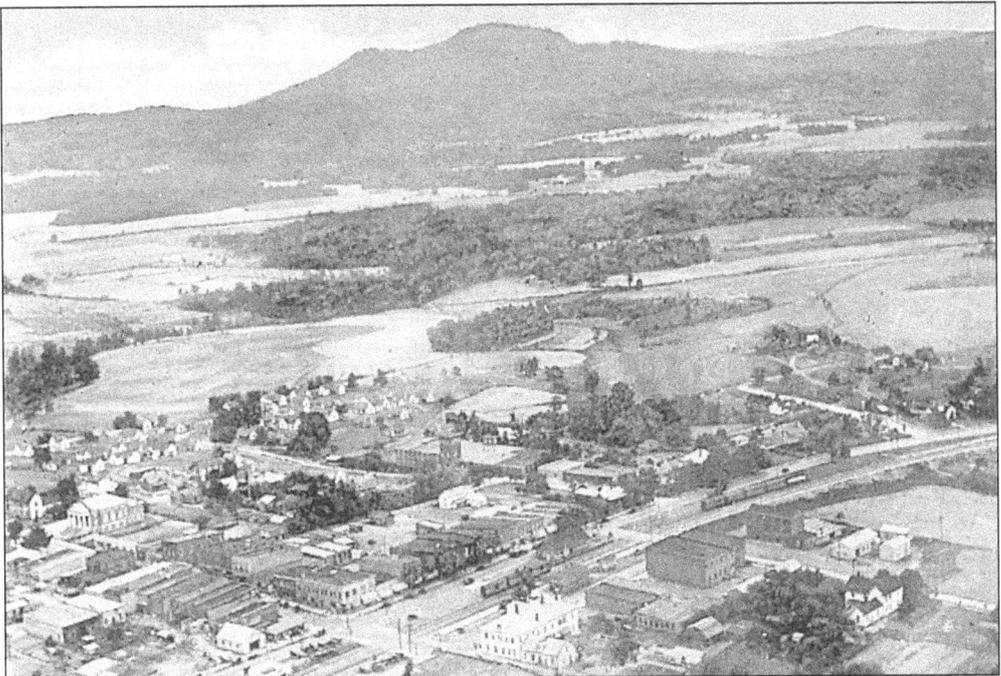

This postcard shows an aerial view of the city of Kings Mountain with the pinnacle to the southeast in the background. (Courtesy of Boyd Hendrick.)

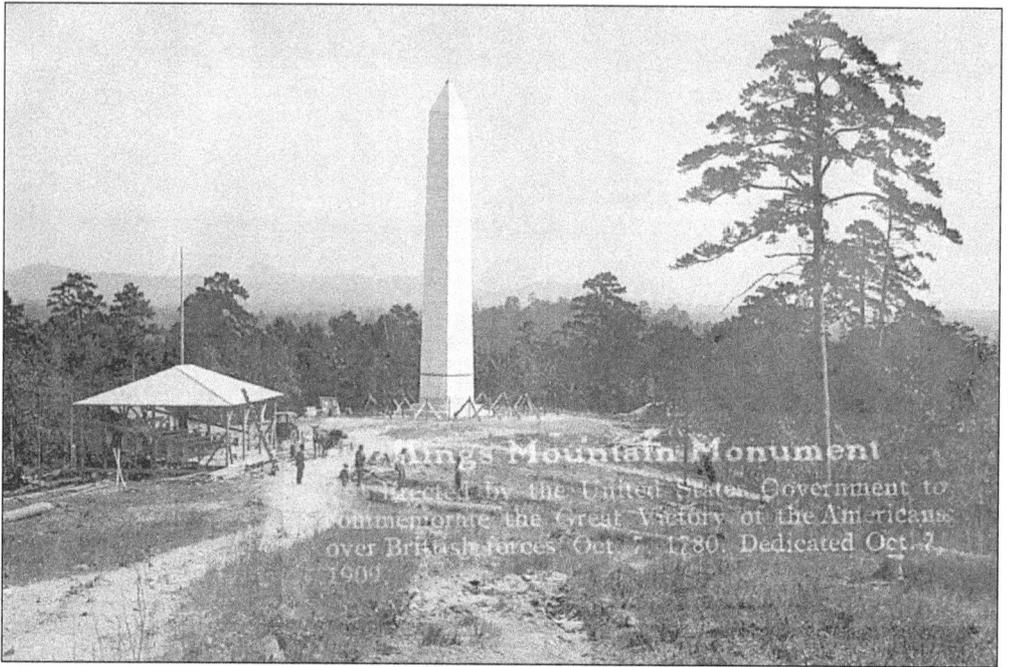

This postcard view is of the October 7, 1909 dedication of the Kings Mountain Monument. The federal government erected the monument to commemorate the Americans' October 7, 1780 victory over British forces. (Courtesy of Jerry Noftsger.)

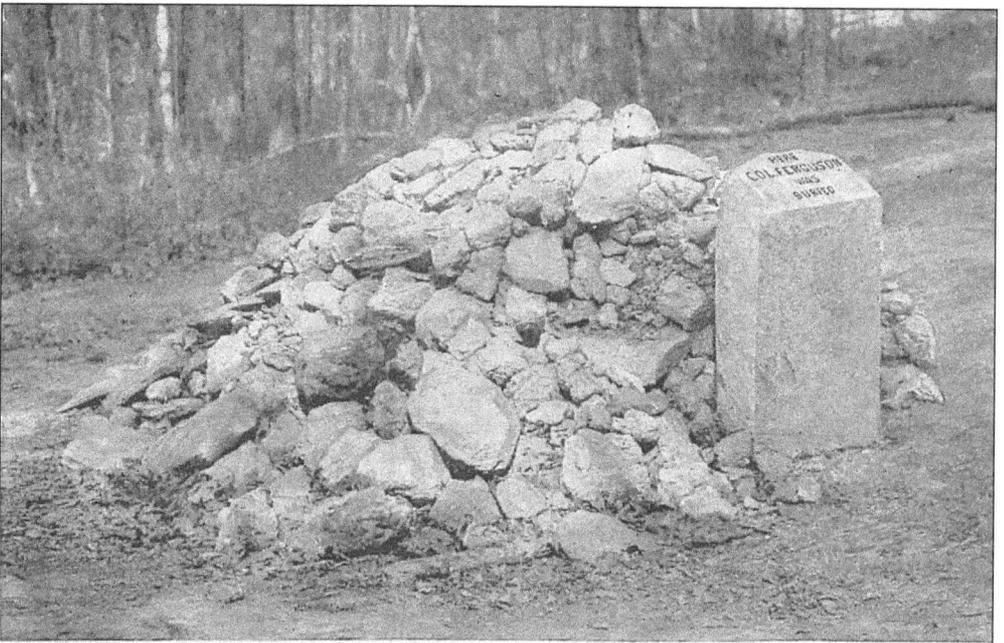

THE GRAVE OF COLONEL PATRICK FERGUSON, BRITISH COMMANDER, KILLED IN ACTION

British Commander Col. Patrick Ferguson reportedly pledged "God almighty cannot remove me from this mountain." Killed in action, he was buried on the mountain. For generations, visitors to the Kings Mountain National Park have placed a rock on Ferguson's grave.

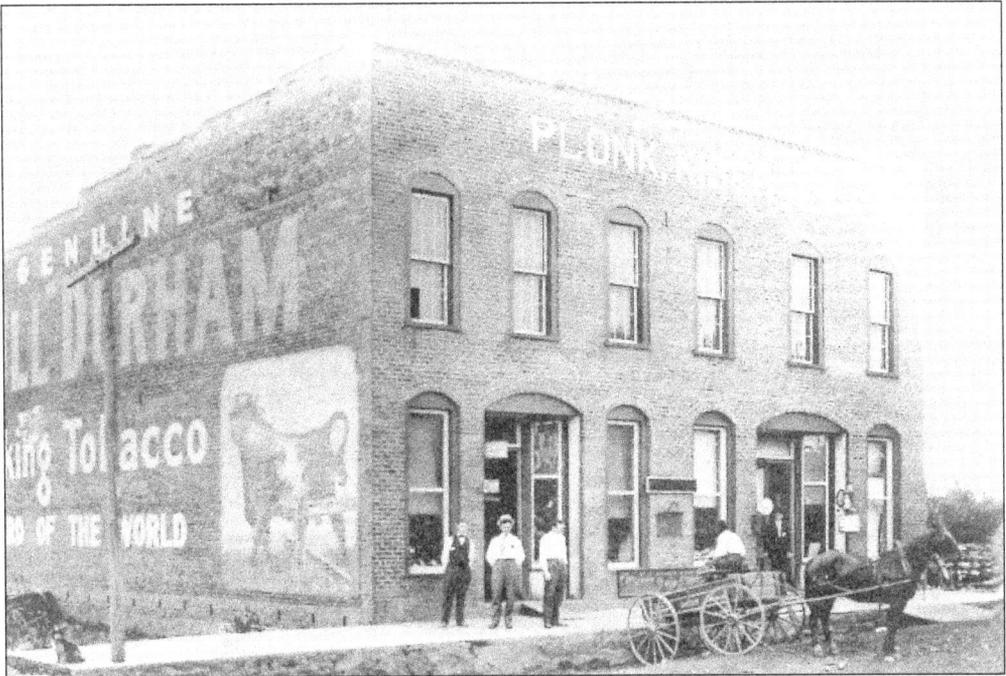

The Plonk-Kiser & Company Store, shown here around the turn of the 20th century on Railroad Avenue, was one of the earliest retail establishments in Kings Mountain. John Oates Plonk Sr., in partnership with the Larkin Kiser family, established the store in 1899. It remained in operation into the 1990s as Plonk Brothers Department Store. (Courtesy of the Cleveland County Historical Museum.)

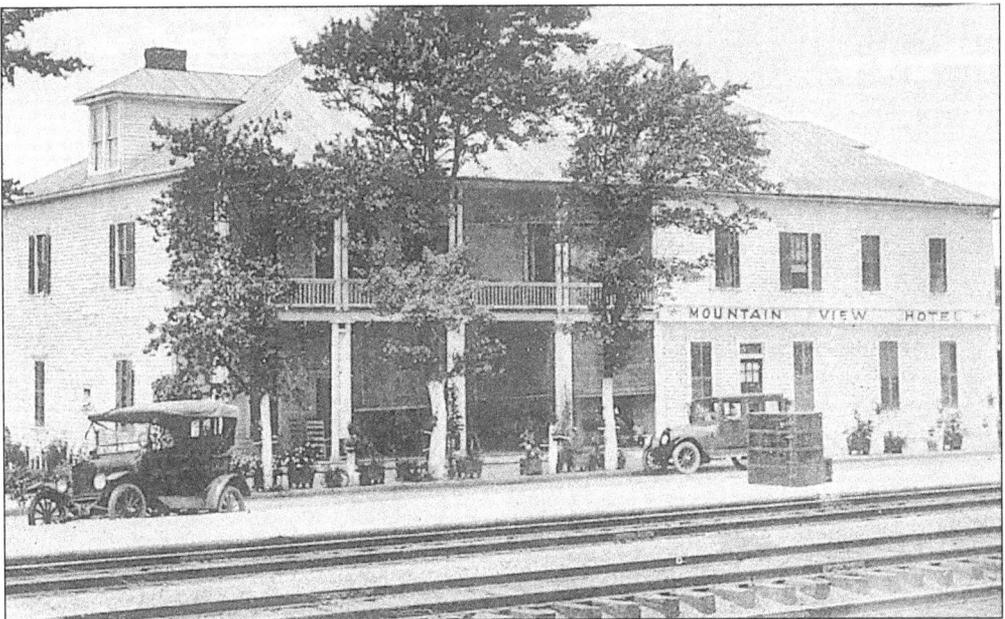

The Mountain View Hotel served rail passengers and tourists seeking the temperate climate of the area. This Railroad Avenue site was later used as a movie theater. (Courtesy of *The Kings Mountain Herald*.)

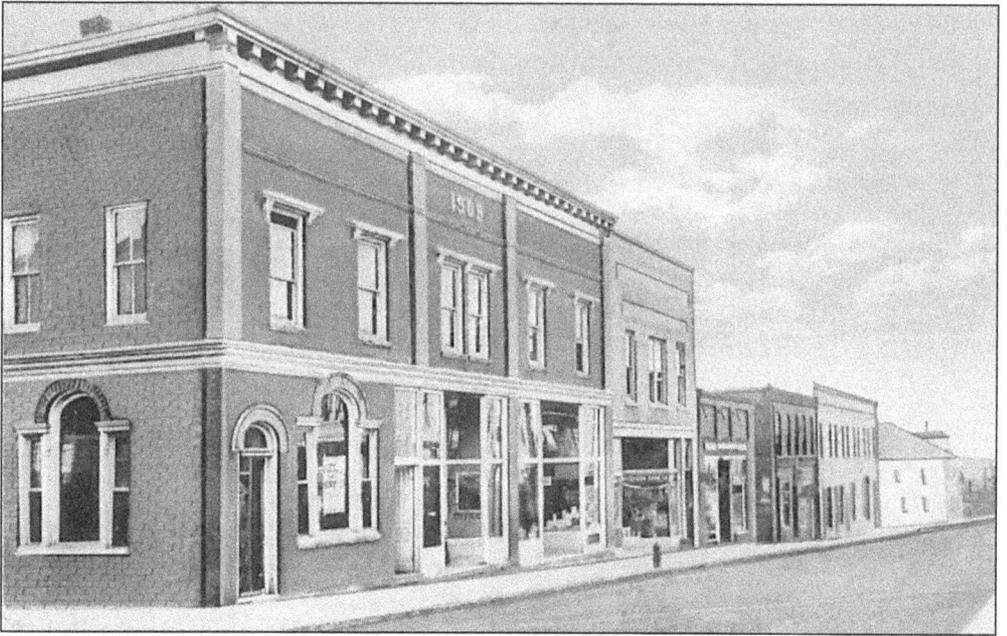

A postcard view shows Mountain Street in the early 1900s. The bank on the corner was erected in 1908. (Courtesy of the Kings Mountain Historical Society.)

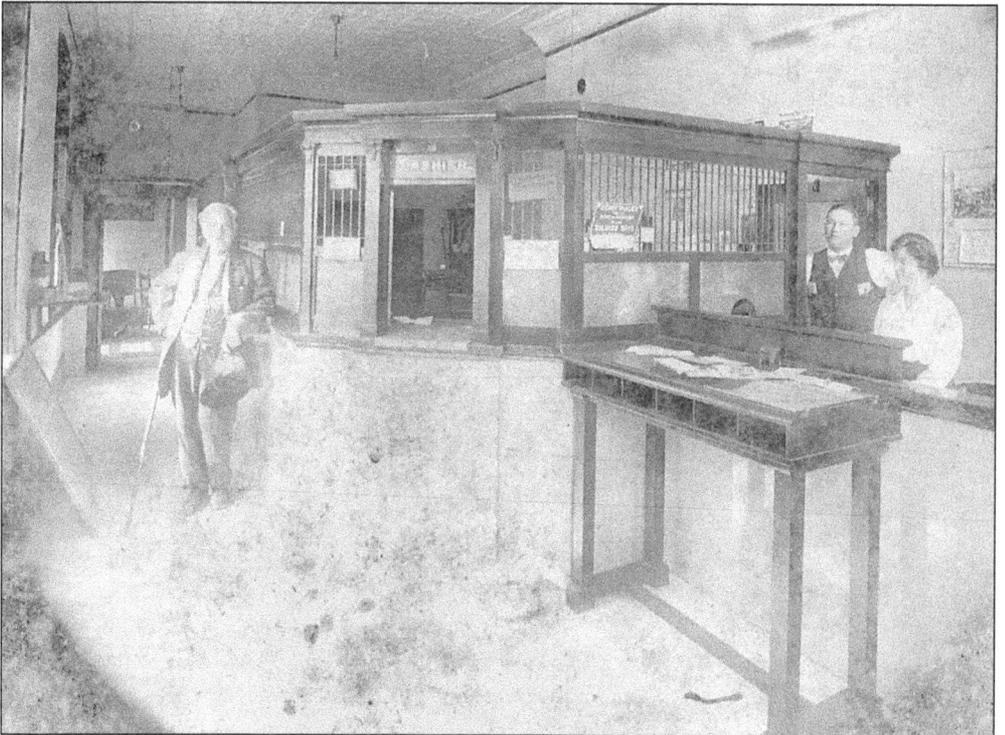

This 1915 photo shows the inside of Peoples Loan and Trust Company. Standing from left to right are Dave Baker, Plato Herndon, and Maude Crouse. (Courtesy of the Cleveland County Historical Museum.)

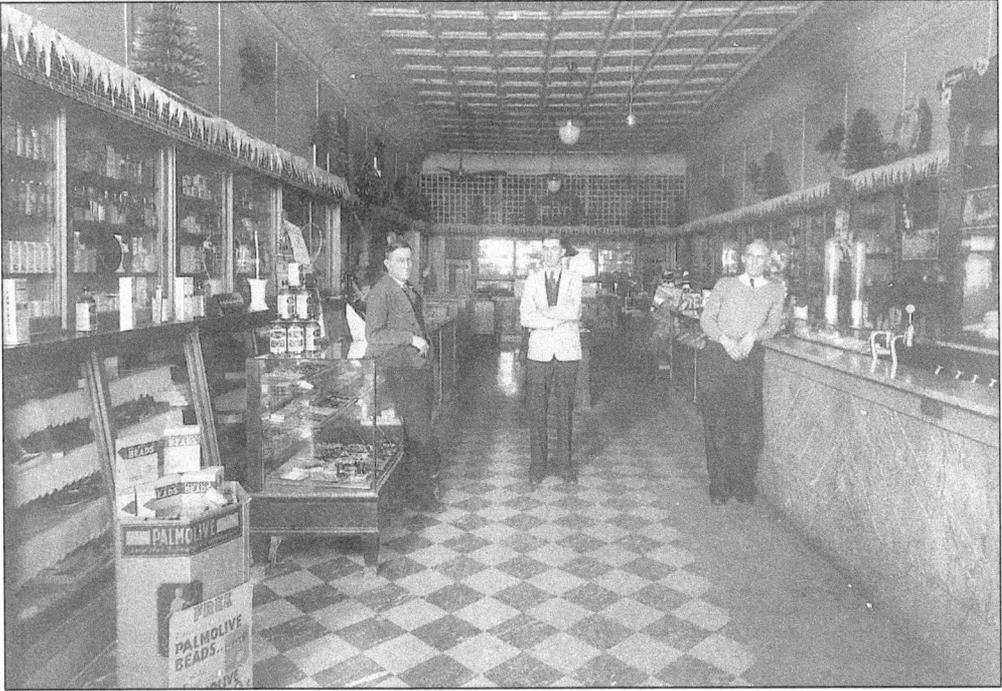

This postcard shows an interior view of what is believed to be Summers Drug Store on Battleground Avenue. George Moss is the gentleman leaning on the counter. (Courtesy of *The Kings Mountain Herald*.)

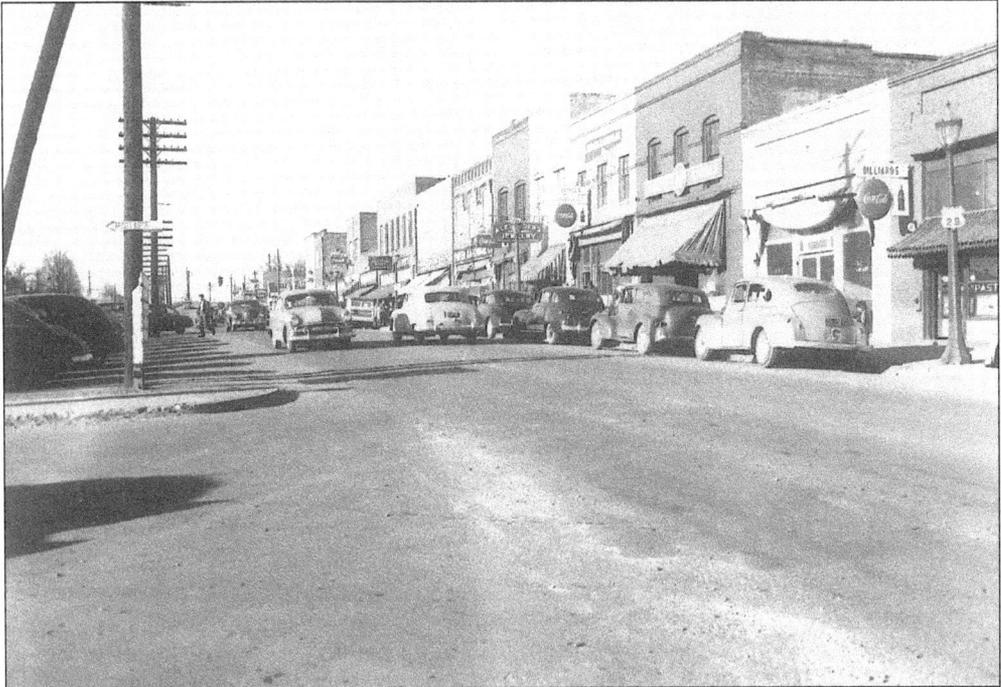

Businesses along Battleground Avenue are seen looking north in the early 1950s. (Courtesy of the Uptown Shelby Association.)

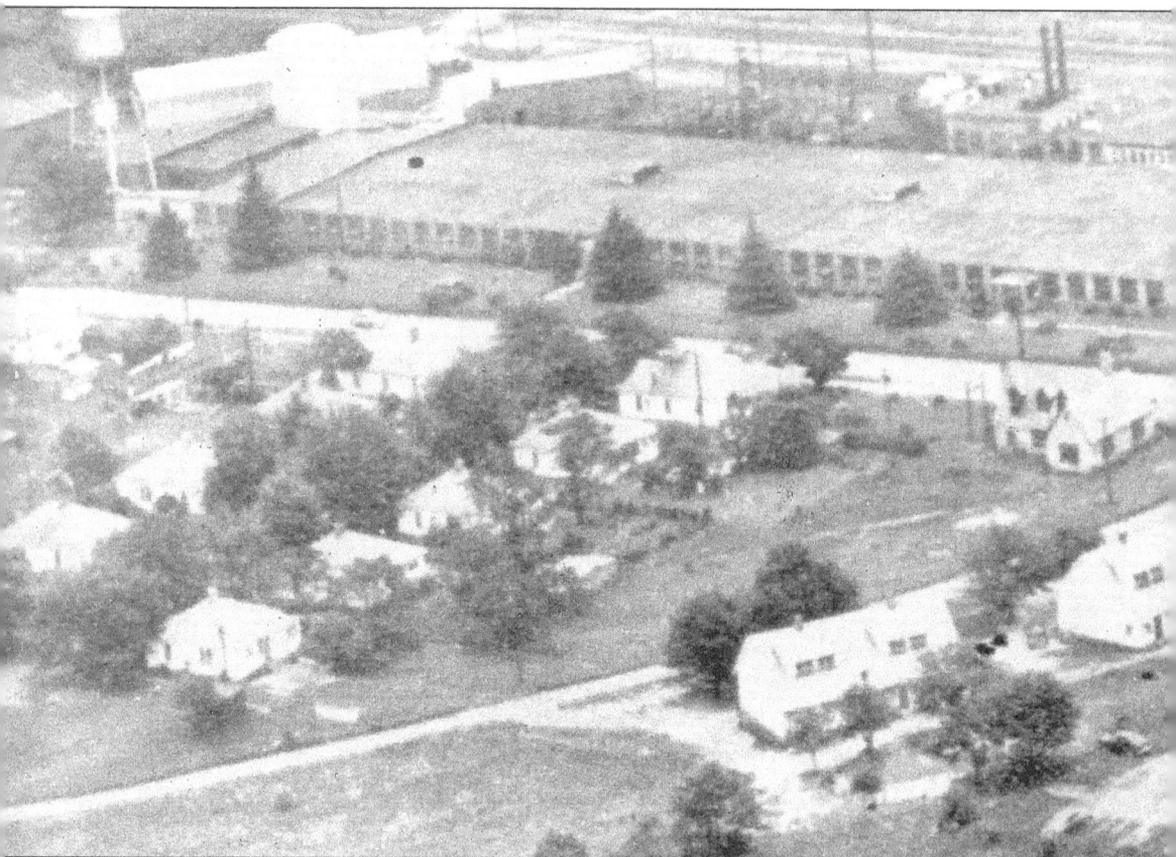

This aerial view shows two of the Neisler Textile plants. To the left is Margrace finishing plant built in 1914, and to the right is the Patrica cotton mill built in 1920. Also visible is the "mill

The Neislers, one of Kings Mountain's leading families, can be seen in this photograph, c. 1920. They are, from left to right, as follows: (seated) Ida Pauline Neisler, Ida Pauline Mauney Neisler, Hugh Neisler, Charles Eugene Neisler, and Margret Sue Neisler; (standing) Hunter Ramseur Neisler, Paul Mauney Neisler, Laura Grace Neisler, Joseph Andrew Neisler, and Charles Eugene Neisler Jr. (Courtesy of Mary Neisler.)

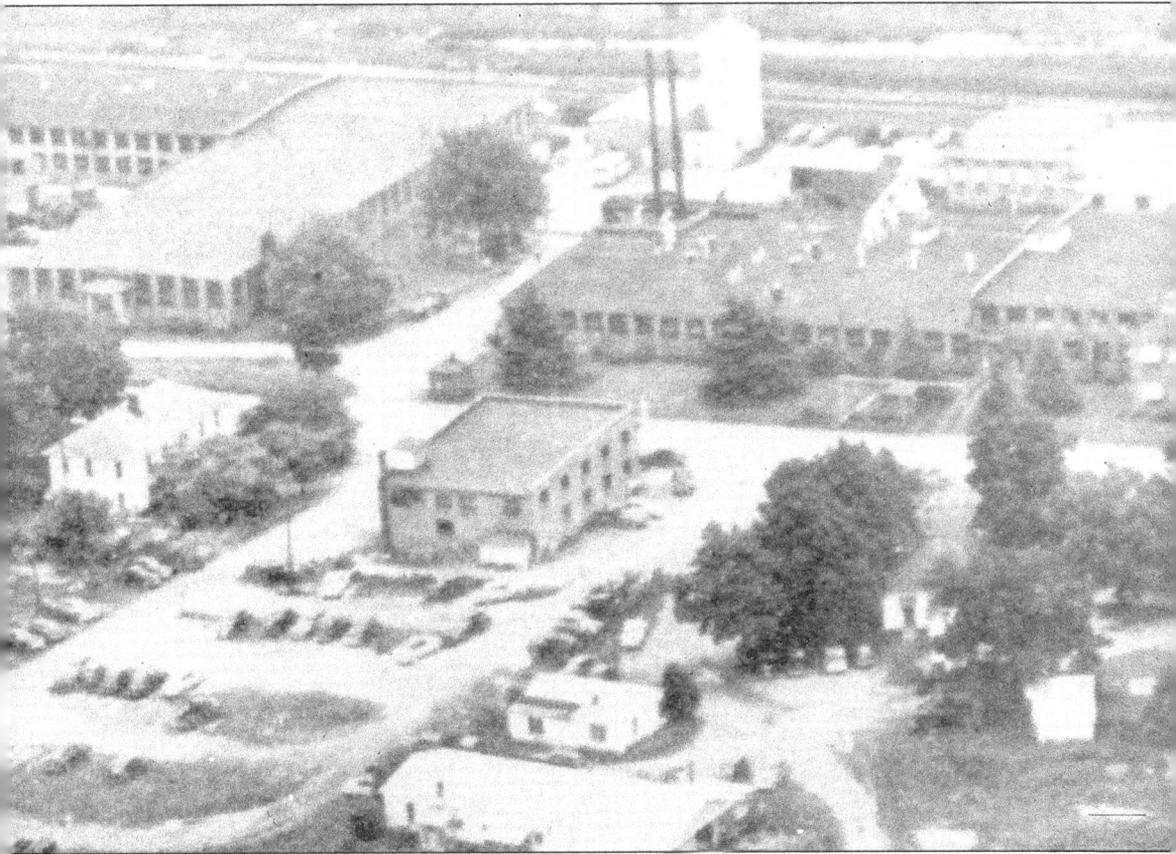

village" that was common to the area in the first half of the 20th century. The village included a company store and housing for the mill employees' families.

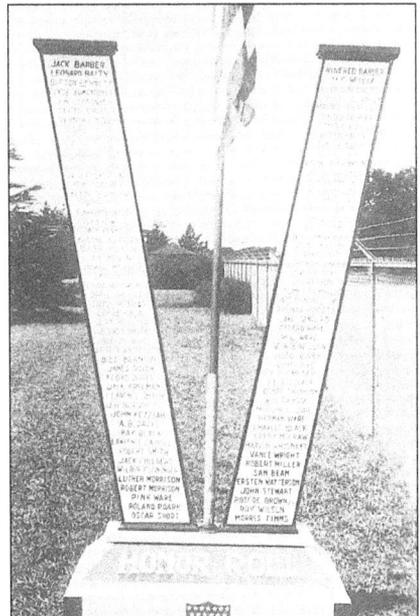

This is a postcard of the monument erected by the Neisler Mills as a tribute to local citizens who served during World War II. (Courtesy of *The Kings Mountain Herald*.)

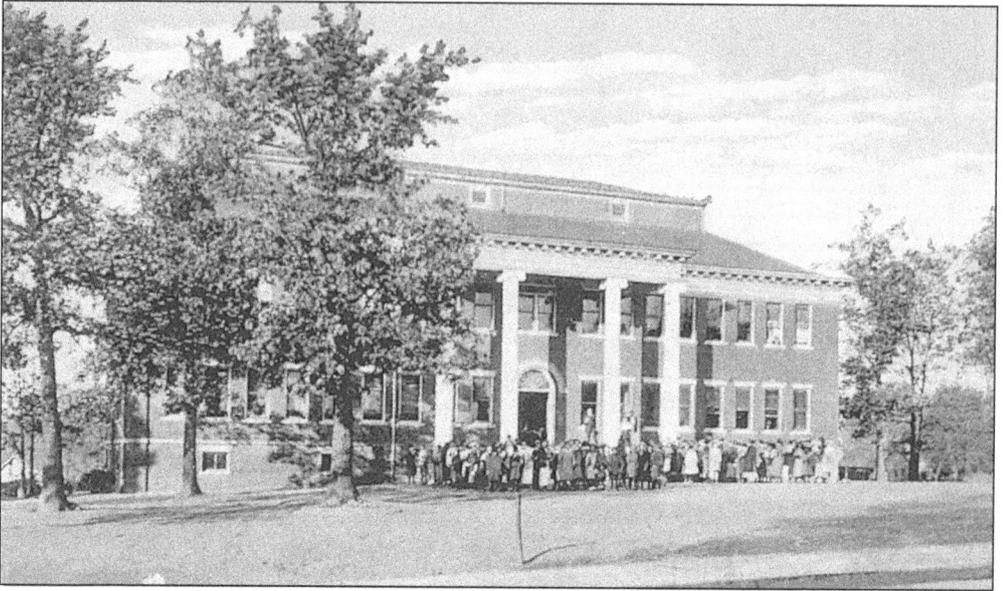

An early postcard shows the Kings Mountain Graded School on Ridge Street. The school burned in 1910 and again in 1932.

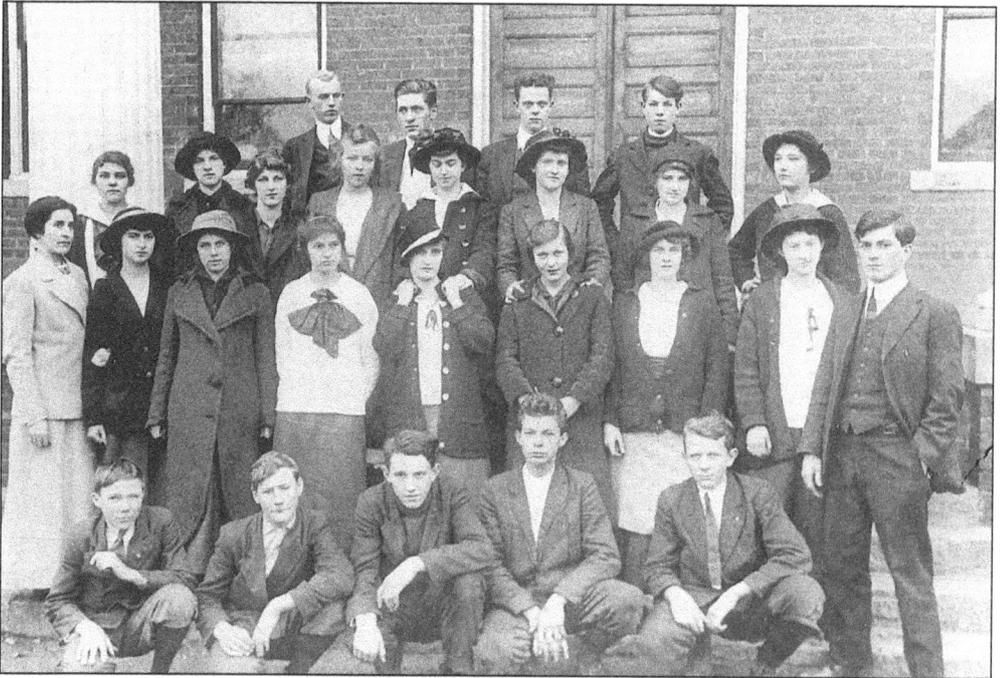

Pictured here is the Kings Mountain High School class of 1914. From left to right are the following: (first row) Oliver Ramseur, Harvey Bennett, Vester Davidson, Graddy Abbot, and John Floyd; (second row) Miss Crawford Sledge, Virginia Mauney, Mattie Ware, Mary Hunter, Louise O'Ferrell, Mary King, Nina Hunter, Ethel McGill, and Mr. R.A. Yoder; (third row) Mary Fulton, Kathleen Williams, Winnie McGraw, Kate Hord, Margret McLaughen, Aileen Ormond, Daisy Houser, and Ruth Davis; (fourth row) Horace Rudisill, Paul Neisler, Roy Hunter, and Charles Bradford. (Courtesy of Mary Neisler)

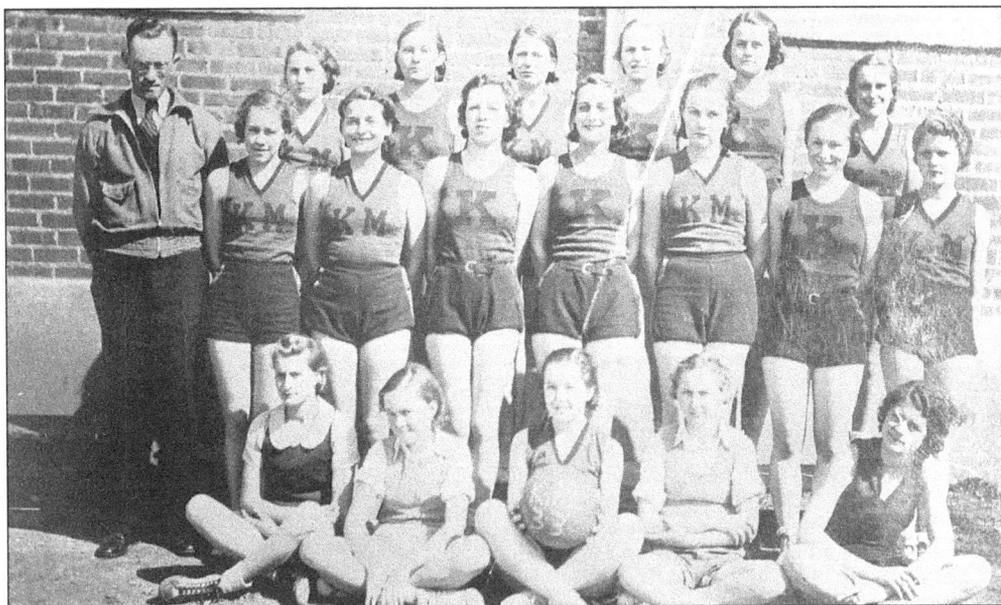

These young ladies are members of the 1933 Kings Mountain High School basketball team. Pictured from left to right are as follows: (front row) unidentified, unidentified, unidentified, Mary Sue McGinnis, and Debbie Suber; (middle row) Coach W.J. Fulkerson, Margaret Cooper, Viginia McDaniel, Marha Watterson, Hazel Oates, Nina Jackson, Martha Sue Stowe, and Virginia Warlick; (back row) Ruth Moss, Helen Williams, unidentified, Jean Ware, Aggie Coenwell, and Dolly Cornwell. (Courtesy of *The Kings Mountain Herald*.)

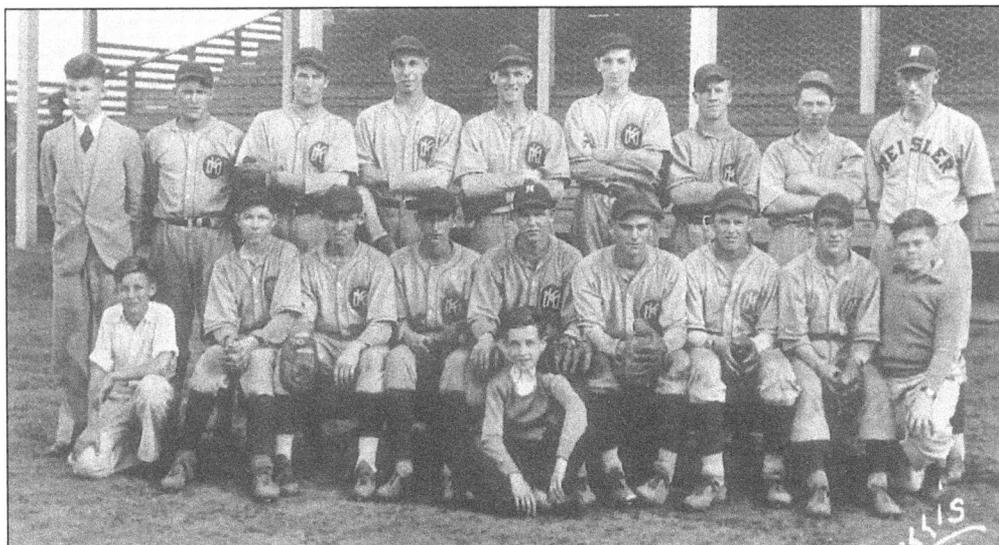

This photo of the KMHS 1935 Western Conference Baseball Champions first appeared in *The Kings Mountain Herald* on May 26, 1935. Pictured from left to right are the following: (front row) Clyde Putnam, assistant manager; (middle row) Roy Thurmond, assistant manager; Tommie Reynolds; J.D. Hullender; Luther Morrison; Jake Early; Clyde McSwain; Leslie Mode; Gene Leonard; and George Mauney, assistant manager; (back row) Thomas Roberts, manager; Theodore Thornburg; Oscar White; J.R. Bridges; James White; Eugene Goforth; Henry Ford; Marvin Foster; and Coach Fulkerson. (Courtesy of *The Kings Mountain Herald*.)

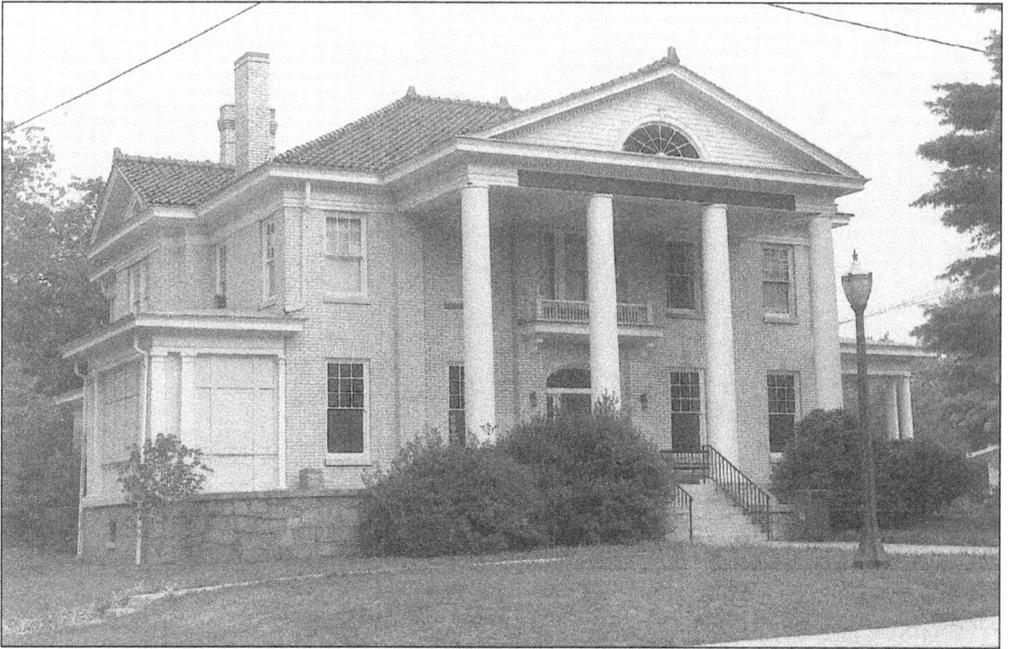

The Dr. J.G. Hord home was built in 1923. In 1874, one of the first schools in Kings Mountain was begun on this same corner by Alex Aderholdt. Today, the home serves as the Mauney Memorial Library. (Courtesy of *The Kings Mountain Herald.*)

Rev. R.J. Davidson served as the minister of the Ebenezer Baptist Church and headmaster of the Davidson School from 1924 to 1967.

Located at the intersection of Mountain and Piedmont Streets were the Presbyterian church and the Methodist church. Today, the Kings Mountain City Police Station occupies the site of the Presbyterian church. The Methodist church was rebuilt on the site.

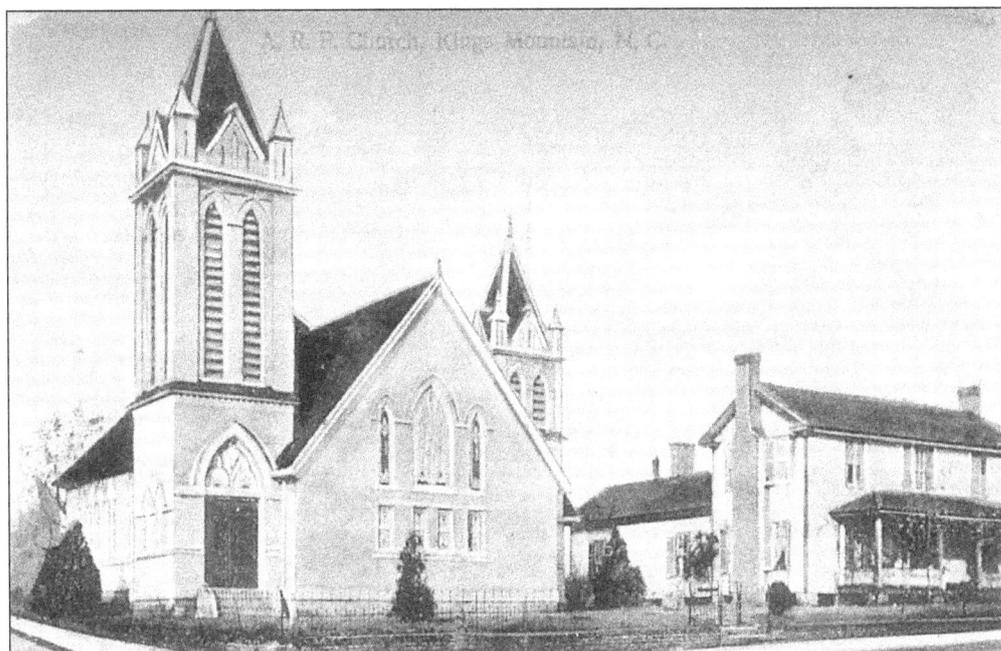

A postcard view shows the Associate Reformed Presbyterian Church as it appeared around 1915. The church was located on King Street at North Piedmont, and was demolished in the 1970s. To the right is the Eleanor Cooper home.

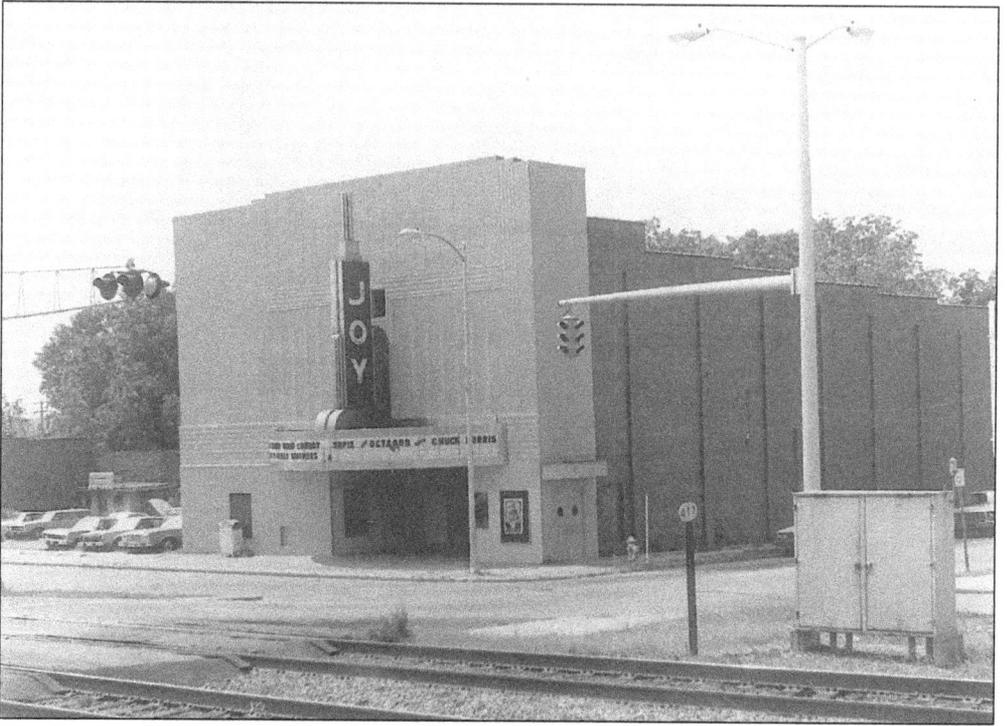

The Joy Theater was a favorite among locals for over 30 years. Situated on the corner of Railroad Avenue and Mountain Street, the building today houses a church. (Courtesy of *The Kings Mountain Herald*.)

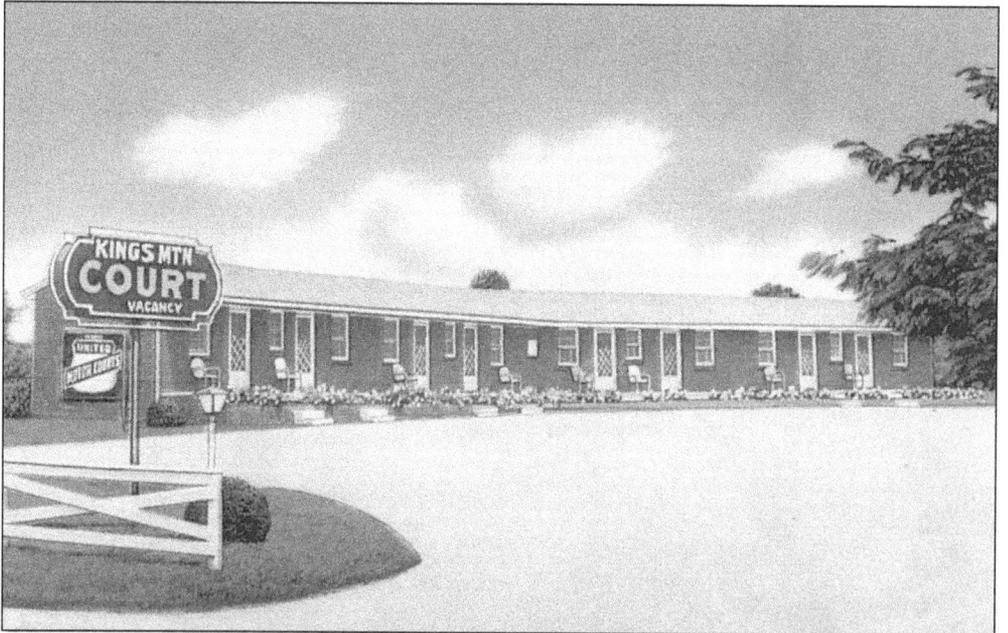

For over half a century travelers from the east entering Kings Mountain along US 74 were greeted by the Kings Mountain Motor Court. This postcard is from a time when the motel's phone number was 914, a three-digit exchange. (Courtesy of Harvey Whisnant.)

Four

BOILING SPRINGS

Boiling Springs was named for a spring that boiled until it was damaged by blasting years ago. It was a small farming community that was incorporated as a town in 1911. In 1907, the Baptists opened a high school that in 1928 became Boiling Springs Junior College. In the 1940s the college was renamed Gardner-Webb in honor of former Gov. O. Max Gardner and his wife, Faye Webb. The town grew slowly and by mid-century it had acquired a bank, a post office, two churches, and a small business district. Today it is a growing town of over 4,000 people and the home of Gardner-Webb University. Photos in this chapter are from the Gardner-Webb University Archives.

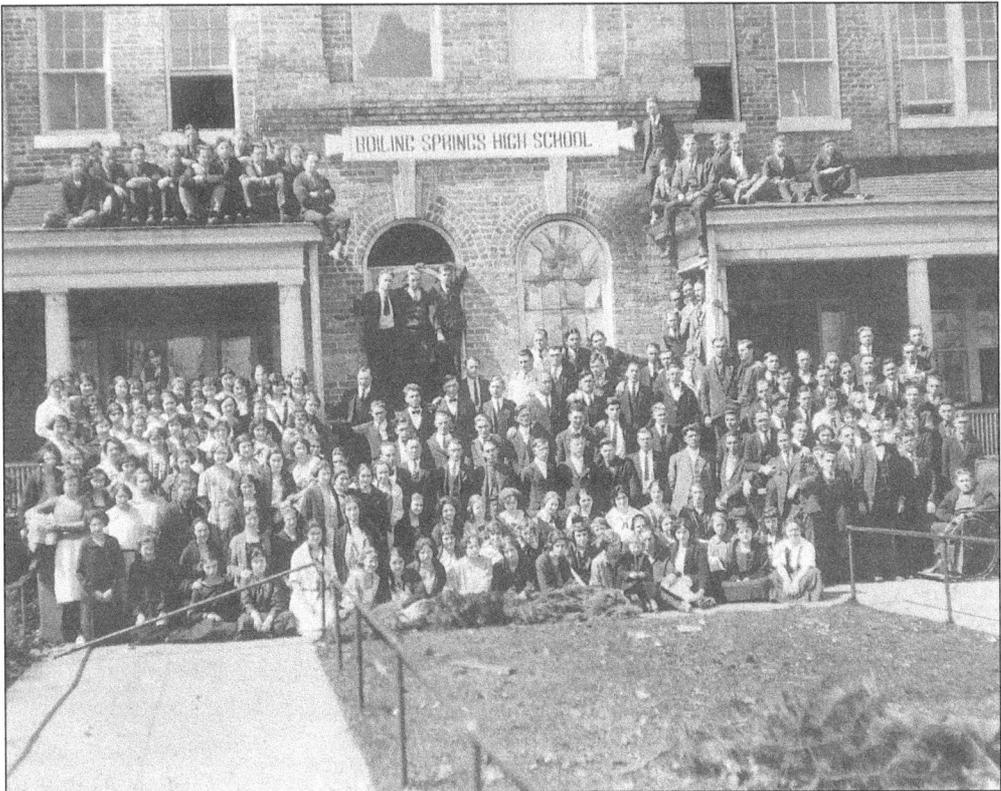

The young men and women of Boiling Springs High School posed in proper attire in the early days of the school. Great emphasis was placed on proper behavior and proper dress.

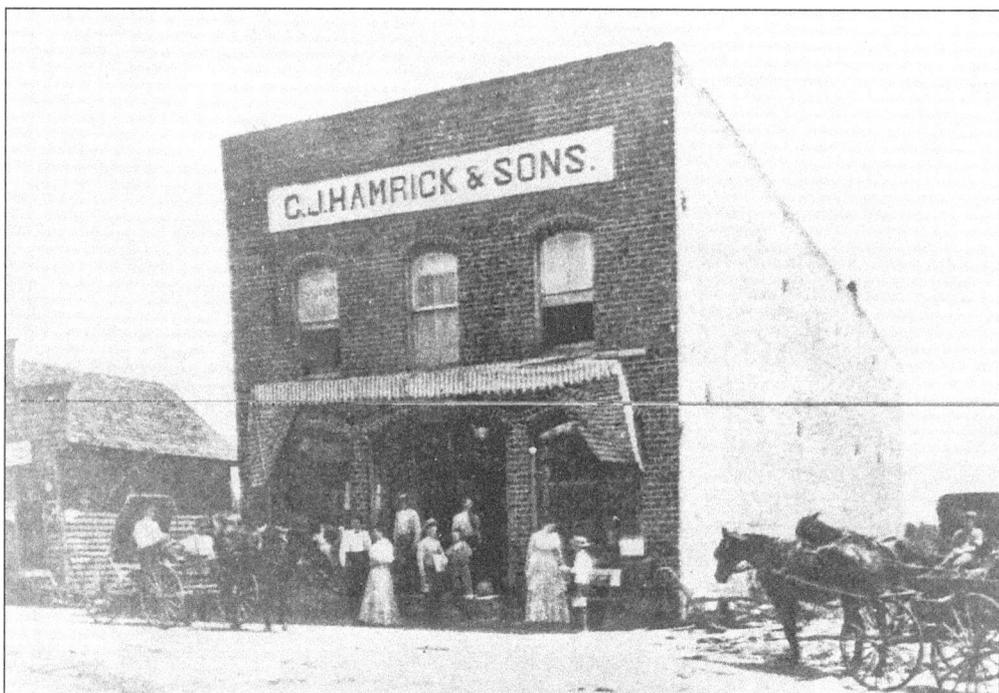

In the early days C.J. Hamrick and Sons was the main store in Boiling Springs. This 19th-century photo shows the early store. Although this building is gone, the Hamrick name remains one of the best known in Boiling Springs.

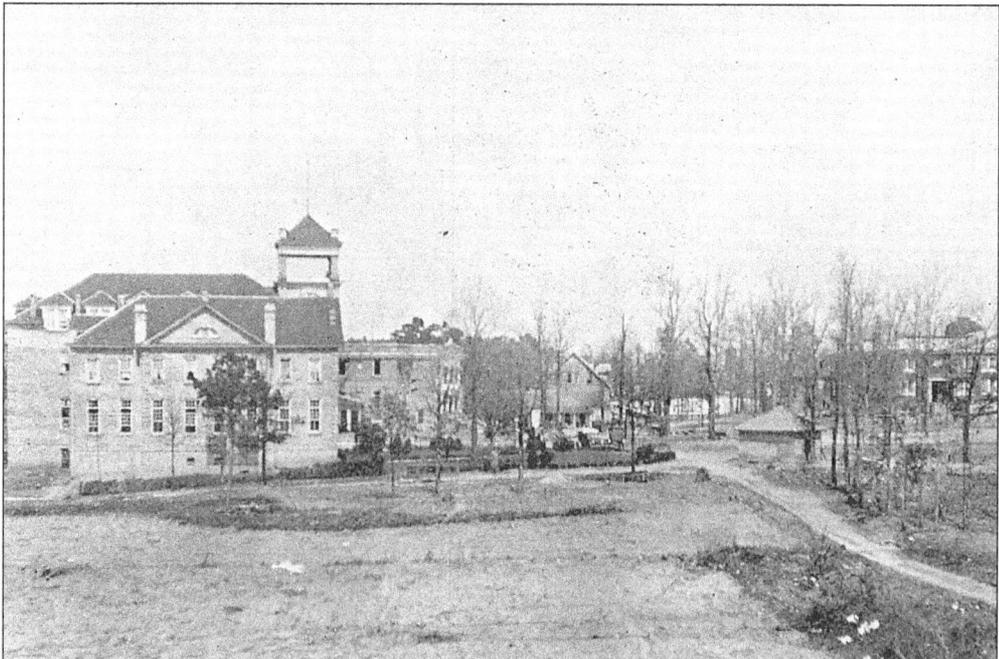

This 1924 postcard shows the Huggins-Curtis Building at left and the newly built Boiling Springs Baptist Church on the right. The Memorial Building can be seen to the right of the main building.

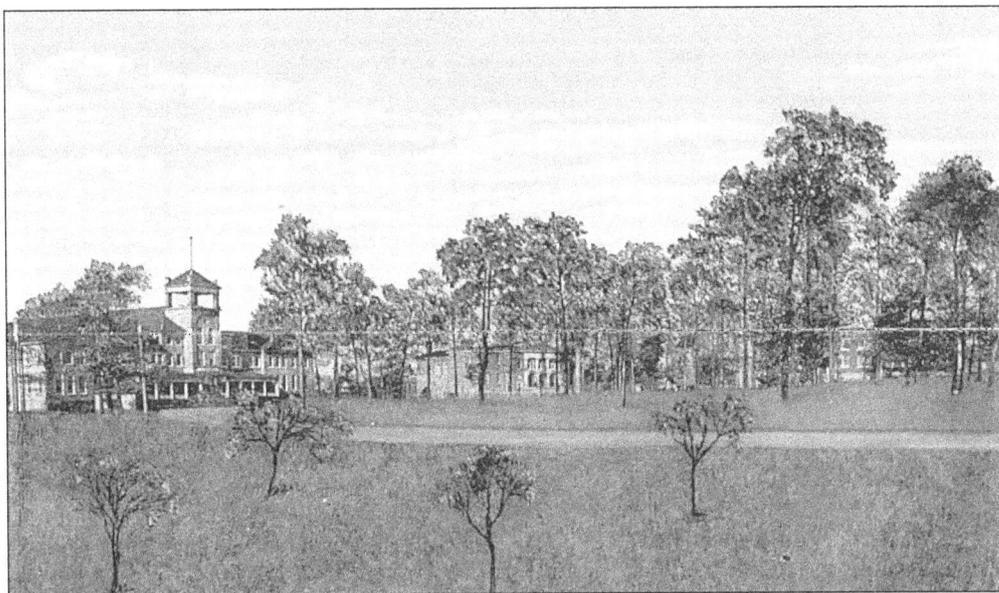

The campus looked much the same in this 1930s scene. The buildings are visible from a different angle. After the Depression the school was more concerned with survival than it was significant growth.

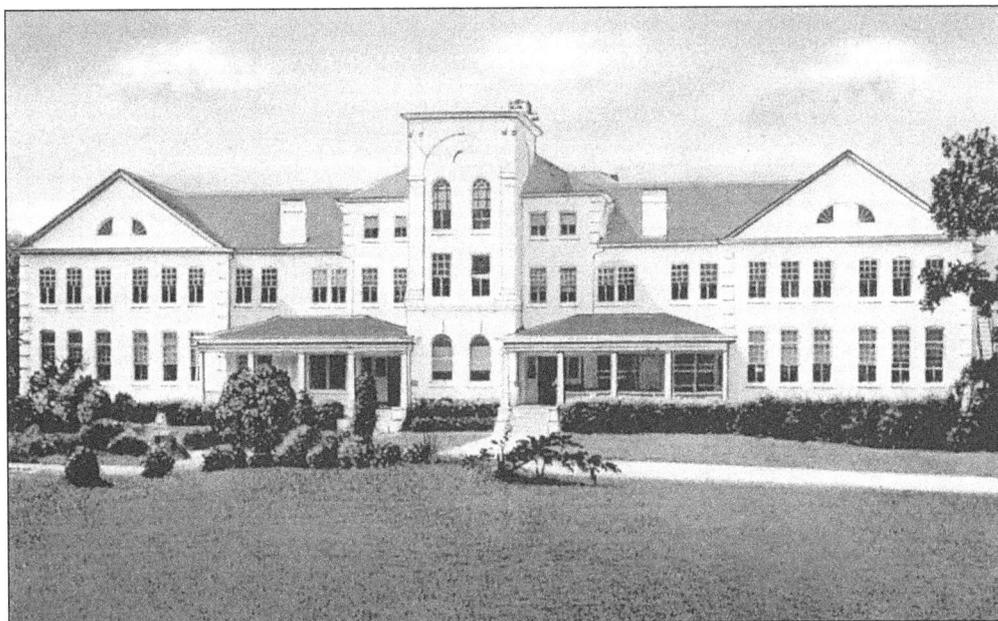

This linen card from the 1940s shows the main building in its refurbished style. It was named Huggins-Curtis in honor of two long-time faculty members. Although the card refers to a girls dormitory, the building served many purposes, including housing the administrative offices. It remained the center of the college until it burned in 1957.

Located next to Huggins-Curtis is the E.B. Hamrick building. Before a 1937 fire it was known as the Memorial Building. It served as a classroom building and housed an auditorium and the administrative offices. Recently refurbished, the Hamrick building today houses Gardner-Webb's School of Business.

The Boiling Springs Baptist Church building was built on South Main Street in 1924 and was sold to Gardner-Webb in 1969. Shortly thereafter the building was demolished to make way for the current Dover Chapel on the Gardner-Webb campus.

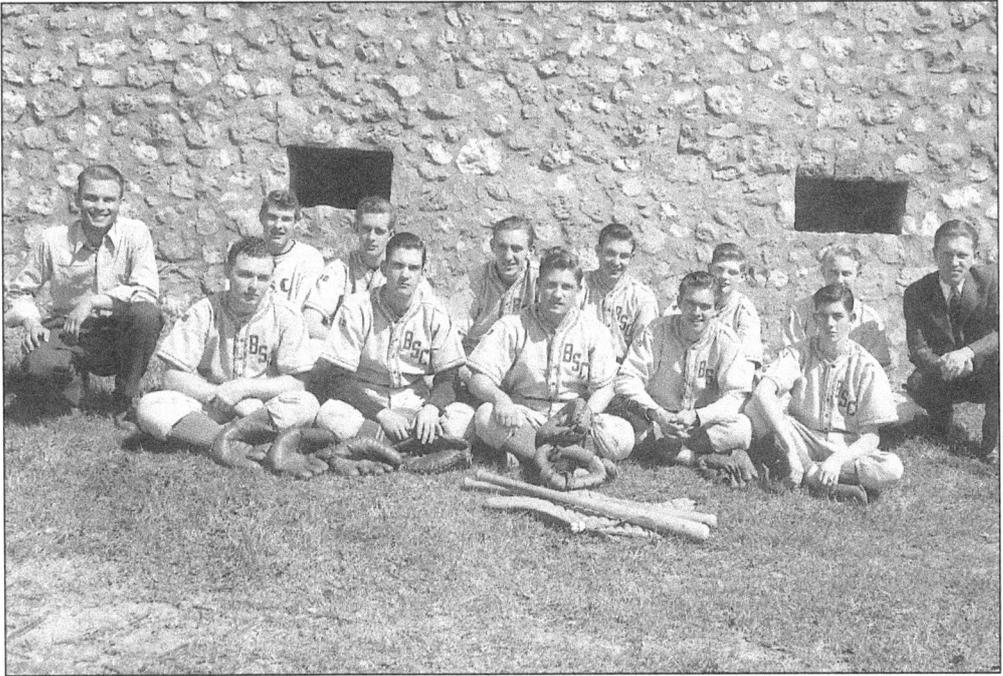

The college used an old rock gym for years. Here a baseball team of the Boiling Springs Junior College days is pictured outside the rock gym.

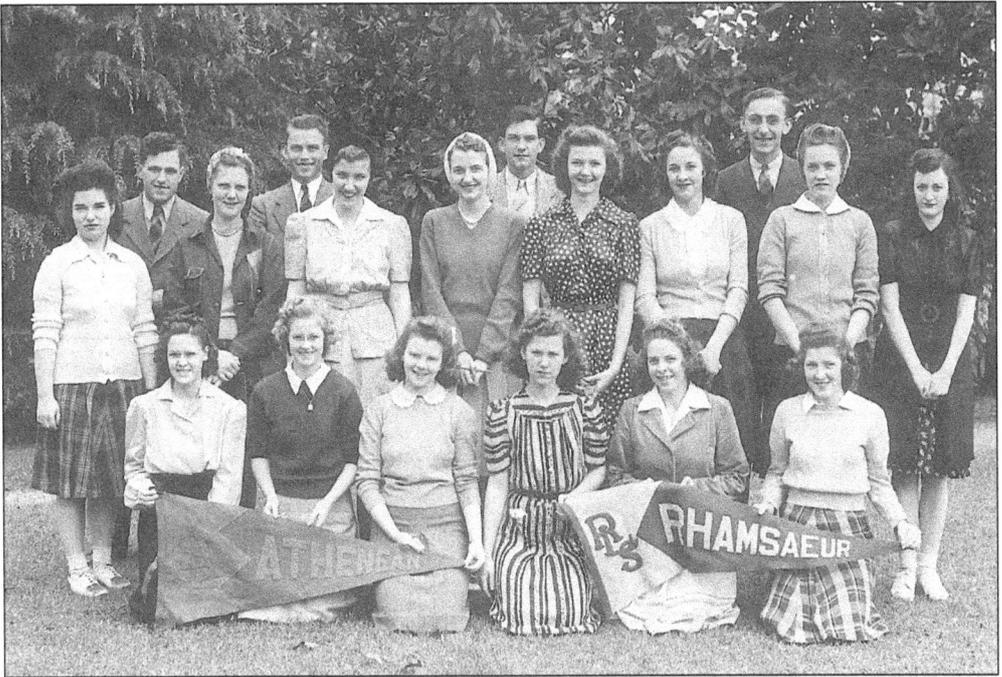

In the days when students were limited in their ability to leave campus (both by lack of transportation and by college rules), there were groups that provided social and educational outlets. These young people of the World War II era were members of the college's literary society.

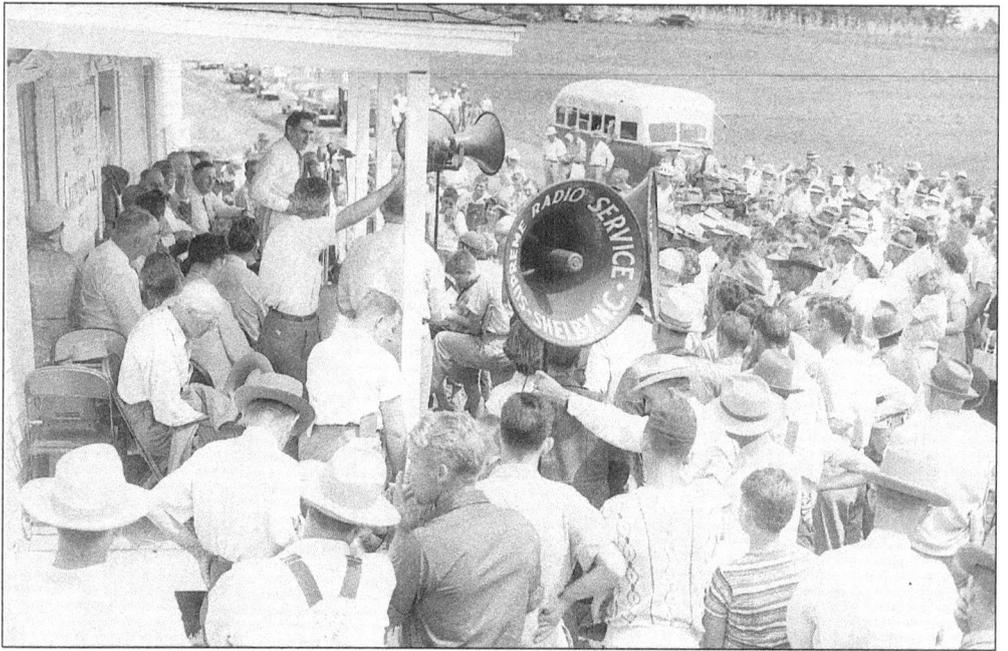

A "Miracle Farm Day" was held in Boiling Springs in 1950, and hundreds gathered to participate. The speaker pictured was the style used at that time to amplify sound. Here, Gov. Kerr Scott speaks from the porch.

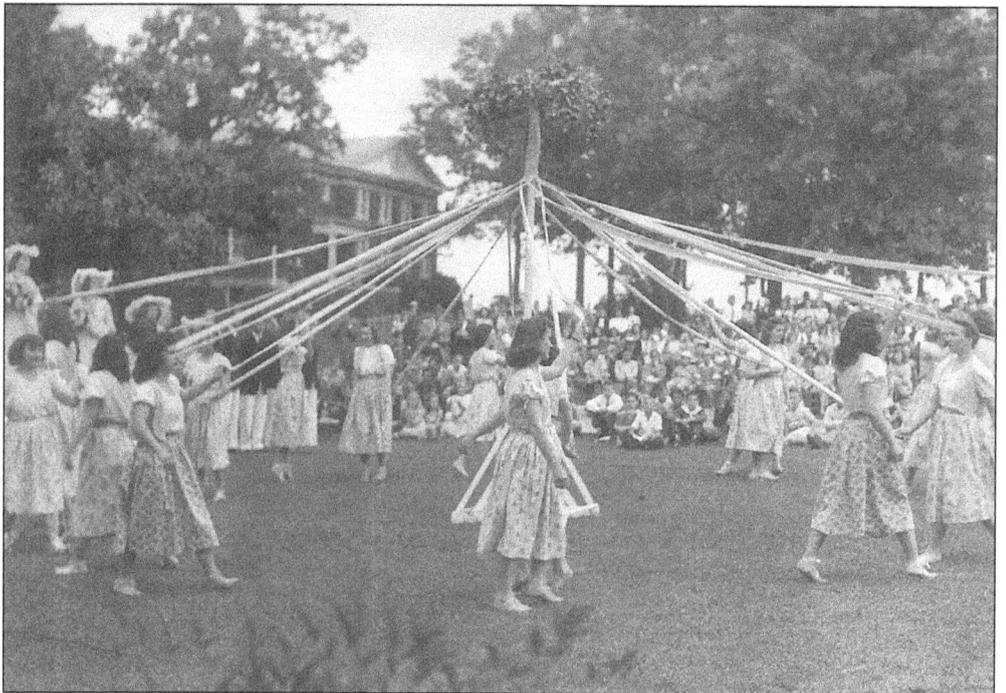

A regular social event in the 1950s was May Day. The annual dance around the may pole was the highlight of the festivities. These coeds are pictured on the lawn beside the Boiling Springs Baptist Church.

This band of the mid-1950s was composed of local students and college students. In the background are numerous houses between the college and the Boiling Springs School.

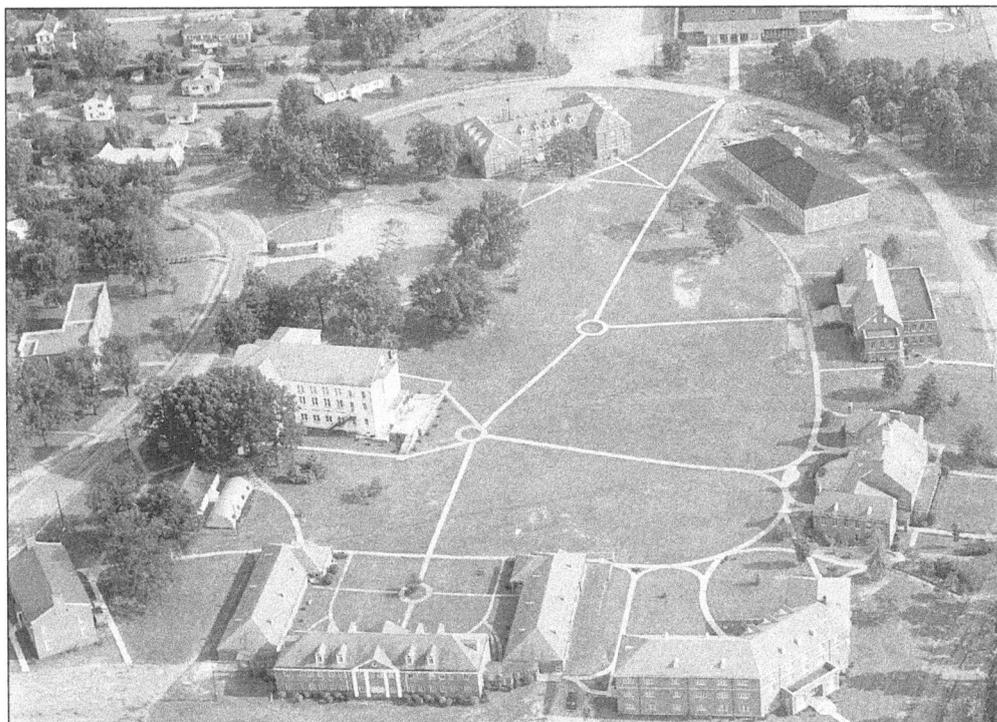

The Gardner-Webb campus is seen from the air as it appeared in the early 1960s. At the bottom left was the original Webb Building before it was doubled in size. The parking area in the left center had been the site of the Huggins-Curtis Building. The Charles I. Dover Campus Center would soon be erected on this spot.

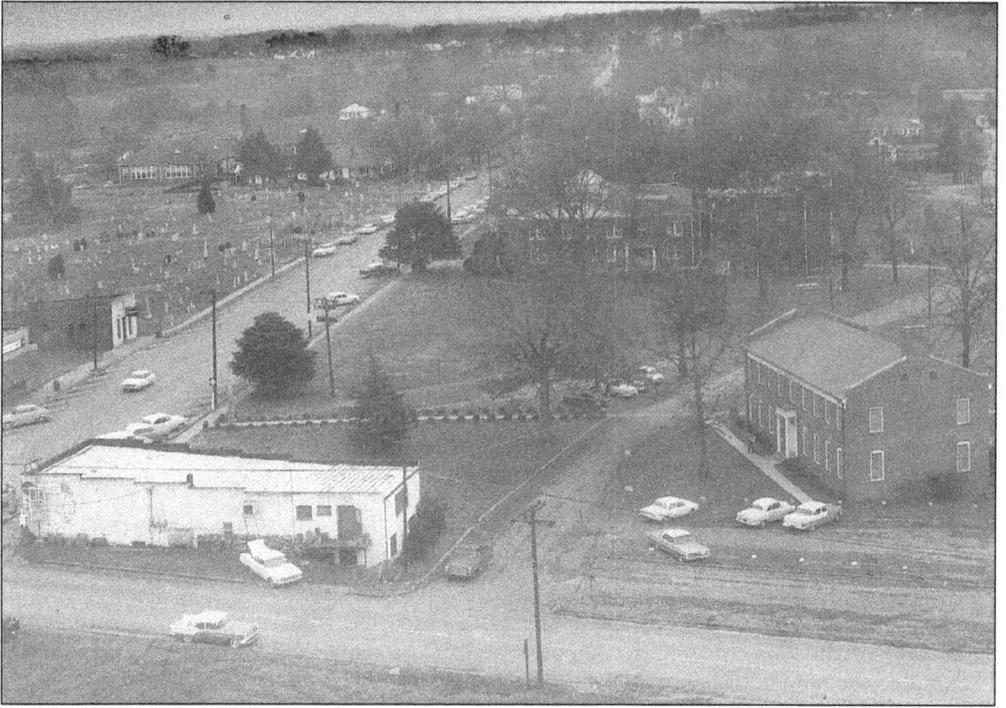

Looking south down Main Street, the white building on the corner was G.T. McSwain's grocery. To the left of South Main Street the cemetery is visible, and to the far right is the new Webb Building.

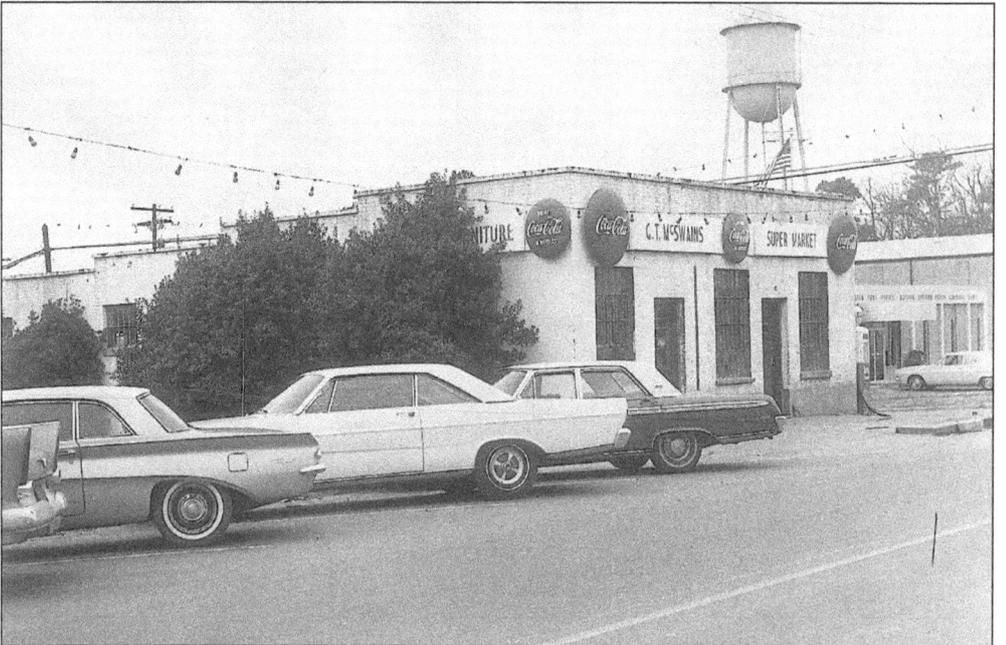

This photo was taken in the mid-1960s on South Main Street looking north. G.T. McSwains Super Market would soon be demolished and replaced with a new store two blocks to the east on College Avenue. The new post office and the old water tower are to the right.

Five

LAWNDALE

The beginning of Lawndale dates back to the mid-1800s as a farming community along the Broad River near a stop on the Lincoln-Rutherford Stagecoach Line. In 1873, Major H.F. Schenck built Cleveland Mills along Knob Creek, in the foothills of the upper part of the county. The village was called Cleveland Mills. In 1888 Schenck built a second mill, this one on the First Broad River along with a power plant and houses for the mill's employees. Lawndale was named for the green, sloping yards of these homes.

Major Schenck was a true pioneer. In 1890, with the aid of his son John, he brought the first telephone service to the county. The major's daughter, Mrs. T.J. "Minnie" Ramseur, and her husband formed Piedmont Academy in 1897. In November of 1899 the Lawndale Railway and Industrial Company began rail service between Lawndale and Shelby. In a time before paved roads, the 11.7-mile rail service provided a means to transport raw material and finished products as well as local citizens to and from Shelby, where both the Southern and Seaboard Railways provided rail service. The railway was affectionately known as the "Lawndale Dummy," for its narrow gauge required a third rail when connecting to the other railways. The name of the mill has changed to Cleveland-Caroknit, but it continues today to be the center of Lawndale.

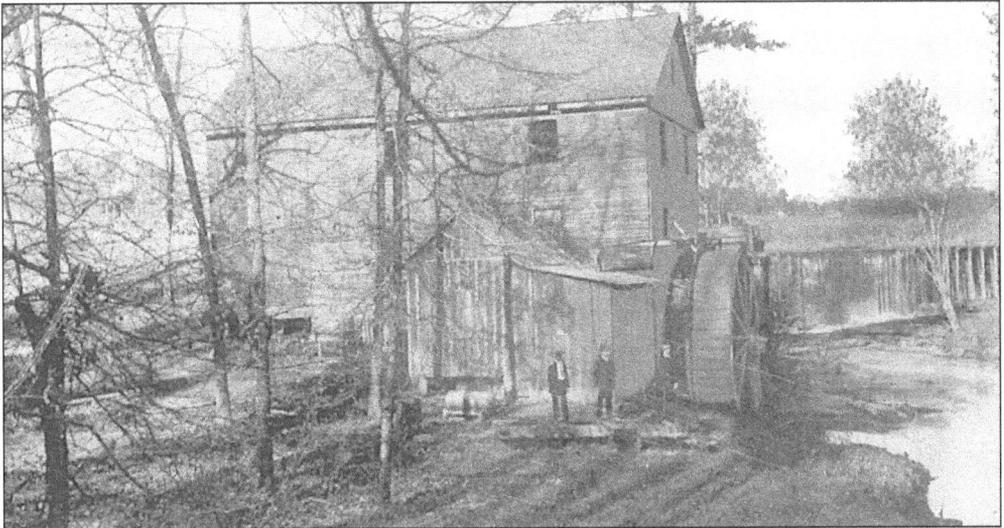

This 1930s postcard depicts a gristmill on the Broad River near Piedmont High School. This postcard was actually sent to Major Schenck during a hospital stay in Charlotte. (Courtesy of Patty Osborne Lee.)

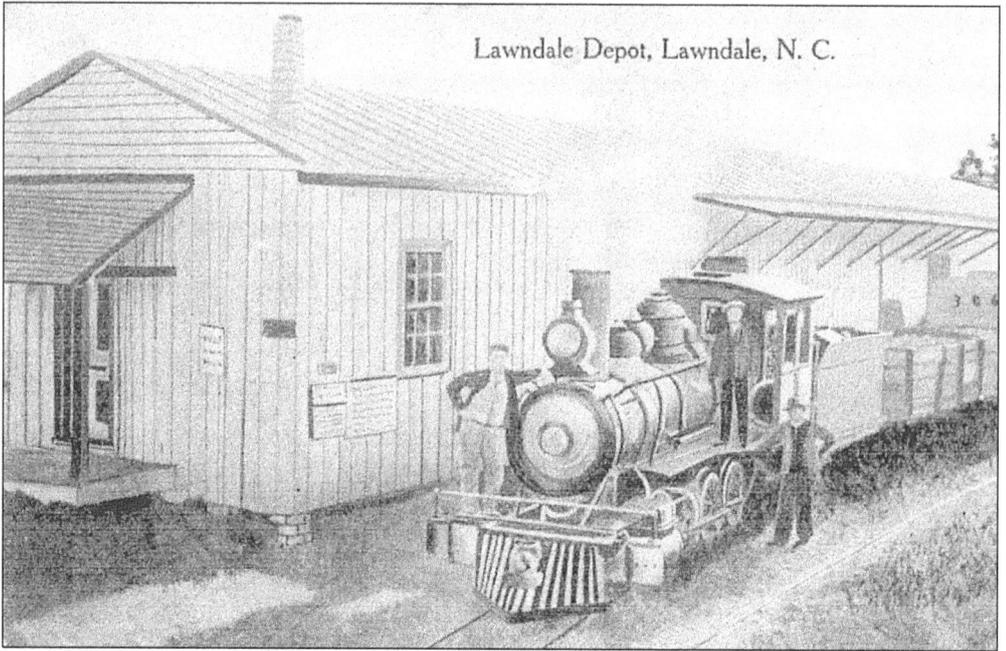

An artist's rendering shows how the Lawndale depot looked after the turn of the 20th century. Engine number 4 of the Lawndale Railway has just arrived with supplies. (Courtesy of Tommy Forney.)

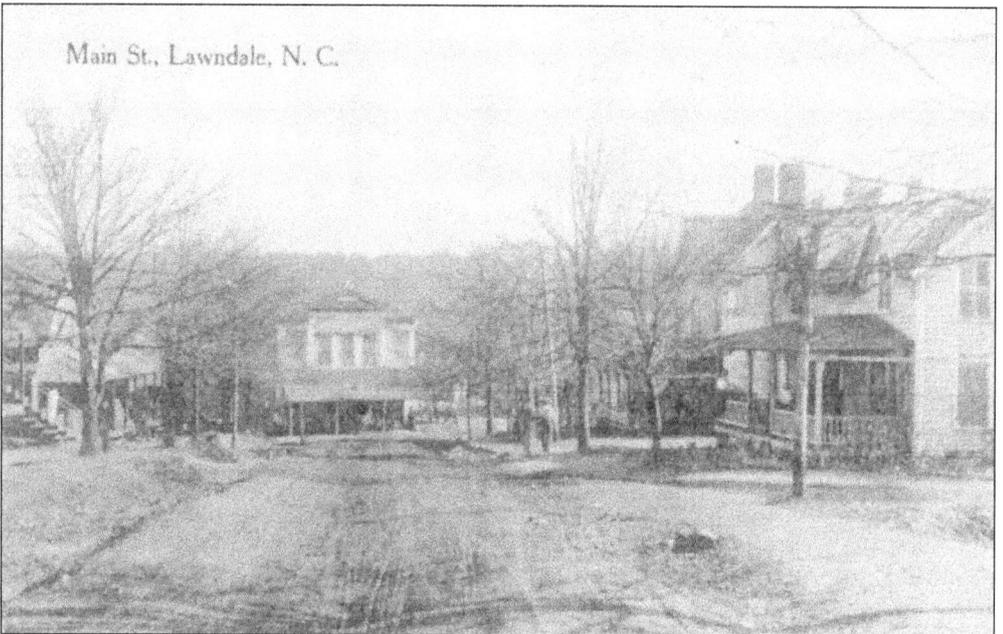

Main Street in Lawndale is seen *c.* 1910. The second building on the right was a hotel and on the left side of the street was a boardinghouse and tavern. In the distance is the Cleveland Mill Power Company. (Courtesy of Tommy Forney.)

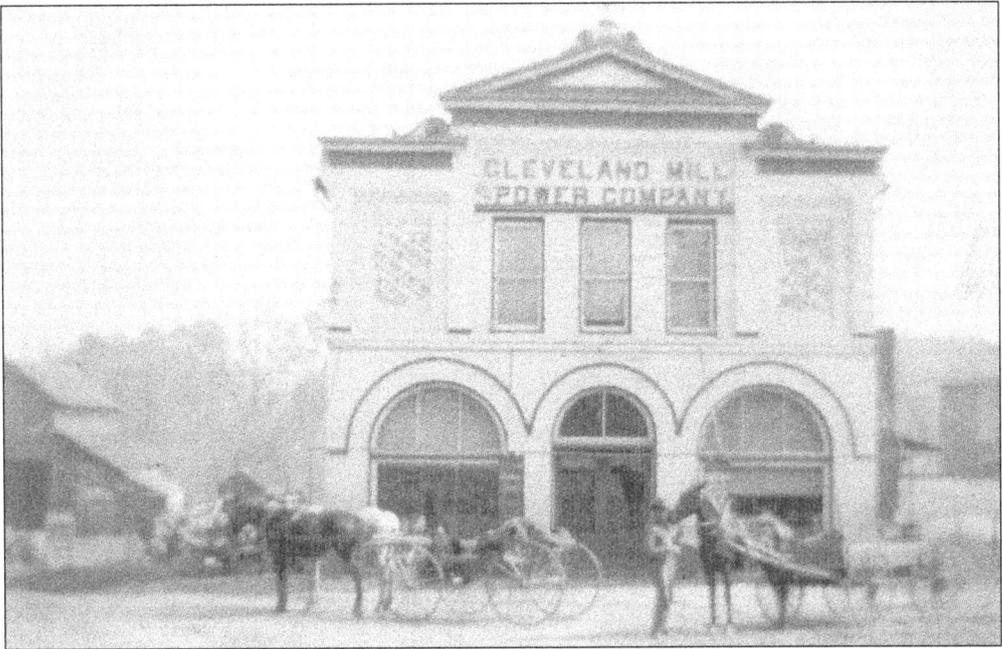

In this close-up view of the Cleveland Mill and Power Company in 1903 a barn and livery can be seen to the left. Before construction of the railway, horse-drawn wagons were used to transport material for the factory. (Courtesy of Tommy Forney.)

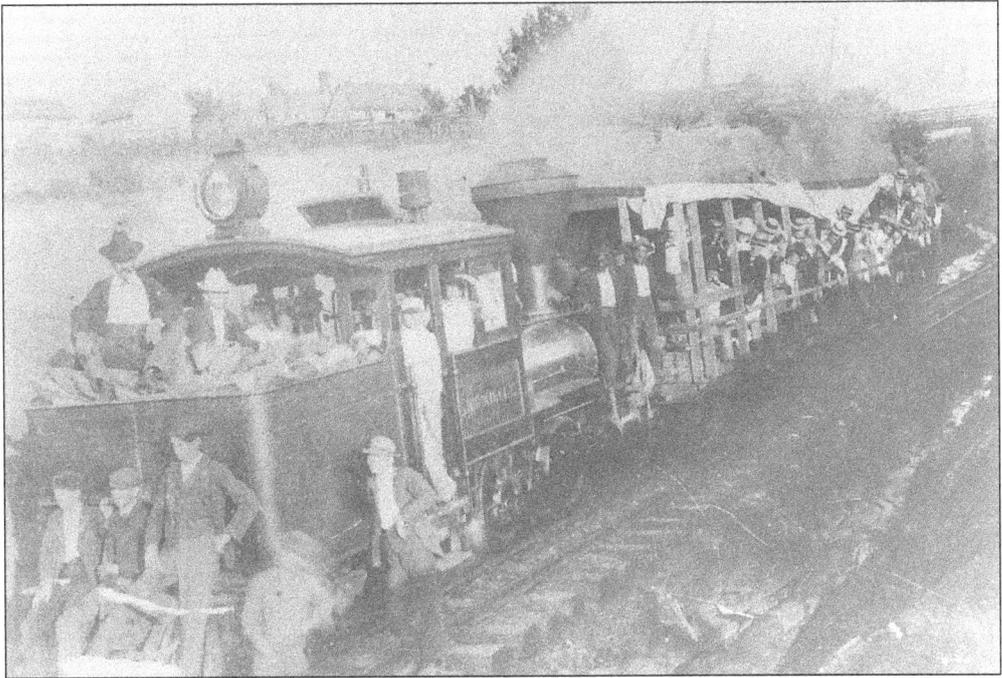

This 1902 photo shows the "Lawndale Dummy" transporting passengers from Shelby to hear North Carolina Governor Aycok speak at Piedmont Academy. The engine is pushing the cars so as not to cover the passengers in cinders. The Sumter Street bridge in Shelby can be seen in the distance. (Courtesy of Tommy Forney.)

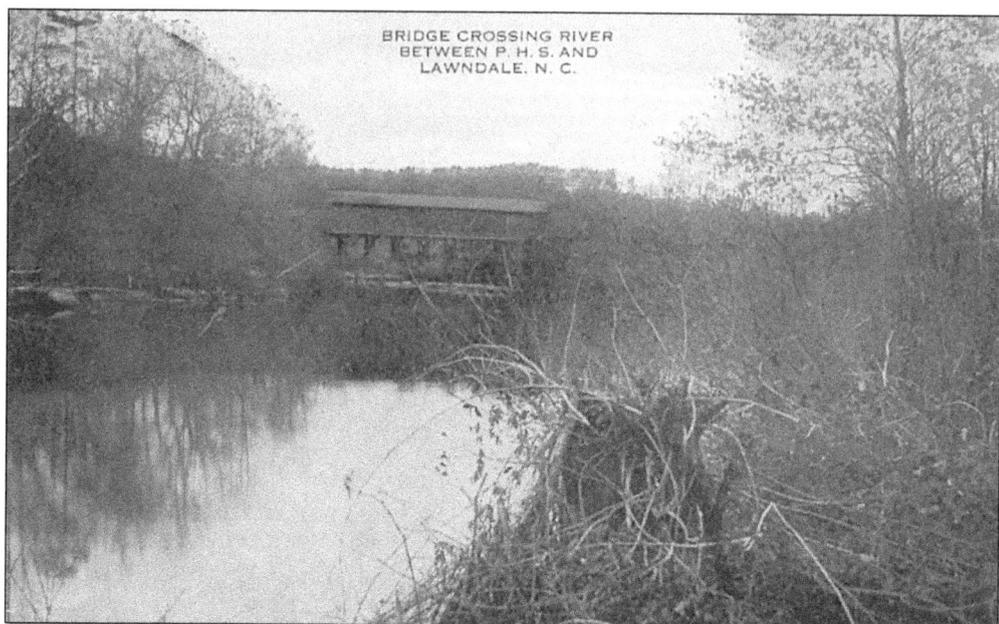

This postcard view shows a covered bridge that crossed the Broad River, connecting Lawndale with Piedmont High School. The schoolhouse was located near the old Cleveland Mill community along Knob Creek. (Courtesy of Patty Osborne Lee.)

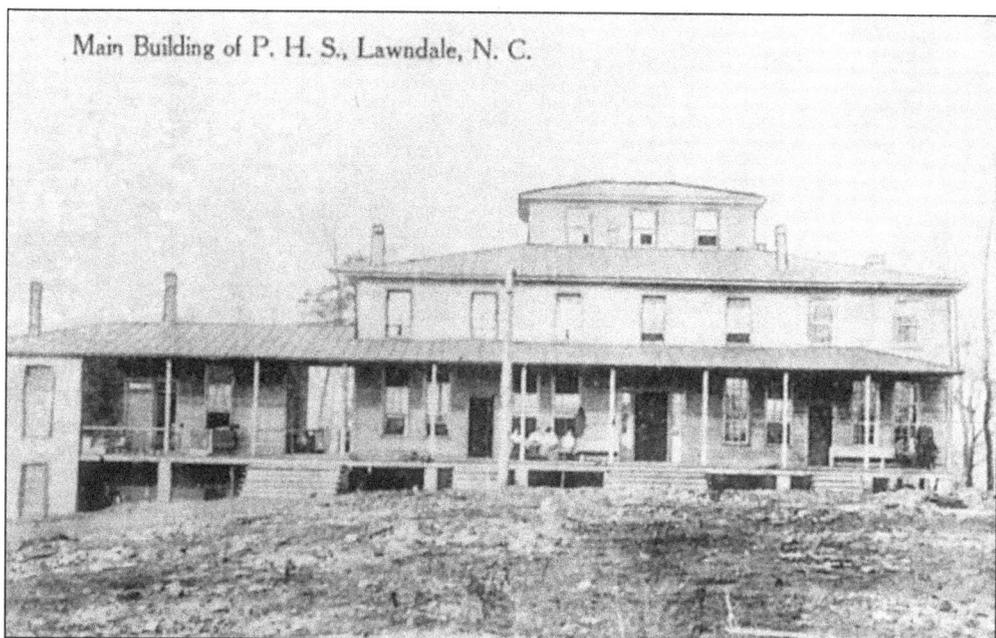

The main building at Piedmont High School can be seen in this postcard view. Before the schoolhouse was built, classes were held in the home of T.J. and Minnie Ramseur. (Courtesy of Tommy Forney.)

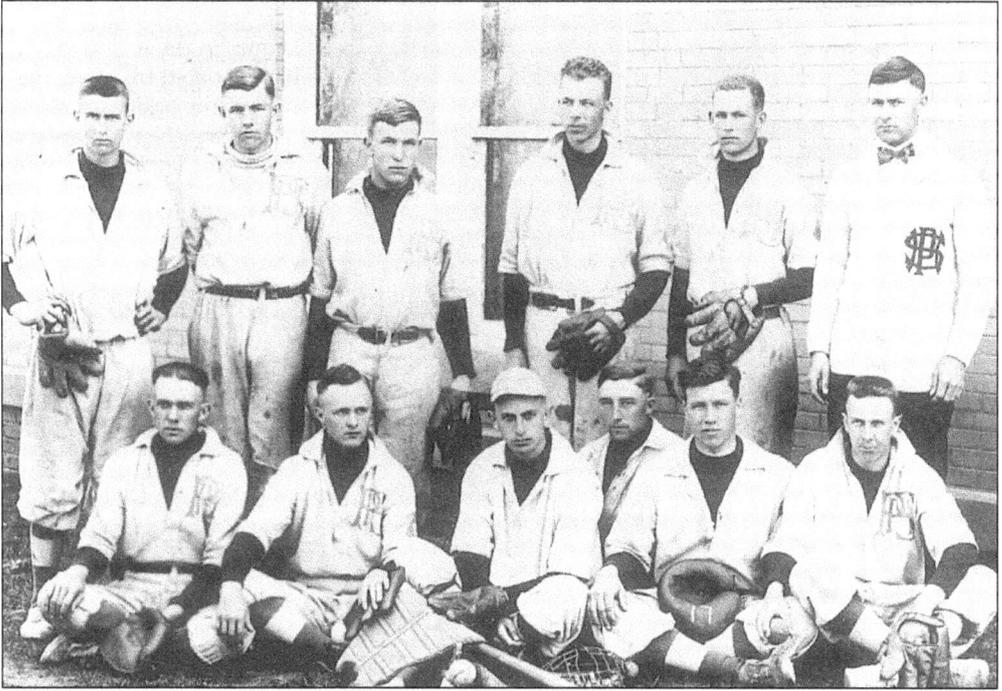

This 1917 photo is of the Piedmont High School baseball team. From 1897 to 1923 Piedmont was a private preparatory school, the second largest in the state. W. Banks Dove served as the school's first principal. (Courtesy of the Uptown Shelby Association.)

Lawndale Bus Line provided service throughout the community. Note the rail car diner in the left center of the photo. (Courtesy of Tommy Forney.)

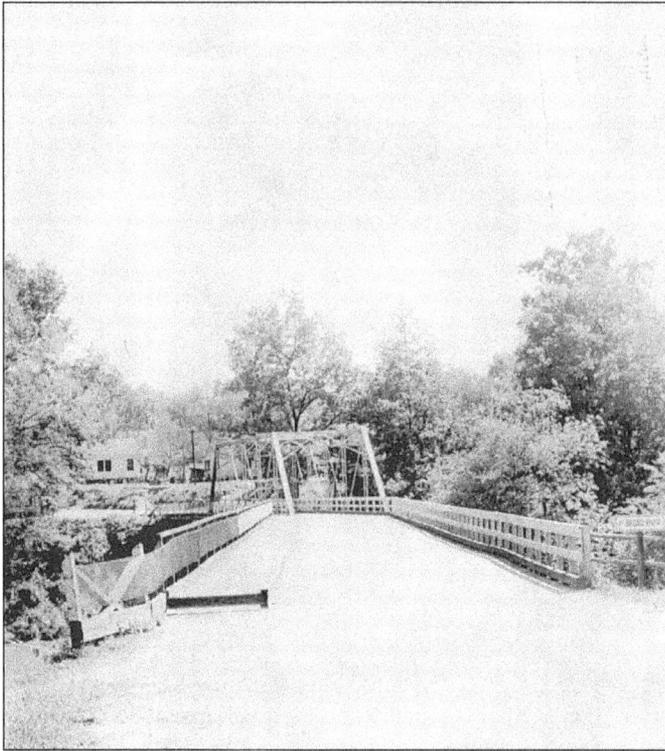

The "crooked bridge" was famous in the region for having two turns along the span of the bridge, crossing the Broad River. (Courtesy of Tommy Forney.)

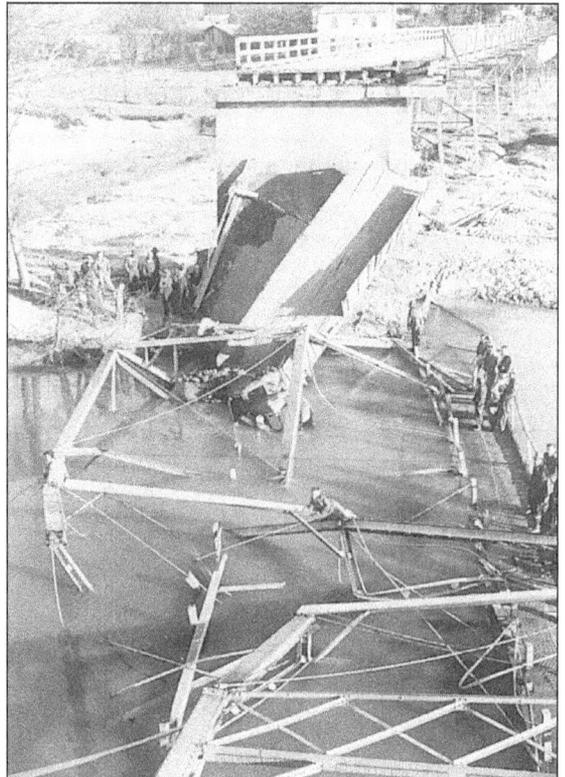

The crooked bridge met its demise in 1943, collapsing from the weight of a truck loaded with bricks. The truck can be seen in the left center of the postcard.

The Cleveland Mill and Power Company is seen as it appeared in the 1930s. The building housed the company store; to the left is the Lawndale Post Office. (Courtesy of Tommy Forney.)

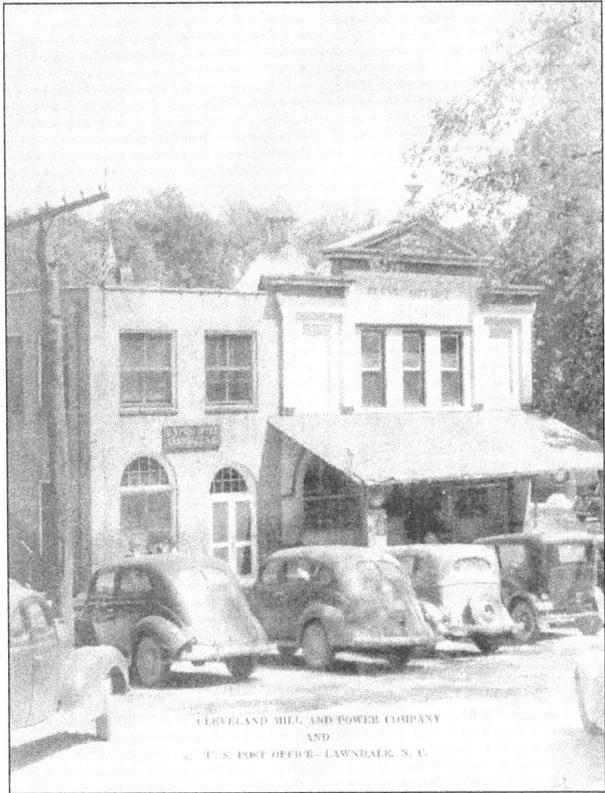

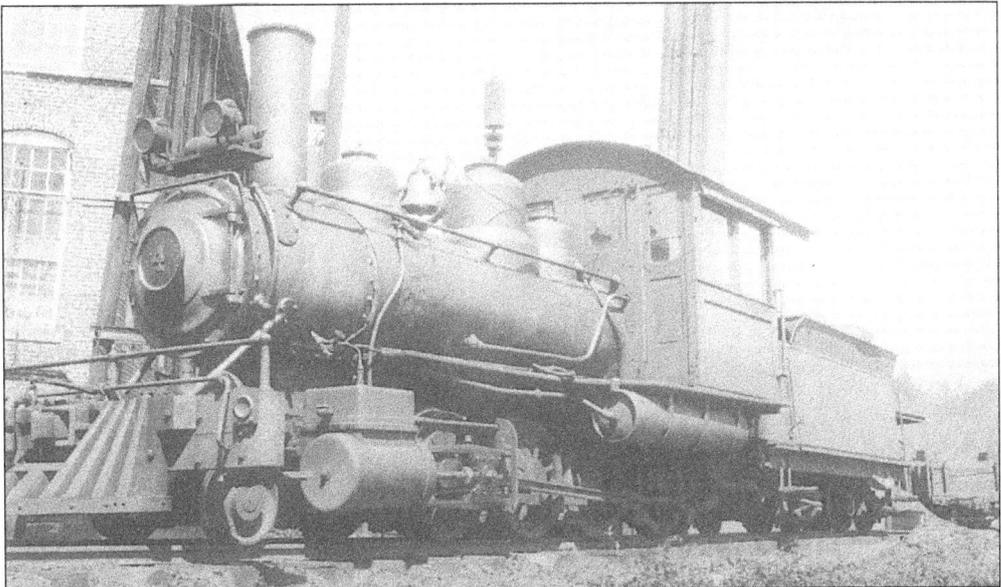

Engine number 4 of the Lawndale Railway is seen alongside the Cleveland Mill. This photo is from the early 1940s, near the end to the 44-year run of the railway. (Courtesy of Tommy Forney.)

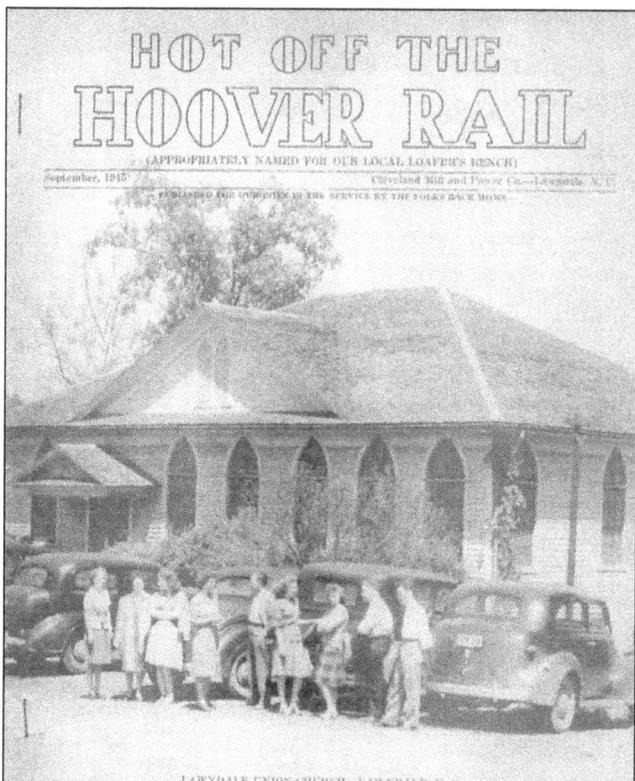

The *Hoover Rail* was published by the Cleveland Mill and Power Company "for our boys in the service." The cover is a 1945 photo of Lawndale Union Church. (Courtesy of Tommy Forney.)

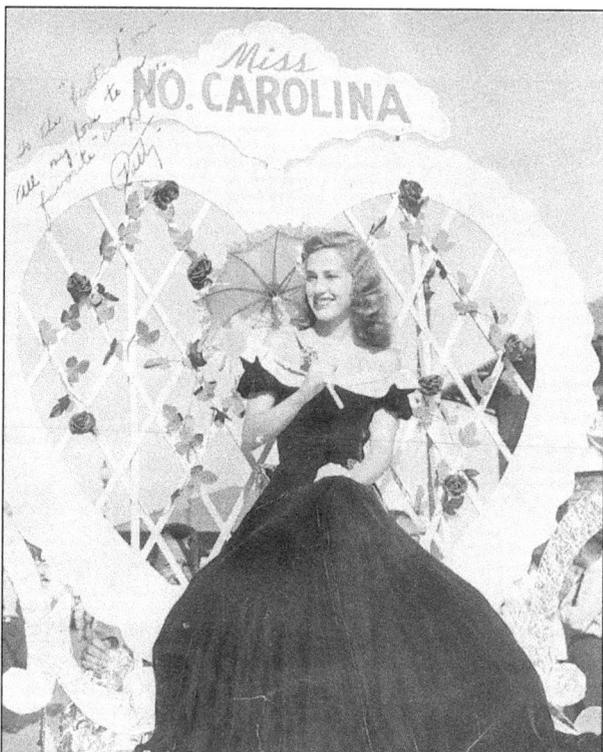

Lawndale native Patty Osborne Lee was crowned Miss North Carolina in 1948. Today, Mrs. Lee lives in Columbia, SC. (Courtesy of Minnie Ann Forney.)

Six

AROUND THE COUNTY

Named for Revolutionary War patriot Col. Benjamin Cleveland, the county was formed from parts of Lincoln and Rutherford Counties by an act of the North Carolina Legislature on January 11, 1841. Elementary school geography taught us that in the days before paved roads, towns were built around railroads and rivers for access to transportation and necessities. Add mineral springs to the formula and you have the basis on which Cleveland County was developed. Rivers, creeks, spring waters, and railroads were at the origin of every community in Cleveland County.

For nearly 100 years cotton fields and cotton gins dotted the landscape of Cleveland County. In an era when "cotton was king," textile plants employed a majority of the county's citizens. "Free trade" brought about what the boll-weevil could not, a change in the industrial workplace of the county. Today, the workforce of Cleveland County is employed in a diverse make-up of industry. From air compressors used around the world to commercial aircraft components, from compact discs to heavy truck bodies and transmissions, the county prospers with a mix of craftsmanship and pride in the workplace.

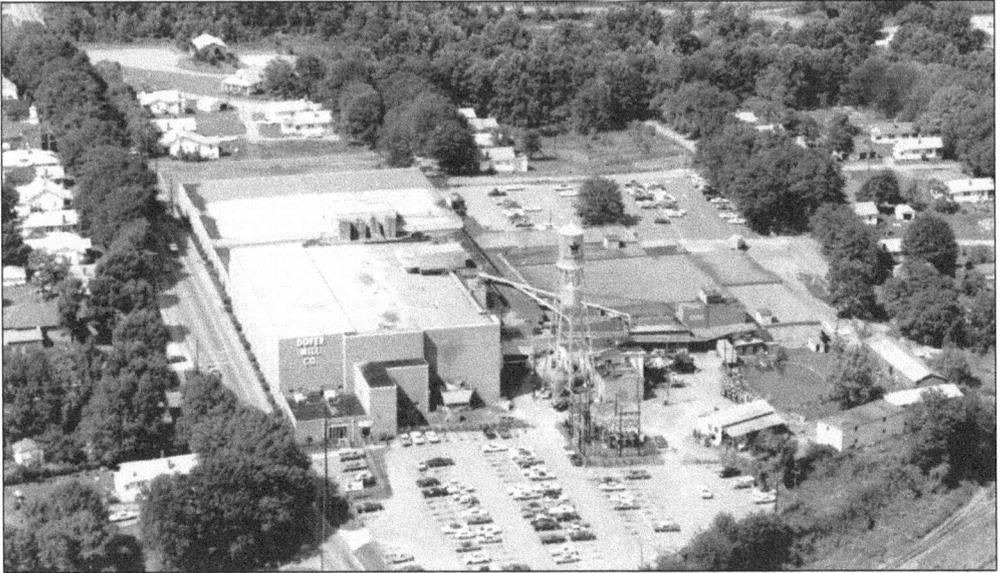

This aerial photo is of the main office of Dover Mill Company located on NC Highway 226, just west of Shelby. Although it is no longer in operation, the county would be poorer today without the economic impact the Dover Textile group had on Cleveland County during the years it employed generations of our citizens. (Courtesy of the Cleveland County Chamber.)

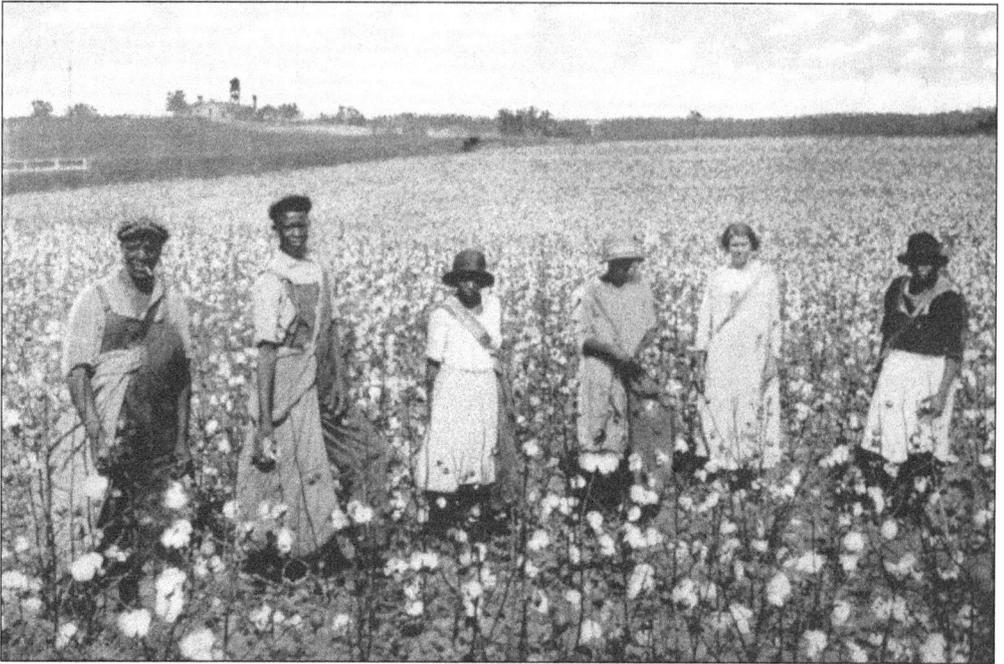

This 1930s postcard depicts a typical cotton field in Cleveland County. From the middle of the 19th century through the 1950s, cotton was the major crop grown in Cleveland County.

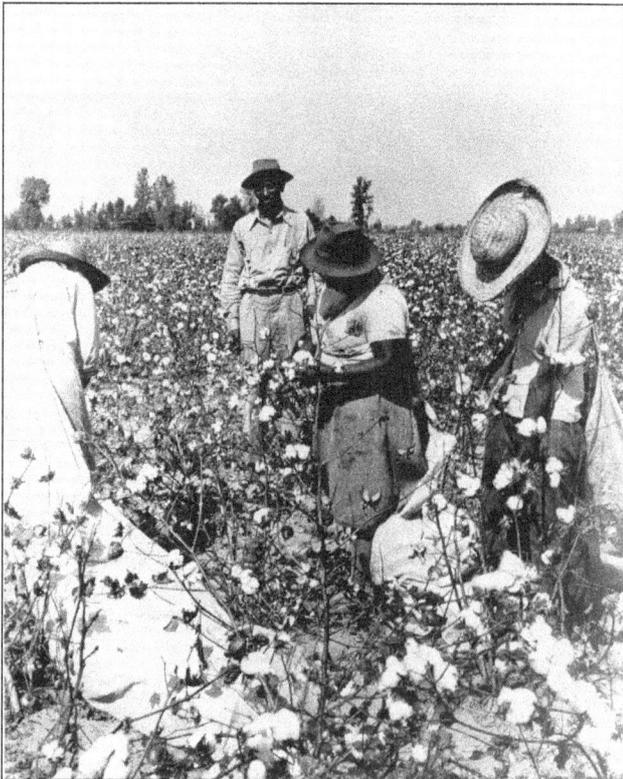

A closeup photo shows workers in the field picking cotton. It was a difficult technique to master, and most workers were paid by the pounds of cotton picked. (Courtesy of the Cleveland County Chamber.)

Always in close proximity to the cotton field, cotton gins spotted the countryside. The O.Z. Morgan family were heavily involved in the ginning of cotton. Along with his responsibilities in the family business, Robert Morgan served the county as a state legislator. (Courtesy of the Uptown Shelby Association.)

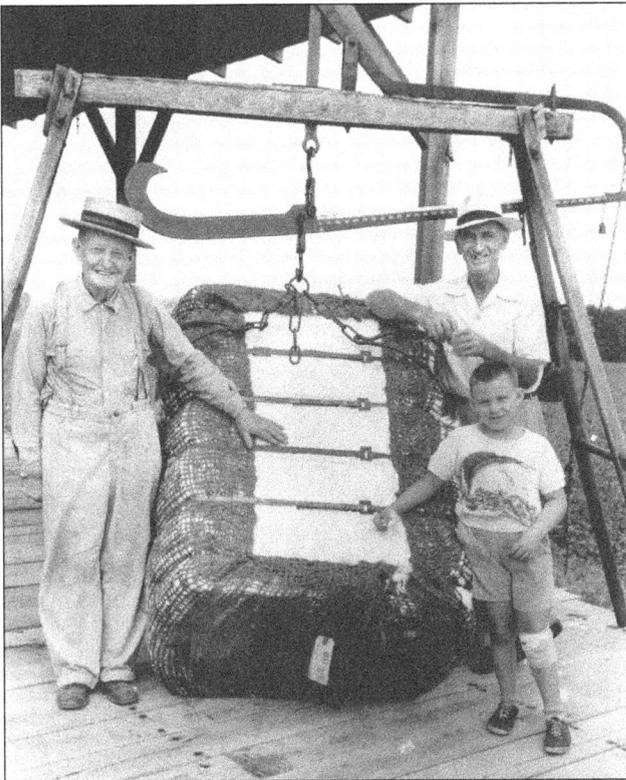

The county took great pride in the cotton industry. The first bale of cotton ginned in the county was auctioned on the courthouse steps annually. The gentleman to the left is Rev. J.A. Walker, and Clyde Putnam is to the left. (Courtesy of the Uptown Shelby Association.)

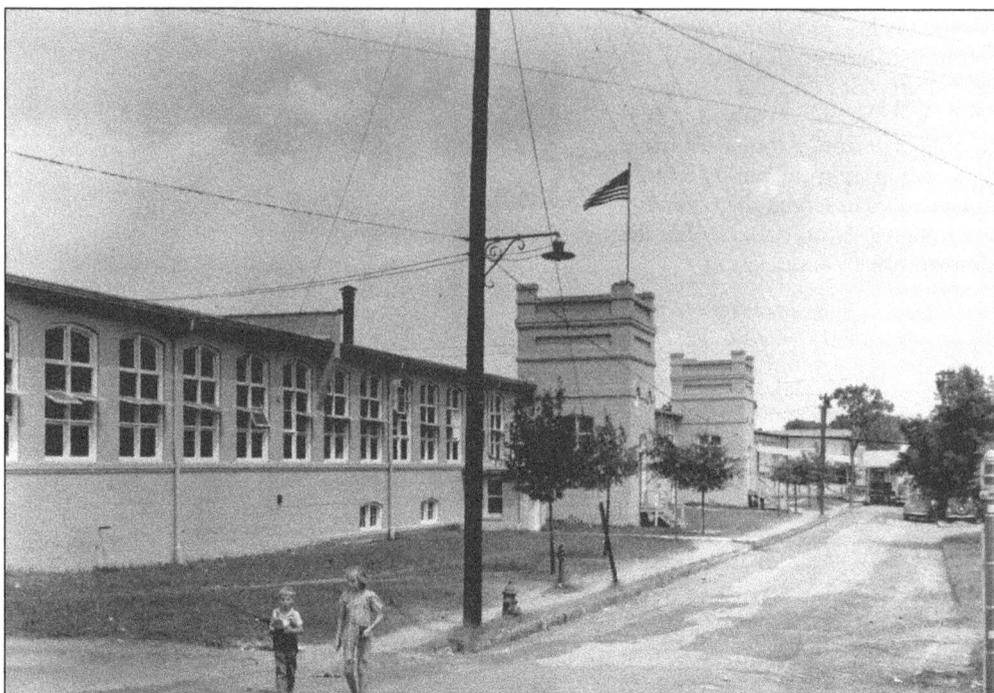

This photo is of the main entrance of the Lily Mill in Shelby. Mills like this were the center of the mill community, with homes and general stores located within walking distance. (Courtesy of the Cleveland County Chamber.)

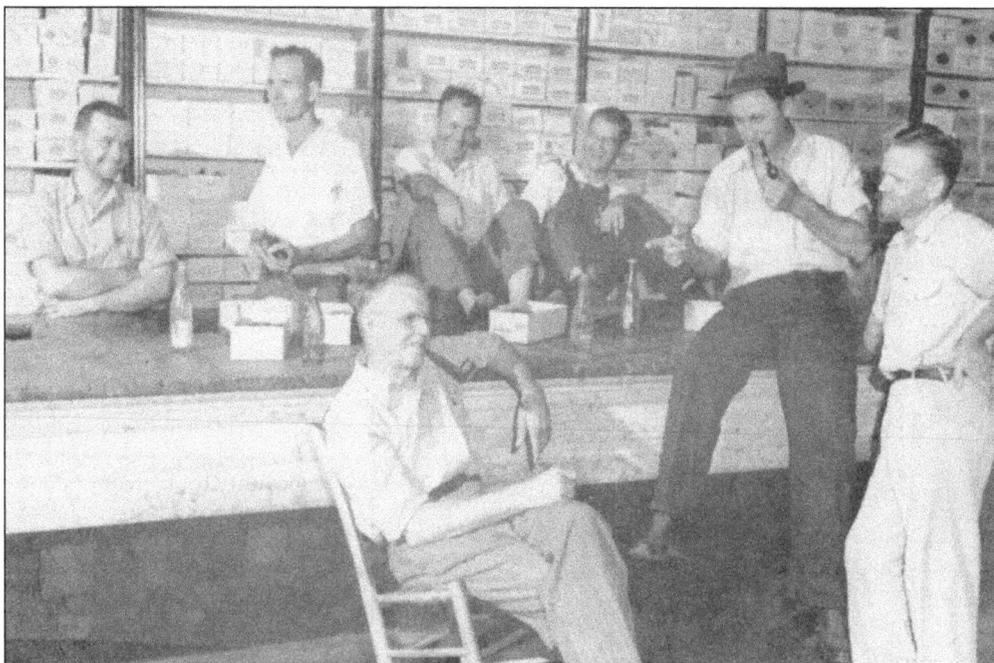

The "Lily Congress" is in full swing at the mill supply store. This political gathering has just been called to order by "Loge" Newton to discuss business and political concerns of the day. (Courtesy of Tommy Forney.)

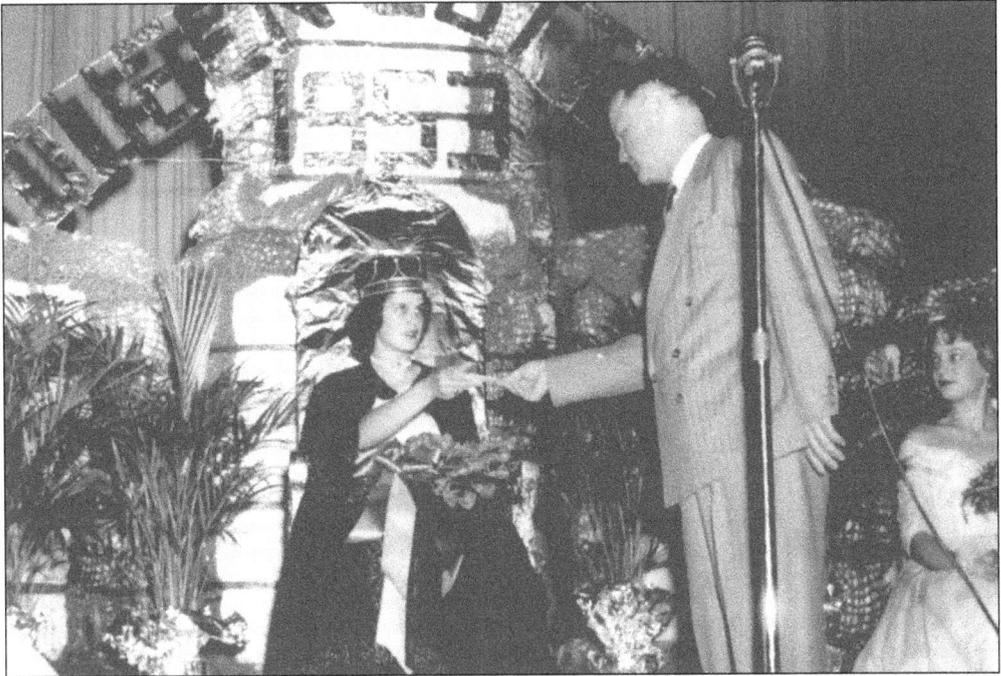

In a time when cotton was king, pageants were held to award the "Queen of Cotton." In 1953 this young lady was crowned Cotton Queen. (Courtesy of the Uptown Shelby Association.)

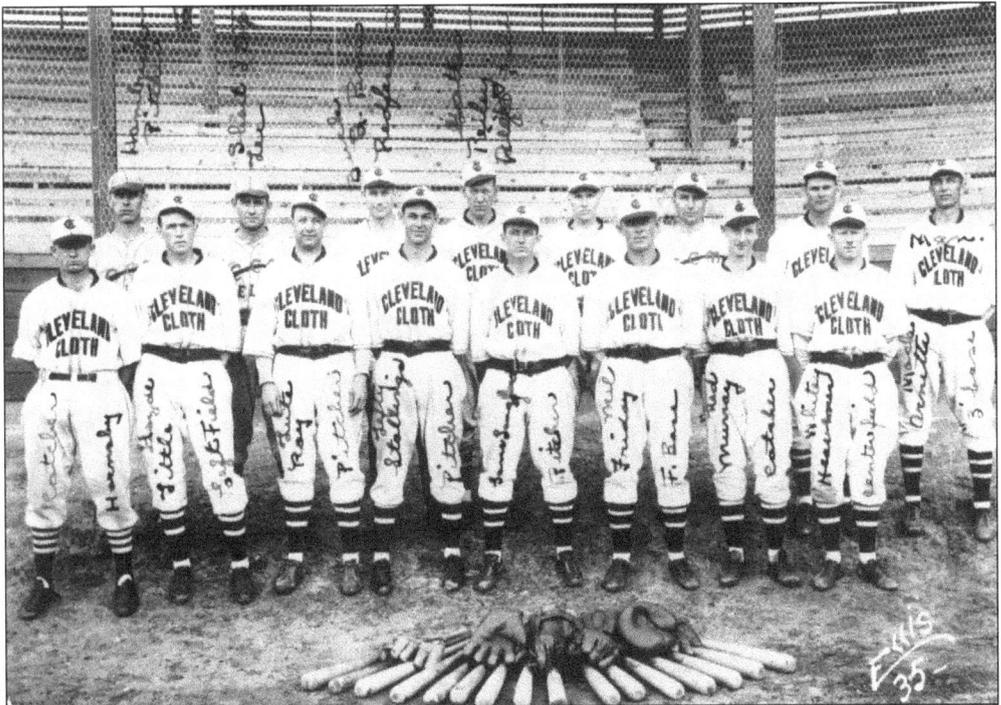

Industrial league baseball teams were a part of the county's cultural make-up. This photograph shows a typical Cleveland Cloth Mill baseball team. (Courtesy of the Uptown Shelby Association.)

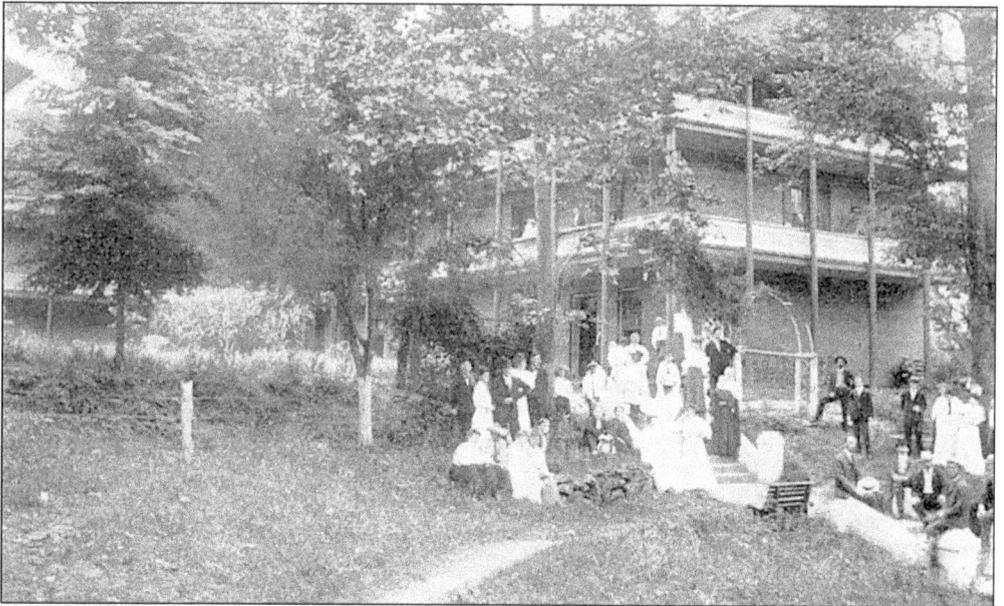

Guests of the Cleveland Springs Hotel gather for this turn-of-the-20th-century photo. Vacationers from throughout the South journeyed to Cleveland County for the medicinal healing powers of the mineral springs water. This hotel was built in 1866 and burned on September 9, 1907, as a result of a lightning strike. (Courtesy of the Cleveland County Historical Museum.)

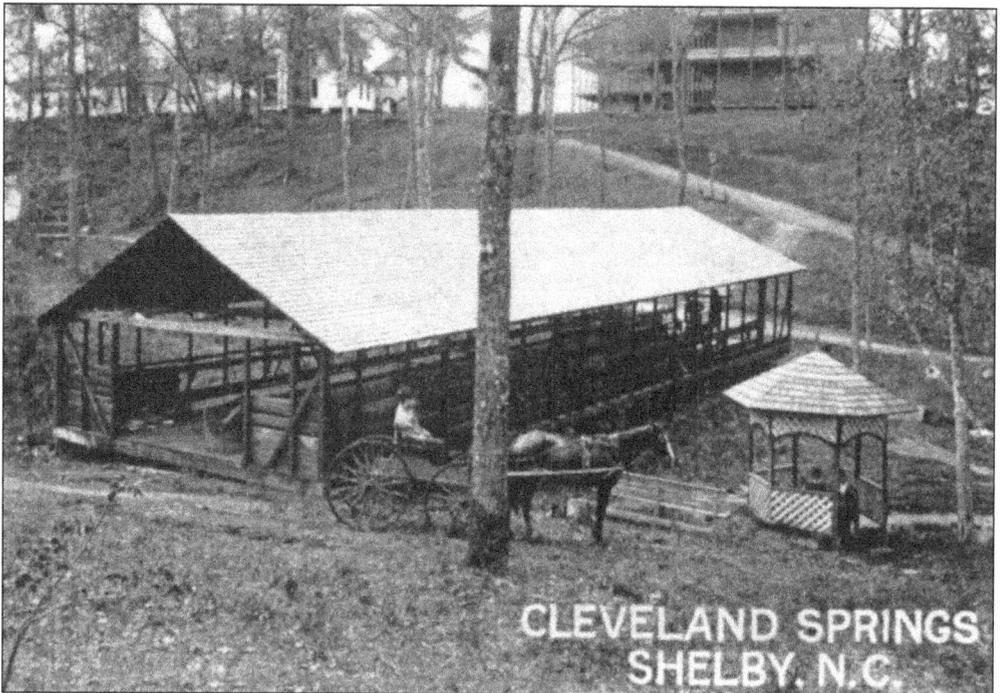

The second of three hotels to occupy this site in a 77-year span can be seen in the distance in this early 1900s postcard. The first hotel was built in 1851 by Thomas Wilson and burned in 1854. (Courtesy of Boyd Hendrick.)

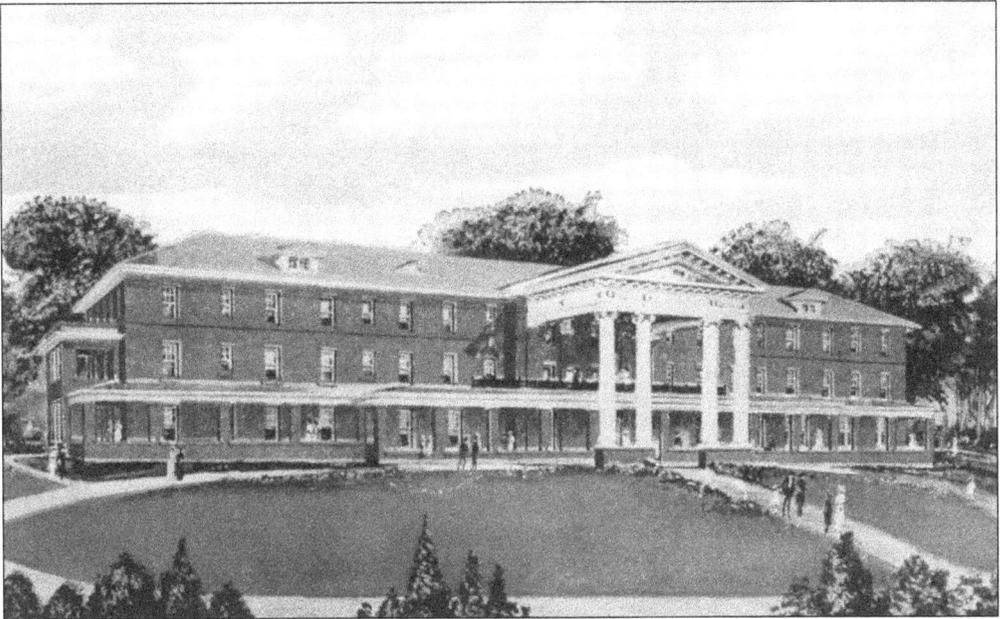

The third hotel was built in 1921 at a cost of $250,000 in what was called "Cleveland Springs Park." The hotel boasted access from Shelby via a concrete road. The road continued to Kings Mountain and connected with the Bankhead Highway that ran from New York to Jacksonville.

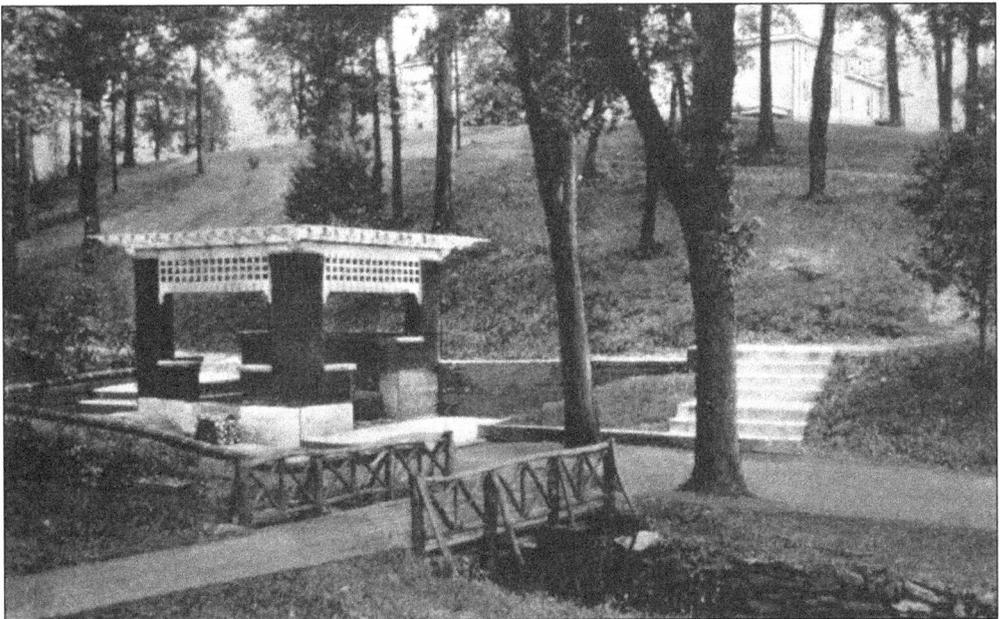

The spring is visible in the foreground of this 1920s postcard, with the third of the three hotels visible in the distance. The last of three hotels to occupy the site burned in 1928. (Courtesy of Boyd Hendrick.)

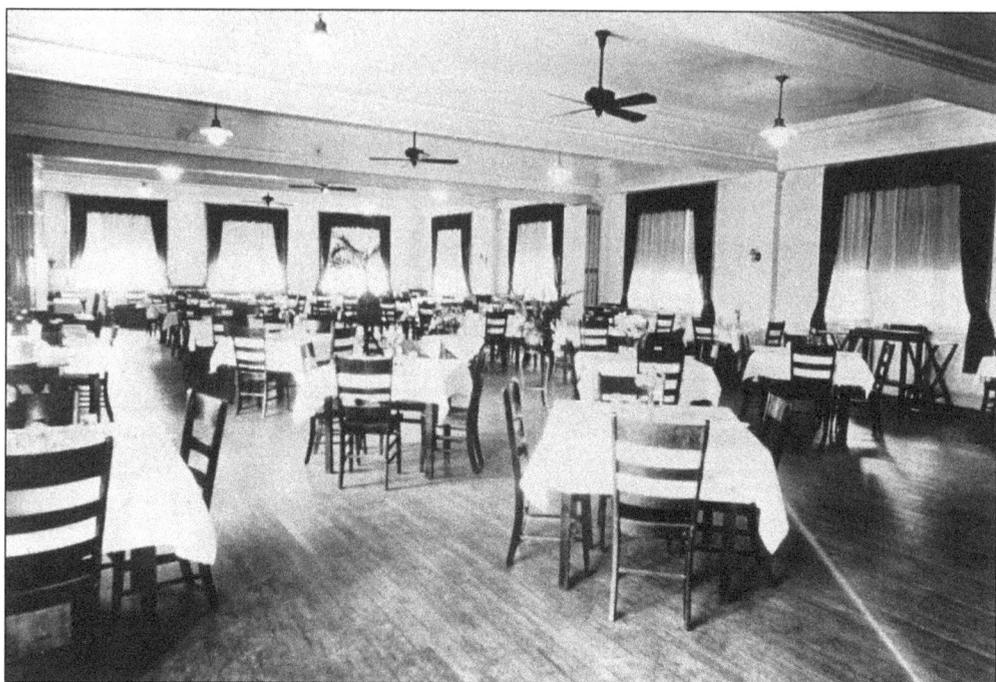

This photo of the dining room of the third hotel gives us a glimpse of the splendor of the hotel during its heyday. (Courtesy of *The Shelby Star*.)

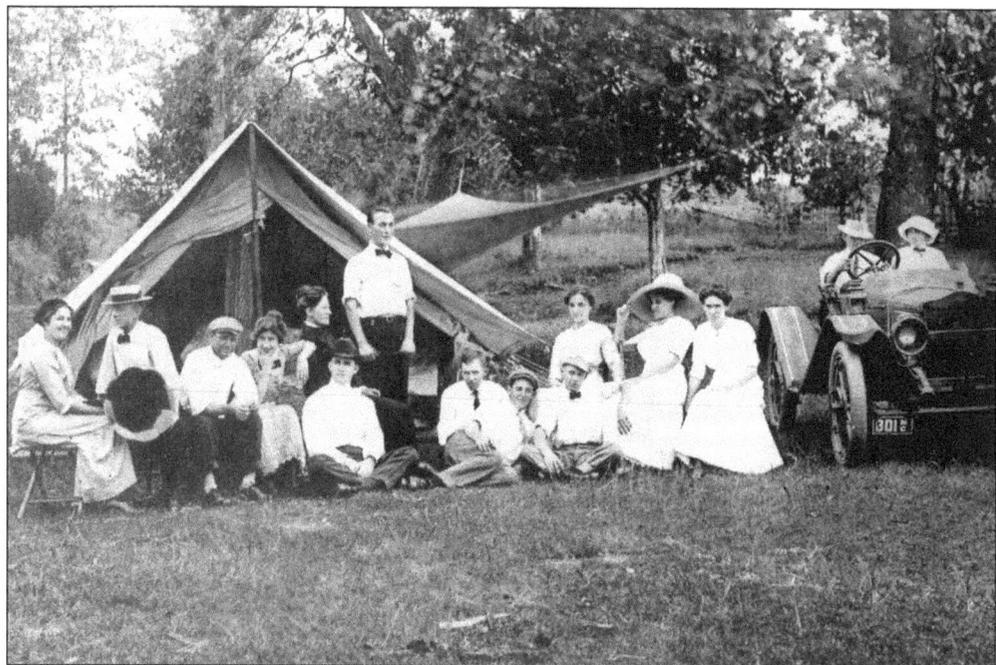

In the fall of 1907 following the fire that destroyed the second hotel, local residents came to camp out near the springs. (Courtesy of the Cleveland County Historical Museum.)

For more than 50 years after the last hotel burned, the columns of the hotel stood amidst the kudzu. Today condominimuns standing on the site bears the name "The Columns."

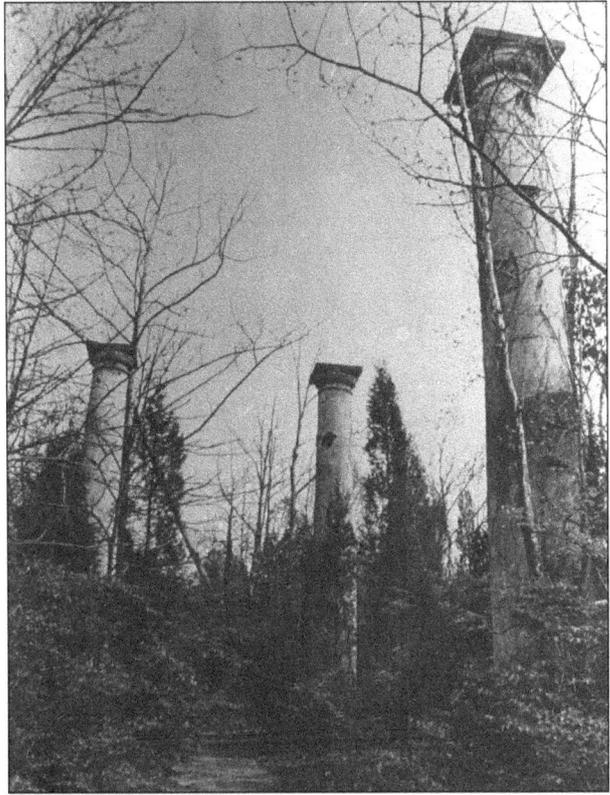

Belwood's Everette Lutz (far right) takes a moment from his work to pose in his apple orchard with Kurt Ledford and his son, Jake Lutz. The name Belwood is derived from "Beautiful Woods." The beginning of Belwood dates back to the 1870s when the community was called "Black Rock." (Courtesy of the Uptown Shelby Association.)

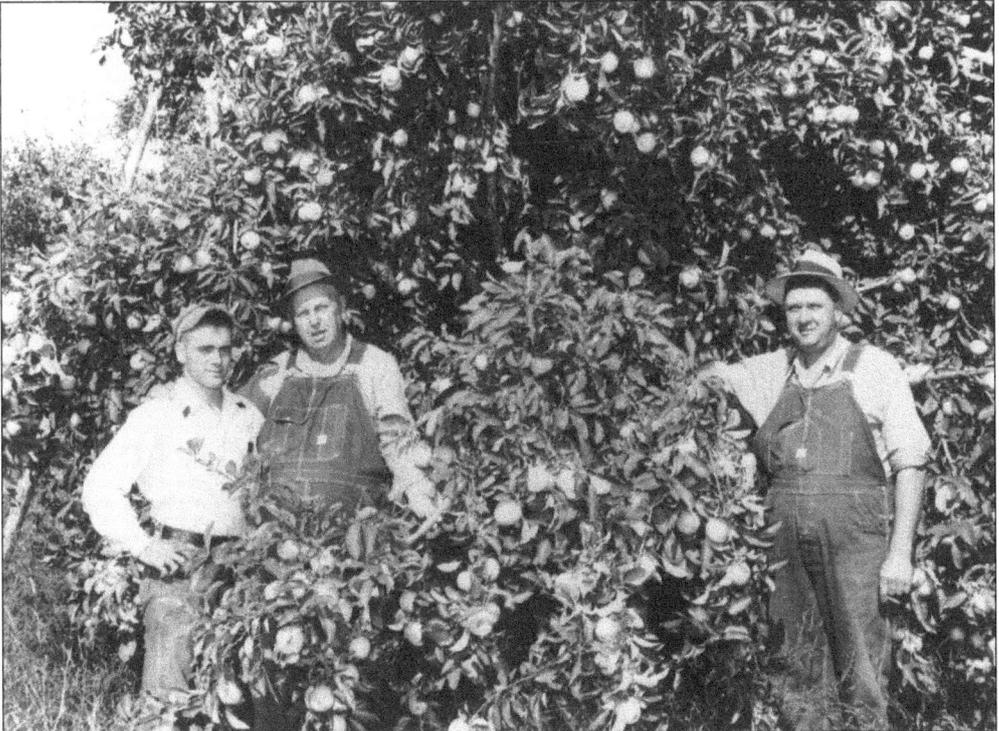

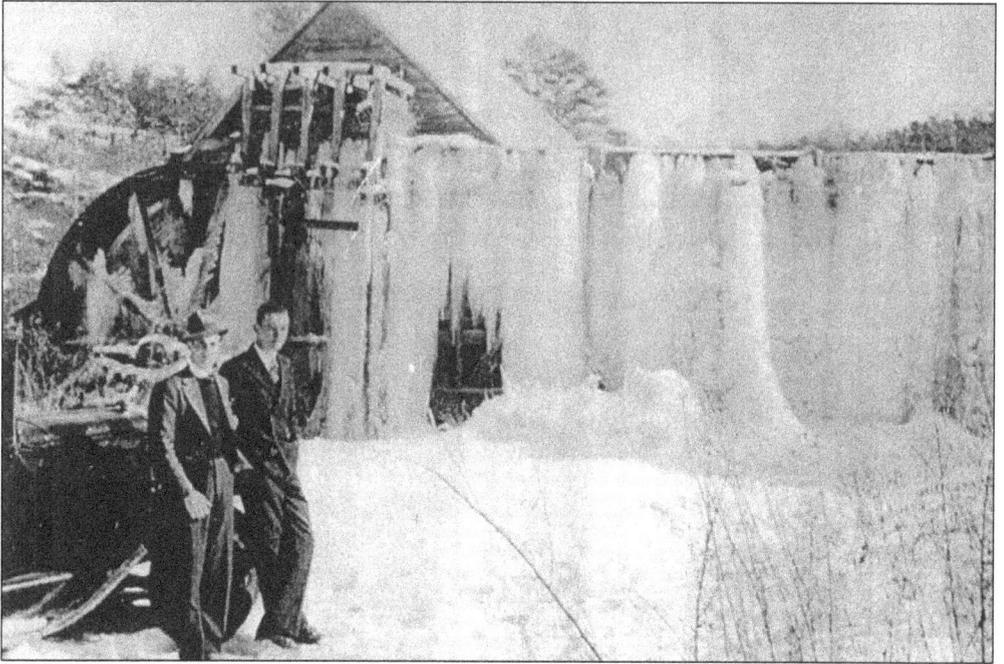

In the winter of 1940, Wards Creek froze at Peelers Mill near Casar. A.C. Bracket and Burell Hull were on hand to pose for the occasion.The freeze was so severe that you could walk across the dam. (Courtesy of Joe Goforth.)

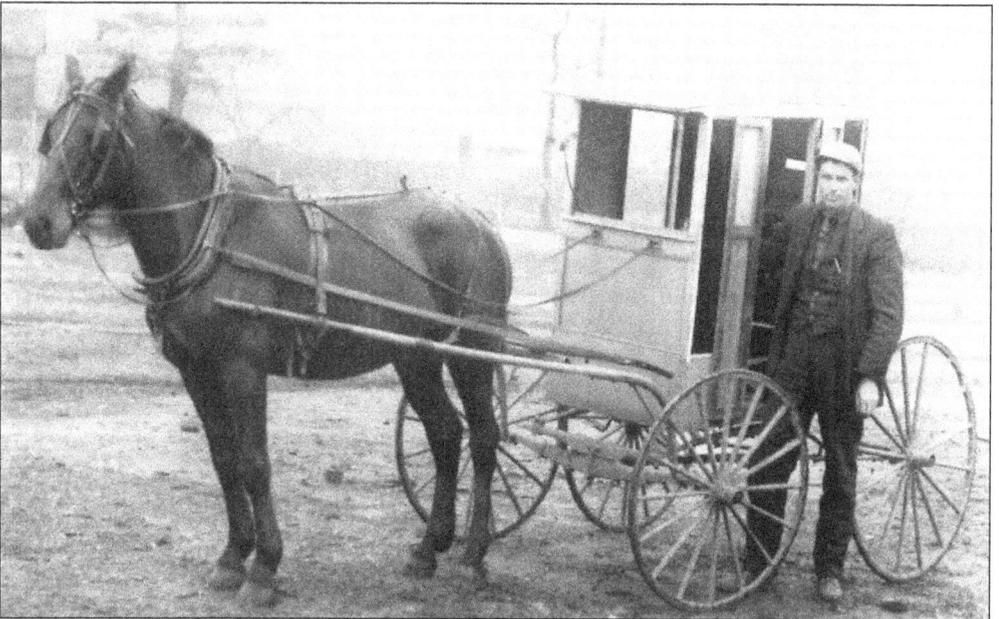

A.A. "Gus" Richard served as mail carrier for Casar from from 1907 until he retired in 1953 at the age of 70. For the first 20 years Gus had the service of several horses to help make the rounds, but none as faithful as "Ole Barney." (Courtesy of the Cleveland County Historical Museum.)

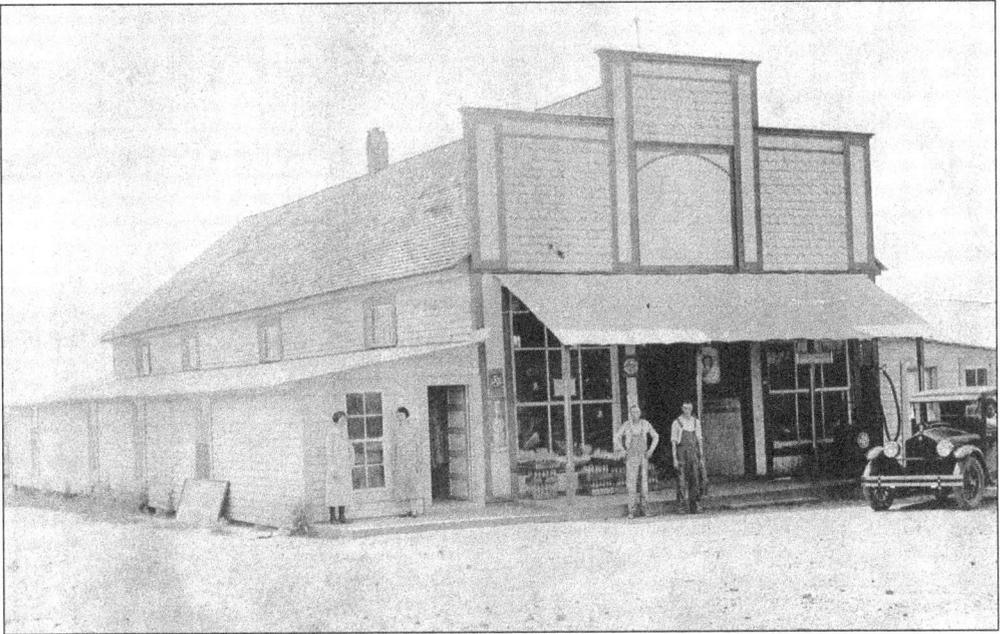

This 1930s photo is of the A.A. Warlick & Co. General Store in Casar. (Courtesy of Andrew Pruett.)

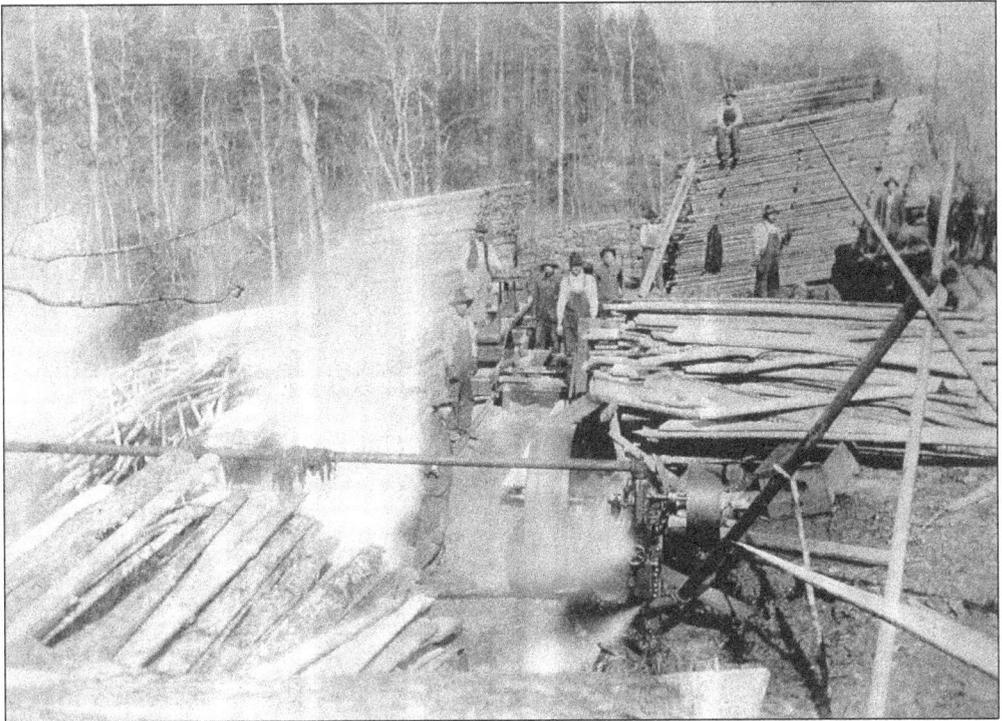

This turn-of-the-20th-century sawmill near Casar is believed to have been one of the first sawmills to operate in Cleveland County. (Courtesy of Andrew Pruett.)

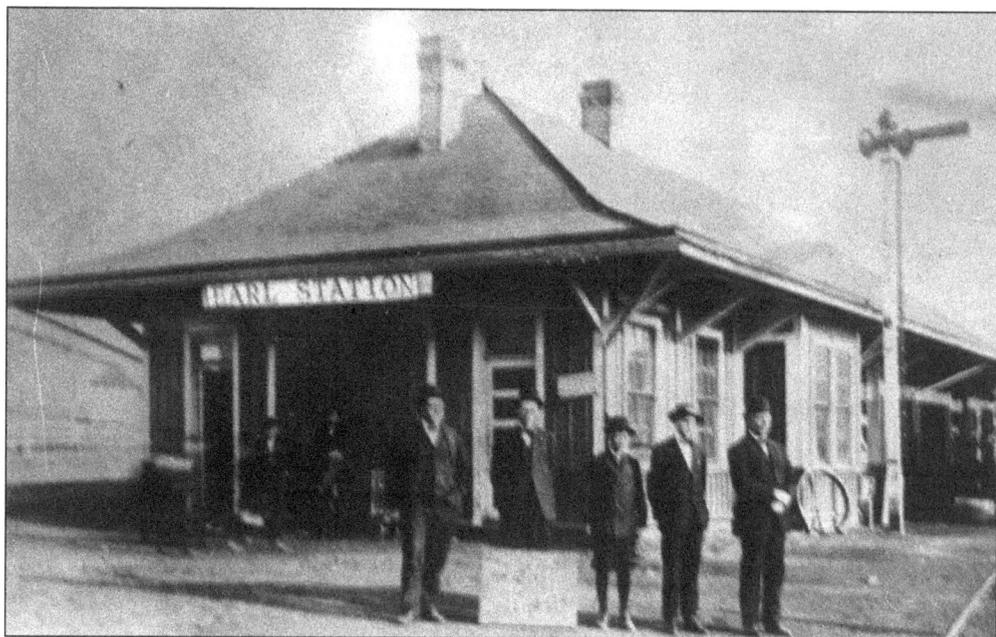

The community of Earl was named for farmer Abel Earl, who gave the land for the Earl Station depot. The Southern Railway first provided passenger service to the community in the mid-1800s. Freight trains still pass along the same tracks through the community today. (Courtesy of the Cleveland County Historical Museum.)

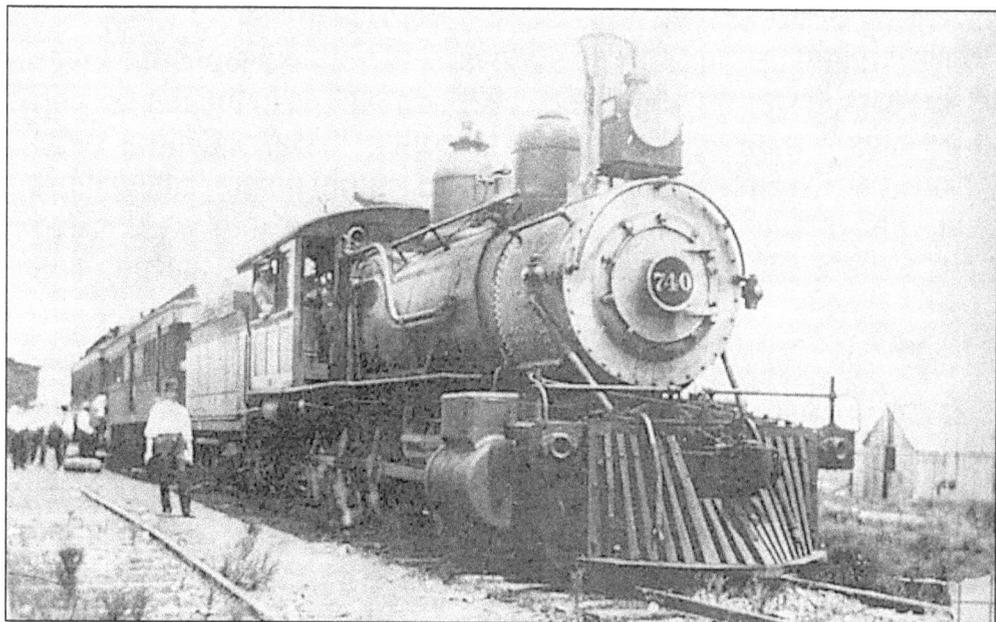

Once more a community was born as a result of the railroad. The Atlanta-Charlotte Airline Railway operated an engine turntable in Grover from the 1880s into the 1920s. The Southern Railway continues rail service through this diverse industrial community. The town of Grover was named for President Grover Cleveland. (Courtesy of the Cleveland County Historical Museum.)

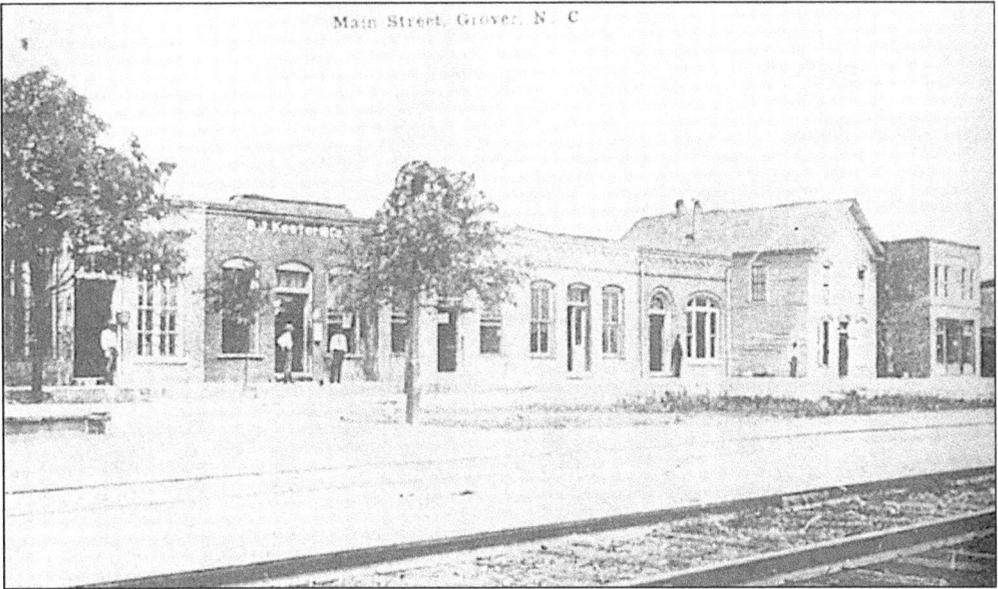

This postcard is of Main Street in Grover. Situated on the state line between North and South Carolina, Grover was originally Whitaker, SC. Steady growth to the north across the state line caused the name to be changed to Grover, NC. (Courtesy of the Cleveland County Historical Museum.)

The children of Charles Franklin "Cap" Harry, the founder of Minnette Mills, are shown here. From left to right are David, Franklin, Frances, Bill (seated, front), Holmes (standing behind Bill), SaDelle, and Jeanette. (Courtesy of the Cleveland County Historical Museum.)

The town of Fallston was named for local businessman John Z. Falls. This postcard view is of the Methodist church in Fallston. (Courtesy of Boyd Hendrick.)

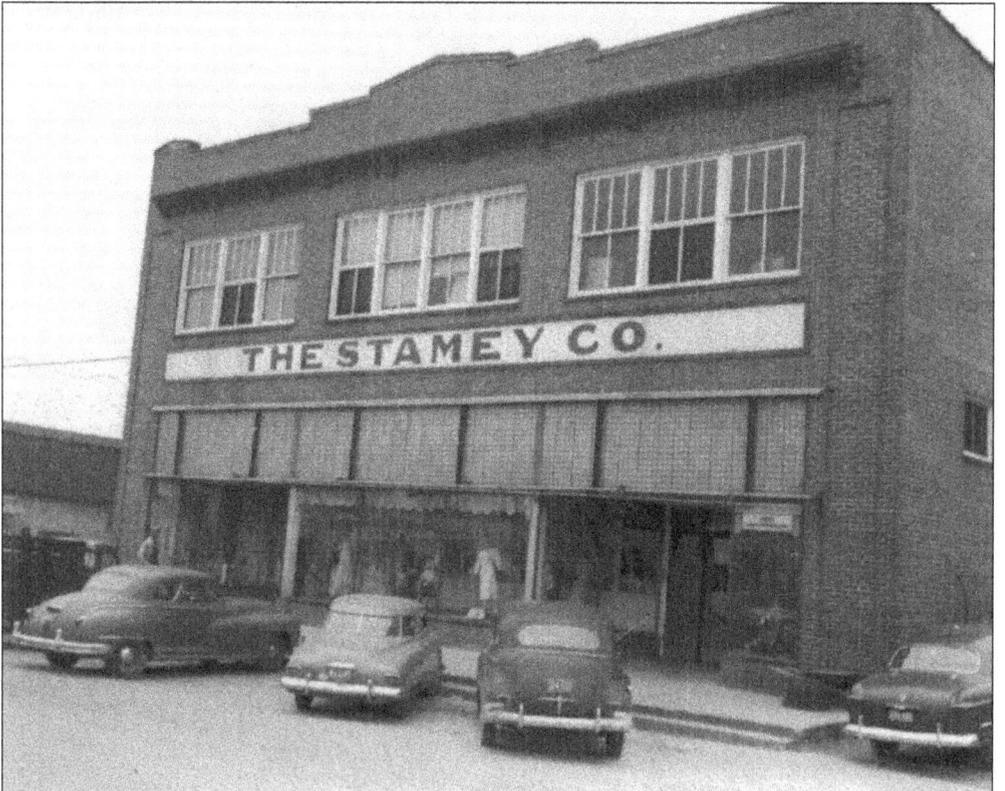

The Stamey Store was a cornerstone in Fallston for nearly a century. Everything from bread to boots was available in the store, located at the crossroads in Fallston. (Courtesy of Tommy Forney.)

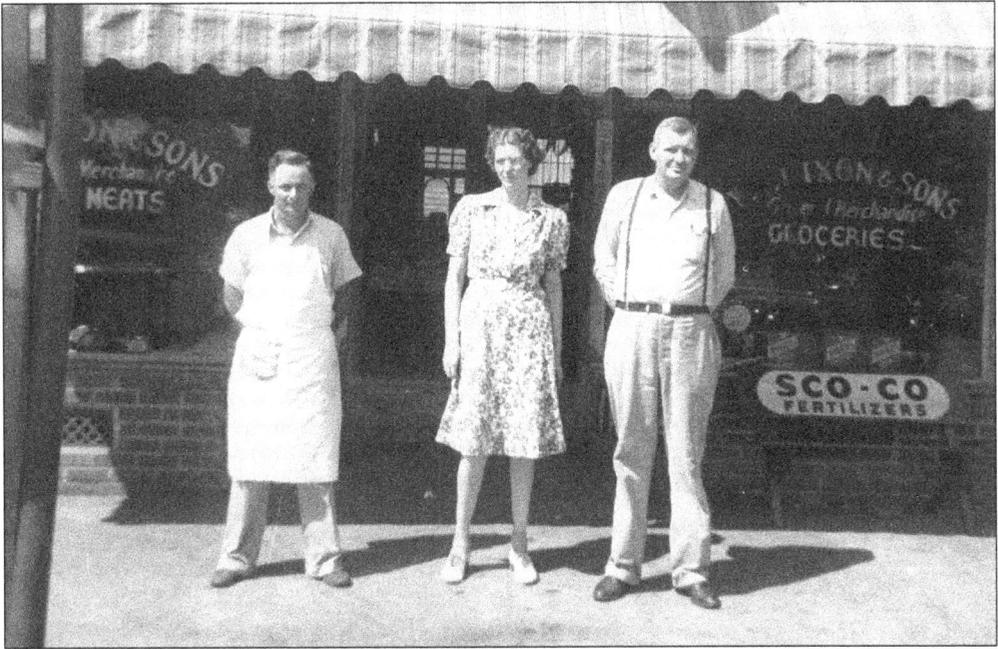

Across from Stameys was the Dixon and Son Grocery Store. Pictured from left to right are Grady Royster, Wilma Lucas (Dixon's sister), and Paul Dixon. (Courtesy of Ralph Dixon.)

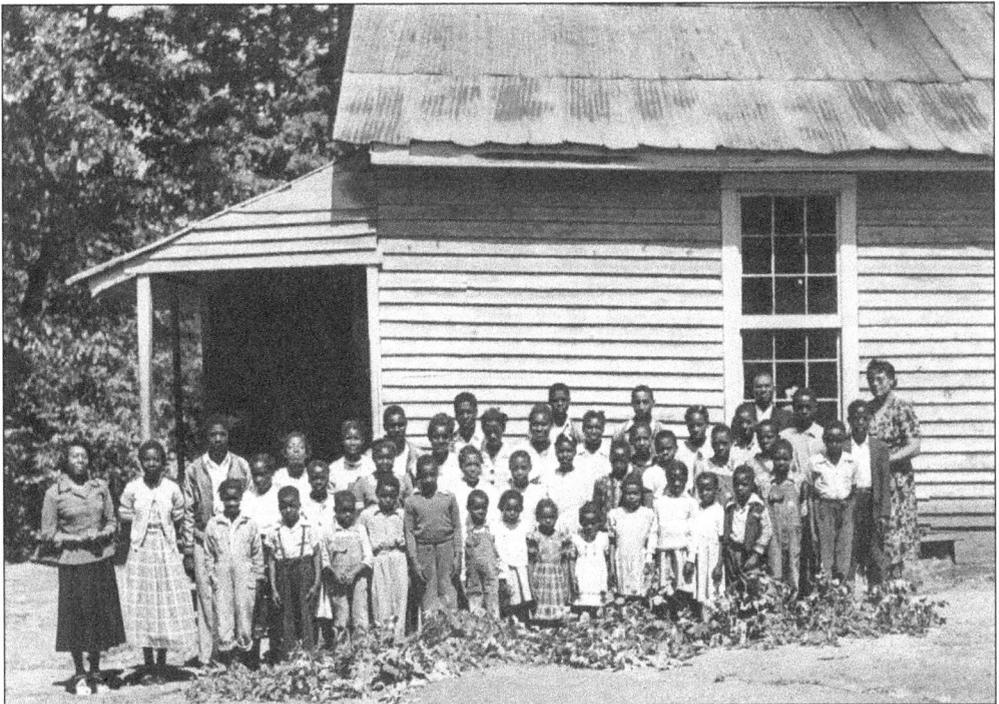

The Ramseur School was located near Polkville on NC Highway 26. The school was named for Headmaster Ramseur. (Courtesy of *The Shelby Star*.)

One of Polkville's favorite sons is North Carolina Superior Court Judge Honorable Forest Donald Bridges. He is pictured here with his first girlfriend, Debbie Shuford.

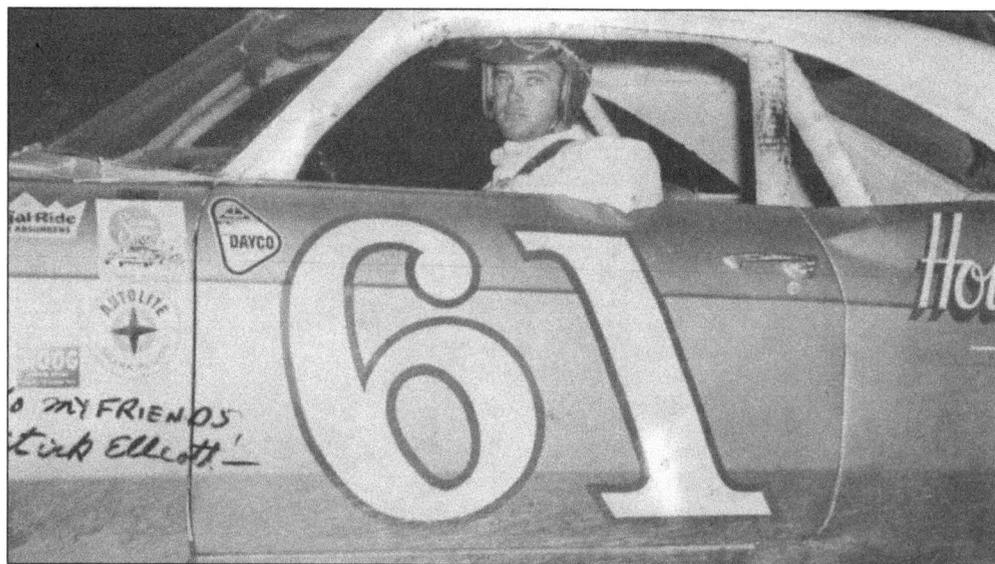

Polkville native Gene "Stick" Elliott was a regular on the stock car circuit in the 1950s and 60s.

A turn-of-the-20th-century postcard from Mooresboro indicated the gentleman held the hand of someone special. (Courtesy of Boyd Hendrick.)

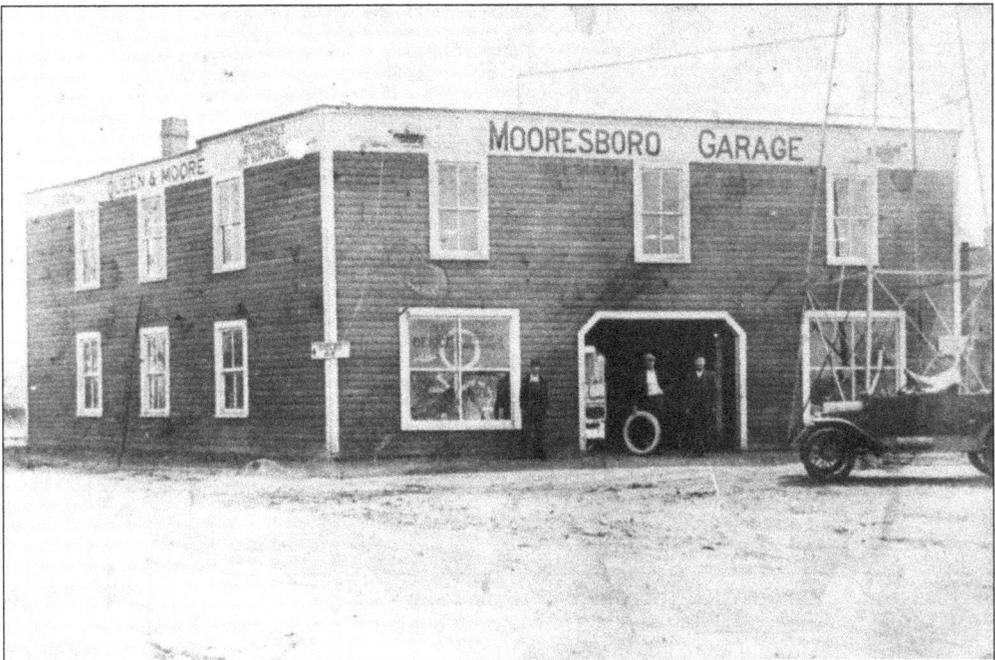

This photo is of the Mooresboro Garage where Henry Ford and Thomas Edison reportedly stopped for a cool drink while traveling through the region. (Courtesy of Boyd Hendrick.)

This turn-of-the-20th-century photo is of J.B. Lattimore, the second mayor of the town that bears his name. Lattimore also served as the town's depot agent. (Courtesy of the Cleveland County Historical Museum.)

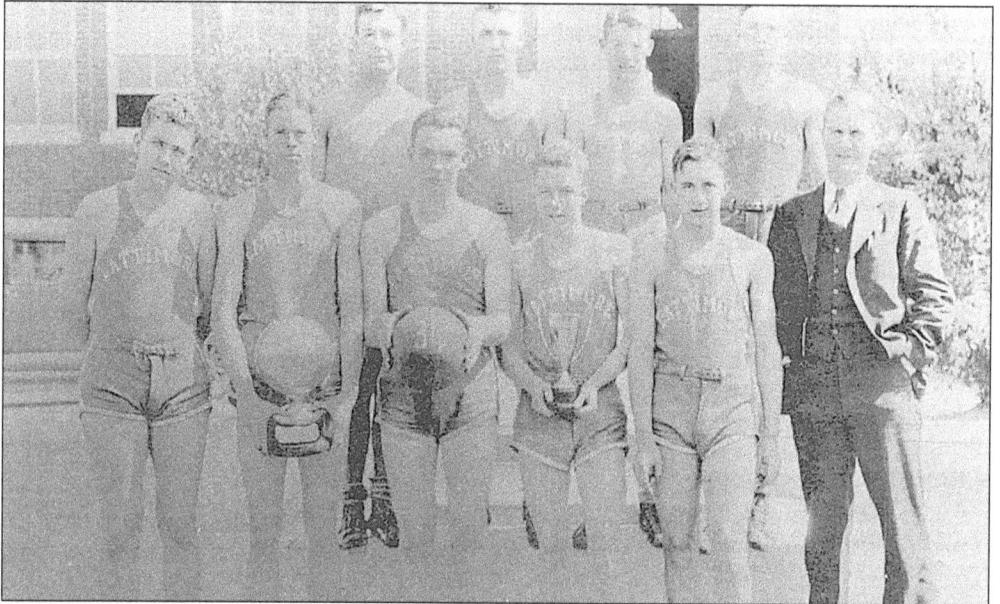

In 1934 the Lattimore High School Basketball team won the state championship. Seen from left to right are the following: (front row) Haskell Harrill, Bill Davis, Glen "Red" Towery, Robert Hunt, Hugh Lee Irwin, and Coach B.E. "Pop" Simmons; (back row) J.C. Humpries, Gordon Blanton, M.E. Threatt, and Dorsey Brooks. (Courtesy of Cleveland County Historical Museum.)

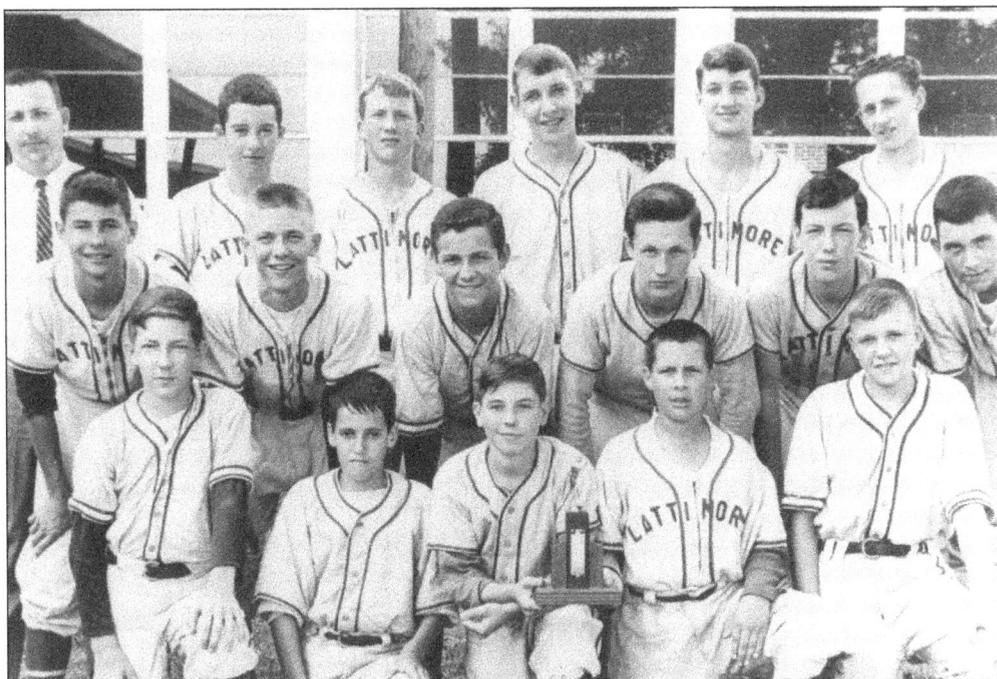

Pictured here is the 1965 Lattimore Junior High League Champion baseball team. Seen from left to right are the following: (front row) Richard Hawkins, Danny Blanton, Ed Clayton, Alan Gold, and Dale Wynn; (middle row) Jimmy Martin, Tommy Hayes, Jerry Mc Intyre, Steve Bell, Franklin Barbee, and Robert Bramlett; (back row) Coach Butch Harris, Roger McSwain, Harvey Whisnant, Don Raynor, Marvin Hamrick, and Floyd Proctor. (Courtesy of Harvey Whisnant.)

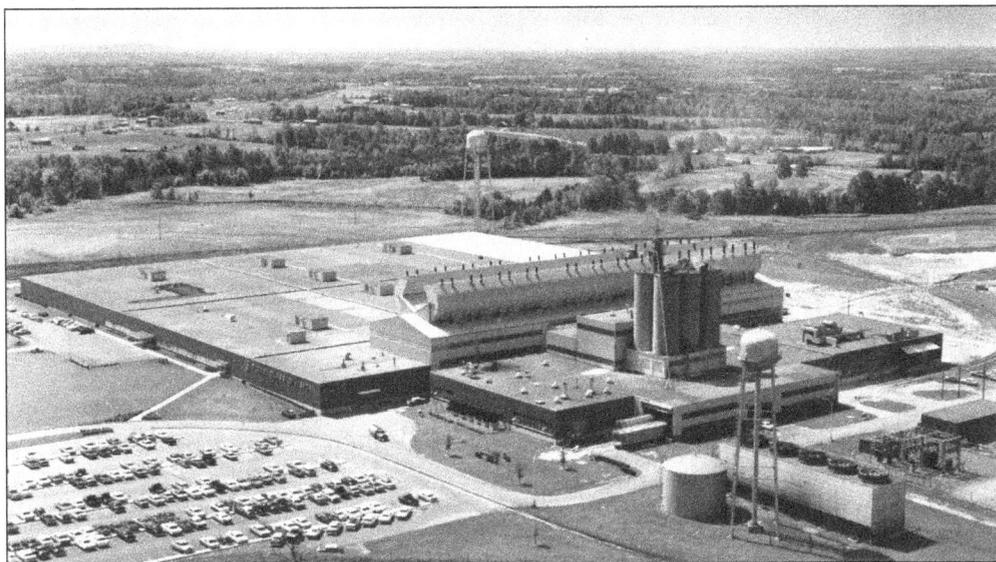

The headlines in the January 25, 1957 *The Shelby Daily Star* announced PPG Industries coming to the county. John "Jack" V. Schweppe, the first plant manager from 1959 to 1975, was a pioneer in the fiberglass manufacturing industry. (Courtesy of the Cleveland County Chamber.)

Rev. John William Suttle, "The Little Preacher," served nearly a dozen rural churches in Cleveland County during his 63-year career (1891–1954). He was elected president of the North Carolina Baptist Convention in 1948. (Courtesy of the Uptown Shelby Association.)

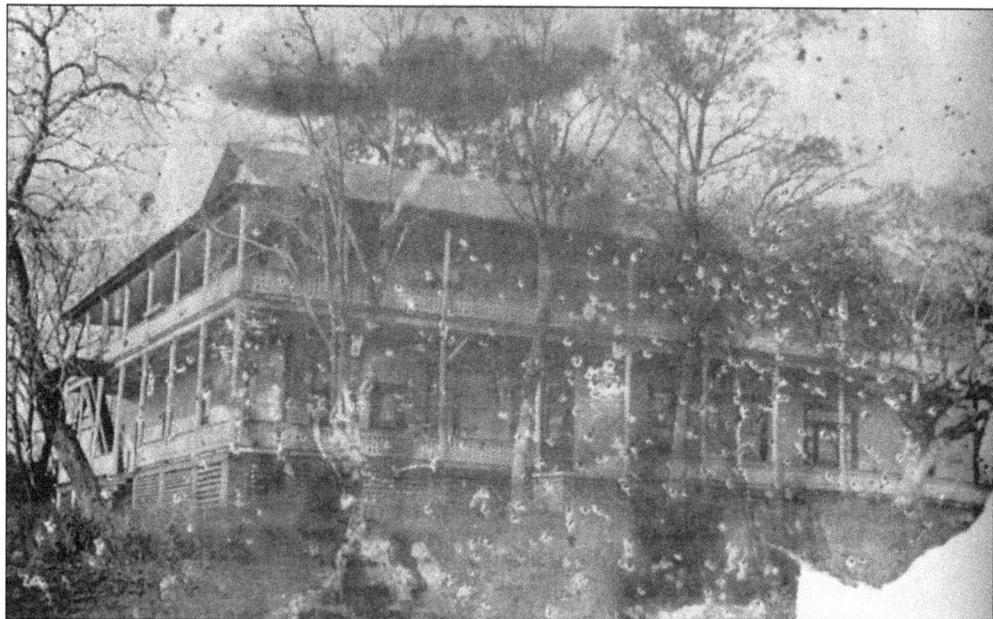

A passenger depot was built near Swangs to accommodate visitors traveling to the area for the healing powers of the Epps Springs Resort. William Patterson later bought the springs and resort and subsequently the name was changed to Patterson Springs. (Courtesy of the Cleveland County Historical Museum.)

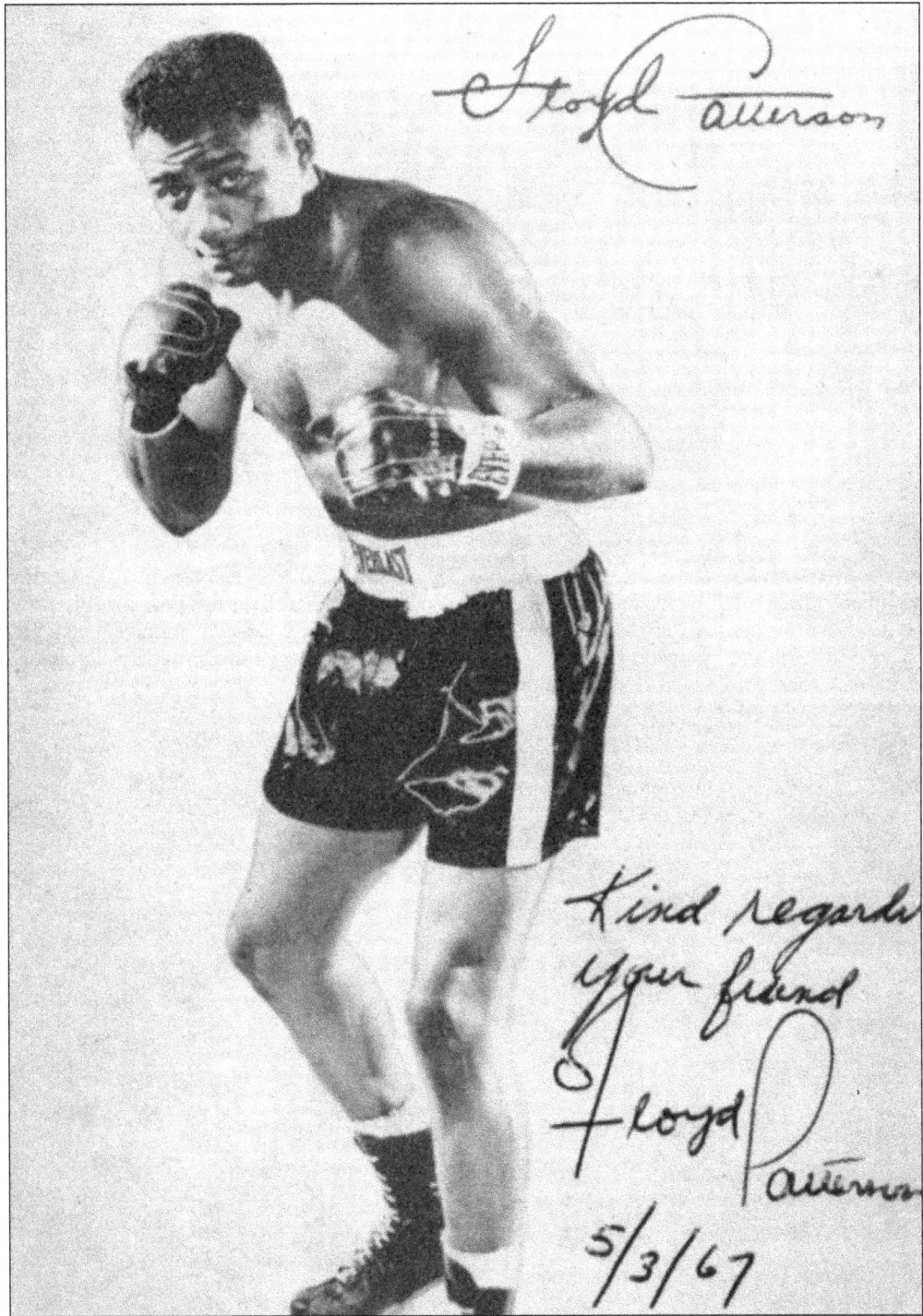

Floyd Patterson

Kind regards your friend Floyd Patterson 5/3/67

Waco was named for Waco, TX, by George Kendrick, the town's first postmaster, who had lived in Texas. Waco's most celebrated native son is former heavyweight boxing champion, Floyd Patterson. Patterson moved from Cleveland County when he was a small child. After he lost his title in the early 1960s, he came to Shelby and was honored in a parade.

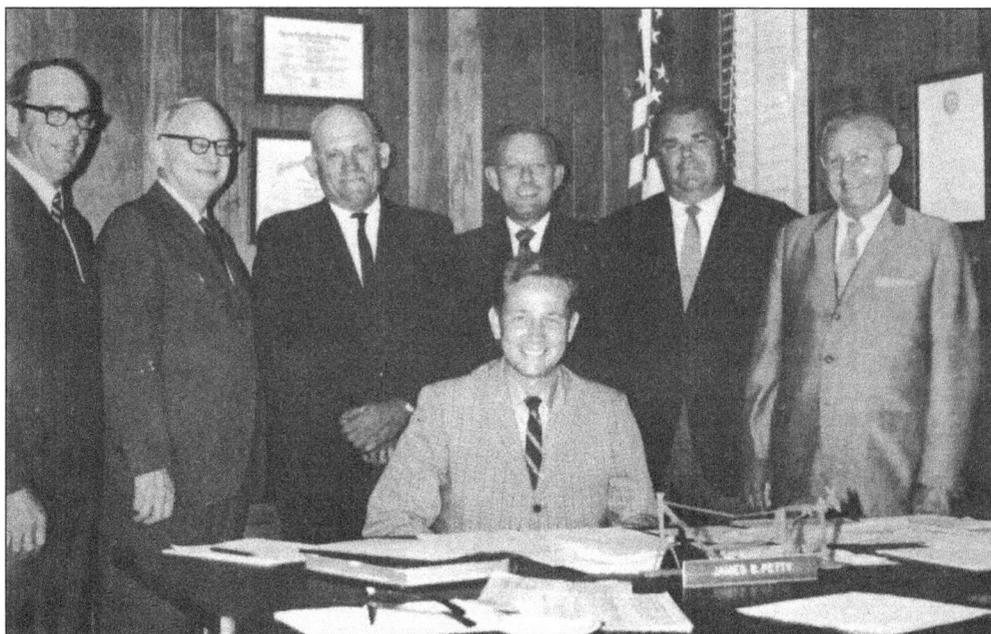

Members of the board of trustees of Cleveland County Technical Institute pose for this 1969 photo. From left to right are C.G.Poston, Cecil Gilliatt, James Cornwell, John Schenck III, Harry Mathews, and Spurgeon Hewitt. Seated in front is the college's first president, Dr. James B. Petty. (Courtesy of Cleveland Community College.)

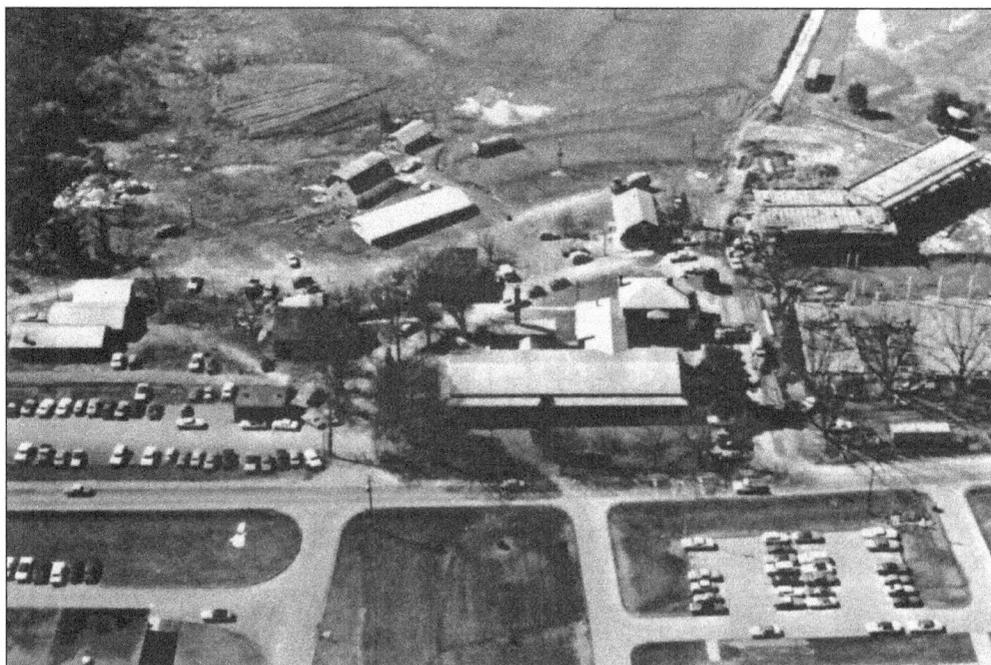

This aerial view shows the changing face of the campus in the early 1970s. In the center of the photo you can see the building once used as the county home and to the upper left construction of the new campus as it nears completion. Today, Cleveland Community College boasts a full time enrollment of over 2,300 students. (Courtesy of Cleveland Community College.)

Seven

CLEVELAND
COUNTY FAIR

In the fall of 1923, members of the Shelby Kiwanis Club began developing a plan to create a county-wide fair, combining the Boiling Springs Community Fair Association and Union Community Fair into one event. The civic club initiated a fund-raising effort with "Cleveland County Fair Night" on January 24, 1924. Through the sale of $20 shares of stock, they raised $15,000 in the first week.

The first Cleveland County Fair was held October 14–18, 1924, with 70,000 in attendance. Attractions included agricultural and craft exhibits, a livestock barn, harness horse racing, and the Millers Brothers carnival rides and stage show revues. Among the first officers of the fair association was local veterinarian Dr. J.S. Dorton, who went on to manage and promote the fair for 38 years. An engaging individual, Dorton was a natural promoter. His determination and innovations served to build the largest county fair in North Carolina.

In the fair's 75 years there have been five managers, Dr Dorton, 1924–61; J. Sib Dorton Jr., 1961–62; Elbridge J. Weathers, 1962–1973; Sam P. Goforth, 1973–76; and Joe A. Goforth, 1977–present. Through the years the fair has grown in popularity and size with a record attendance of 184,353 in 1994. Except where noted all photographs were provided by Joe Goforth from The Cleveland County Fair Association's collection.

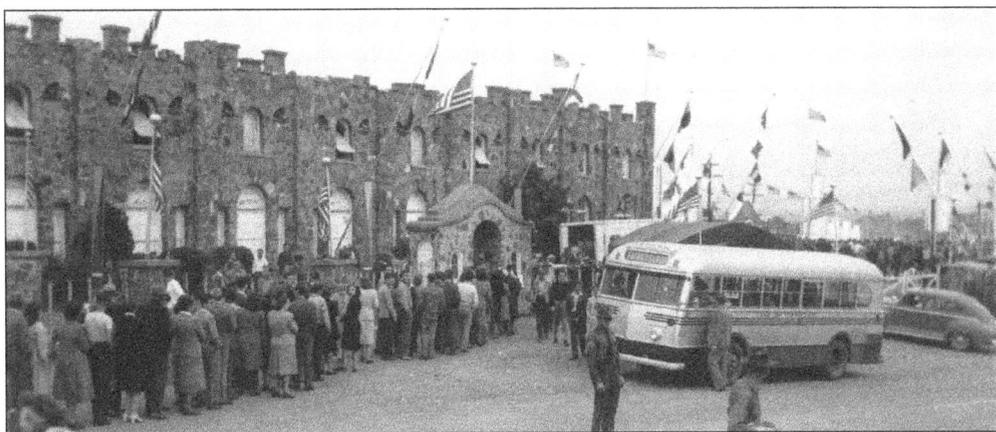

This photo is of the front entrance to the Cleveland County Fair as it appeared in the 1940s. The Shelby Transit Company ran an express bus for fairgoers from downtown Shelby to the main gate on Business 74, 2 miles east of the city. The stone-faced grandstand burned on Christmas Eve, 1951.

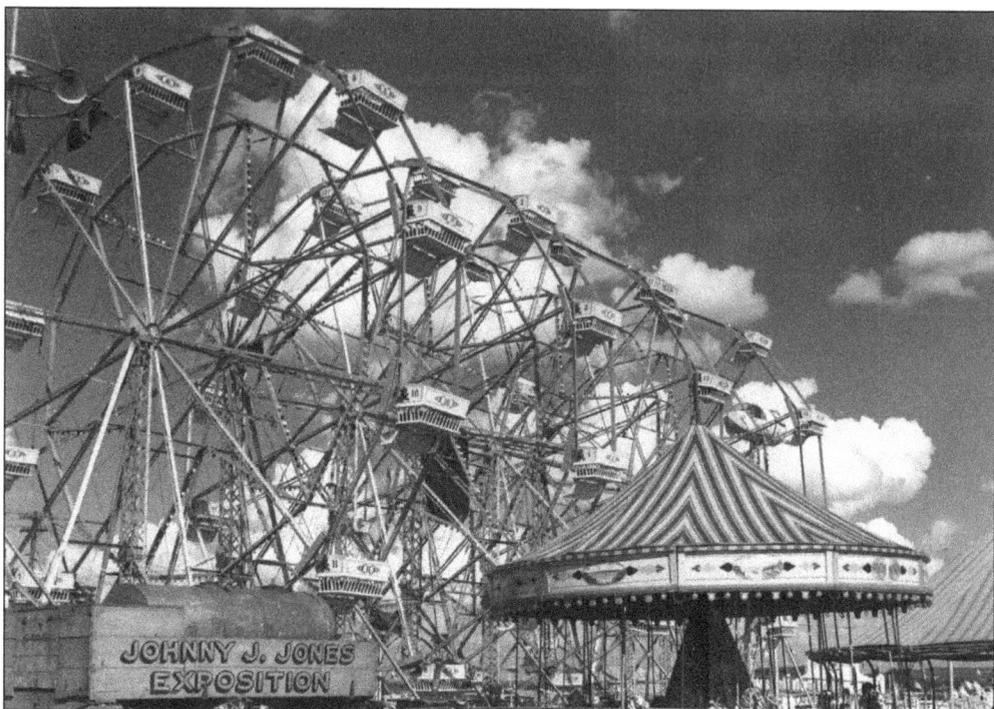

Johnny J Jones Shows provided the carnival rides in the late 1930s. In 1939 they featured four Ferris wheels.

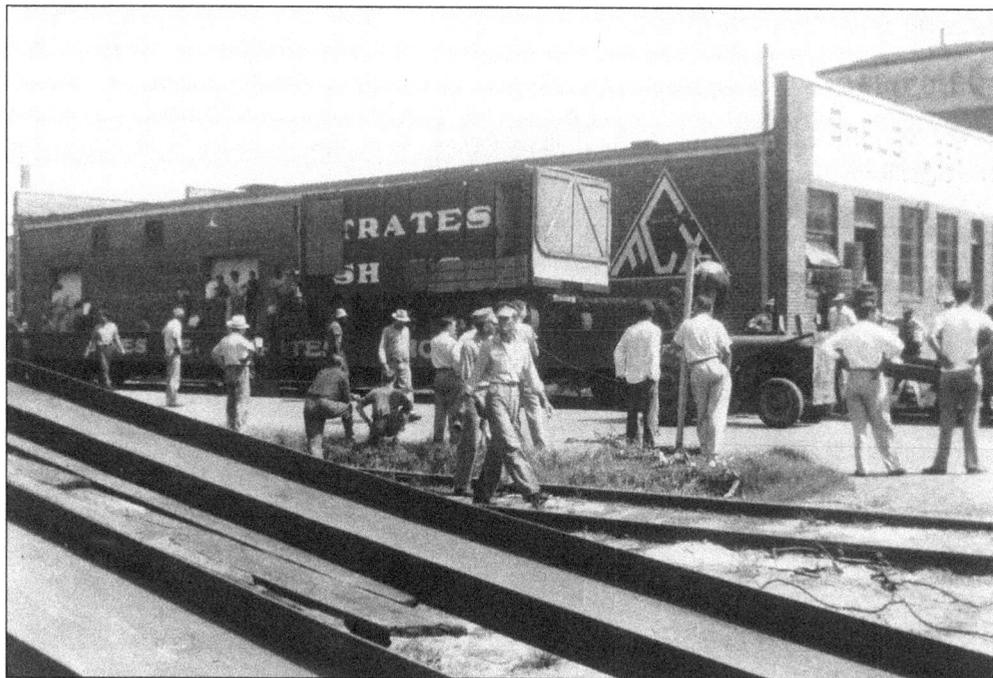

In the 1950s the John E. Strates Show was the main attraction. The fair train unloaded from the Southern rail depot on Morgan Street. Local residents often lined Marion Street to view the procession of tractors and wagons traveling to the fairgrounds.

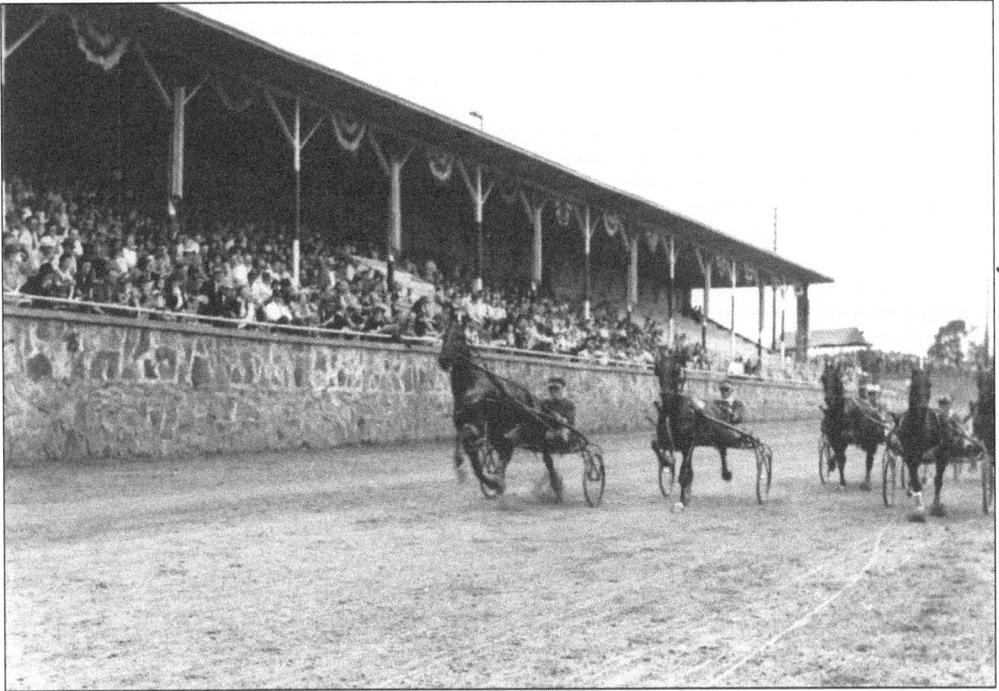

In the early days of the fair, harness horse racing was a popular grandstand attraction. Popularity waned after the Second World War and horse racing gave way to the roar of automobile racing.

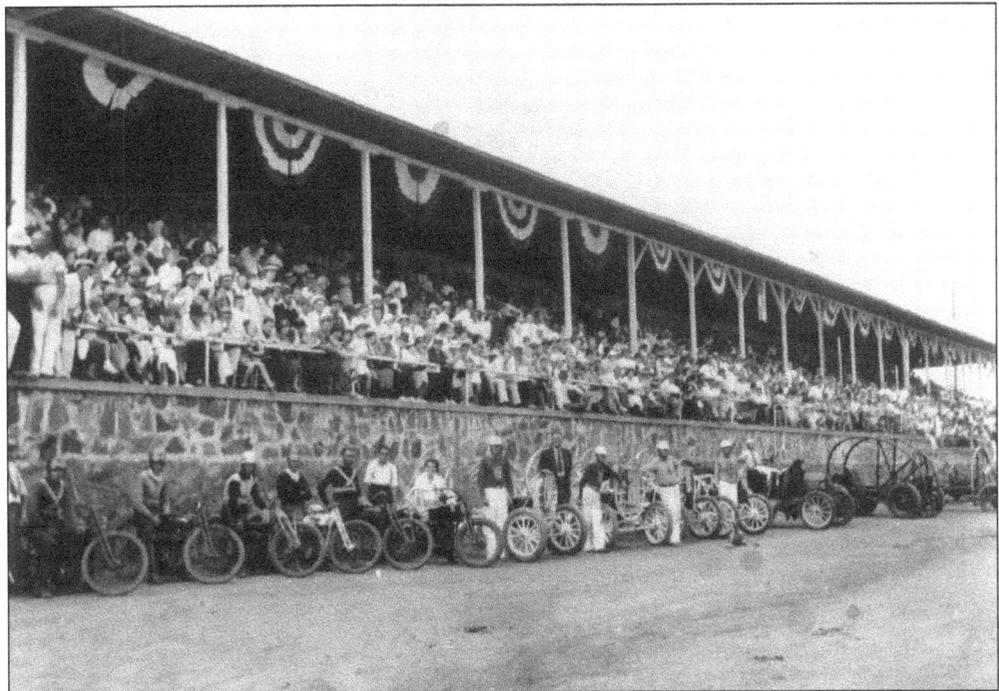

Motorcycle racing was featured in the early days of the fair. It would be more than 40 years before motocross racing would sound the return of motorcycles racing in the infield of the old track. (Courtesy of the Uptown Shelby Association.)

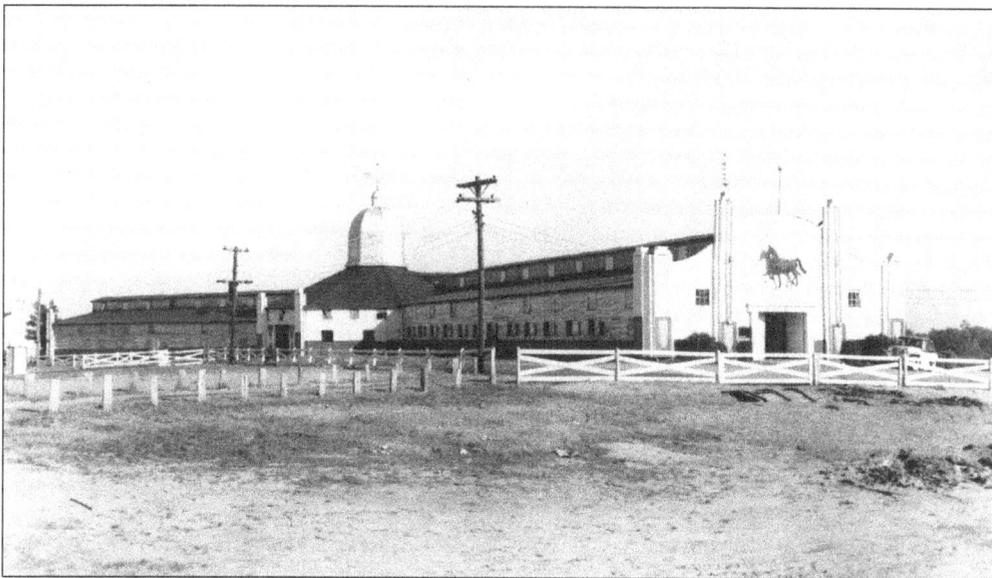

Livestock exhibits have always been a mainstay of the fair. This photo shows the cattle barn as it appeared in 1949. The barn was destroyed in a controlled burn in the early 1970s to make room for a new exhibit barn.

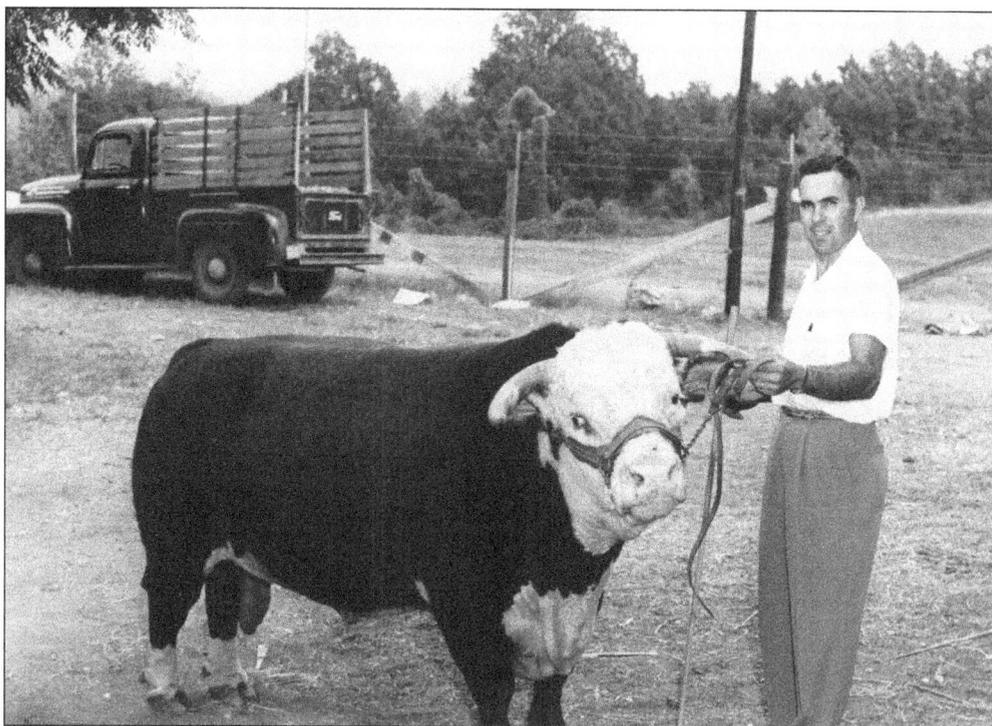

Today John Hendrick is a member of the fair's board of directors and one of the most successful farmers in the county. In 1951 John was the proud owner of the "senior champion" bull.

The annual fair coincides with the fall harvest of locally grown crops. Wayne L. Ware Sr. proudly displays apples from his Kings Mountain farm in this 1940s photo. The farm is still in operation with Mr. Ware's son Cameron and daughter Jean still active in the business. (Courtesy of Jean Ware.)

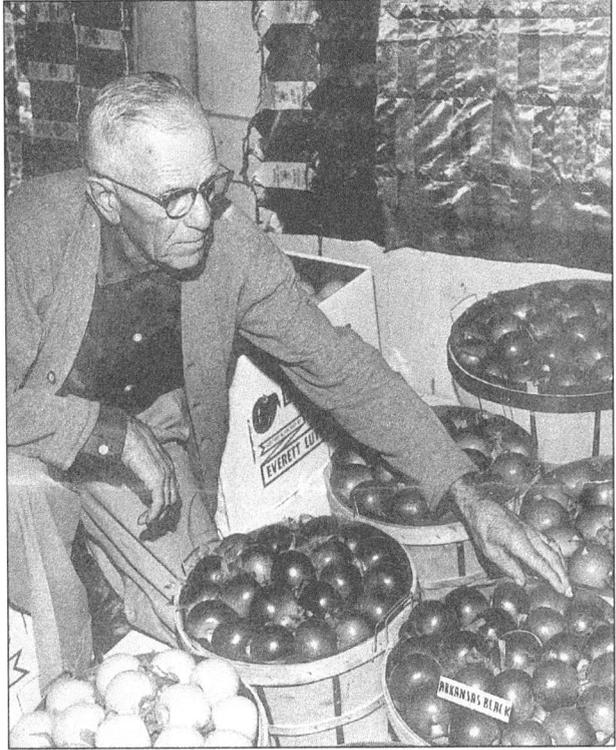

"Bobby the Great Performer" and his master entertained fair-goers in this 1941 photo. The organ grinder had trained Bobby not to accept pennies when accepting contributions.

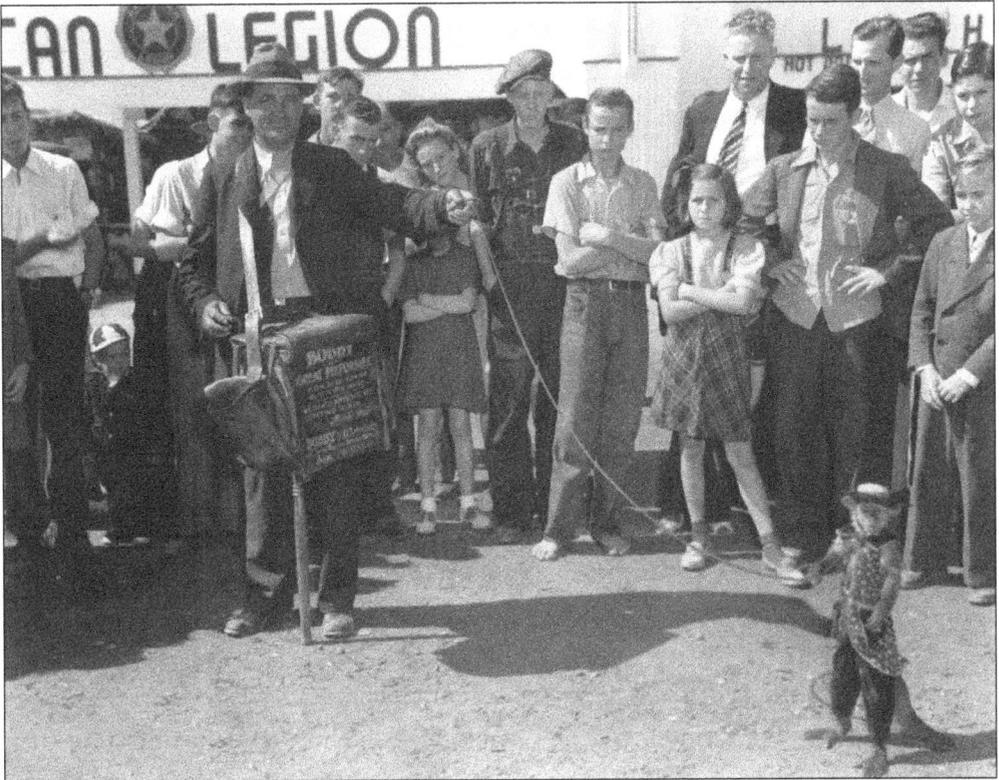

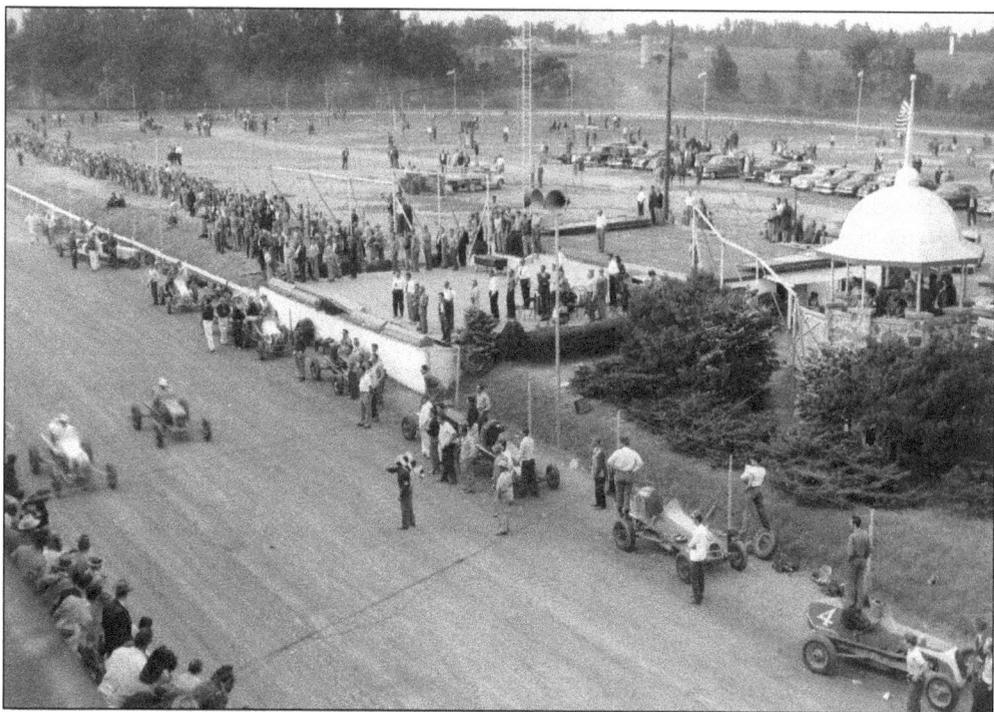

In 1948 "Indy"-type racers were the featured attraction on Saturday afternoon. The domed structure to the right was the public address announcer's vantage point on the one-half-mile dirt track.

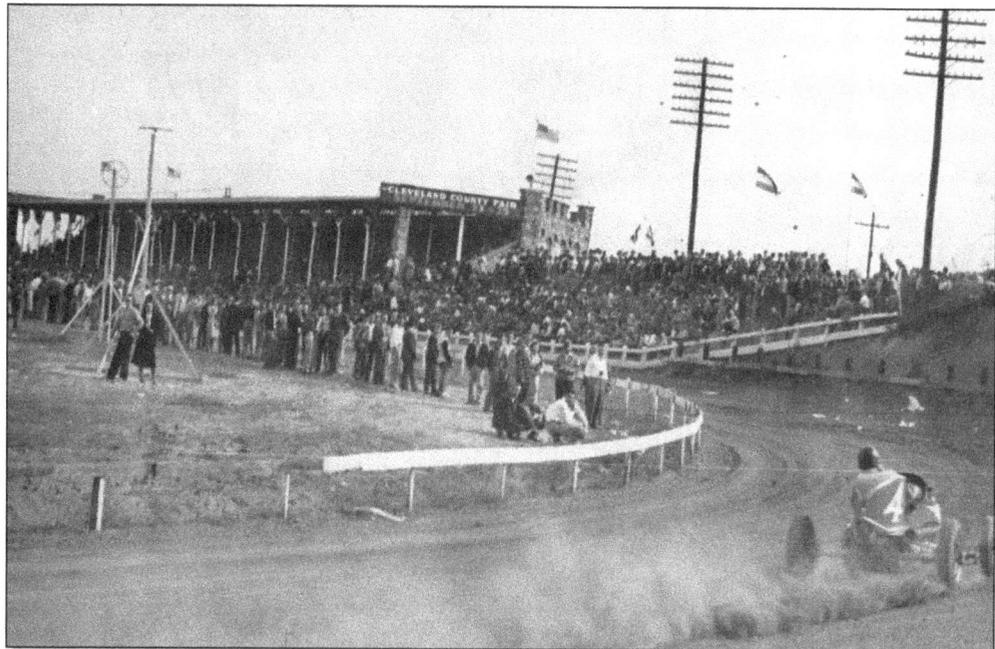

A racer enters turn four, heading for the front straight. The old grandstand was filled to near capacity to catch the excitement. With today's regulations one would not see spectators standing behind a simple plank fence near the track.

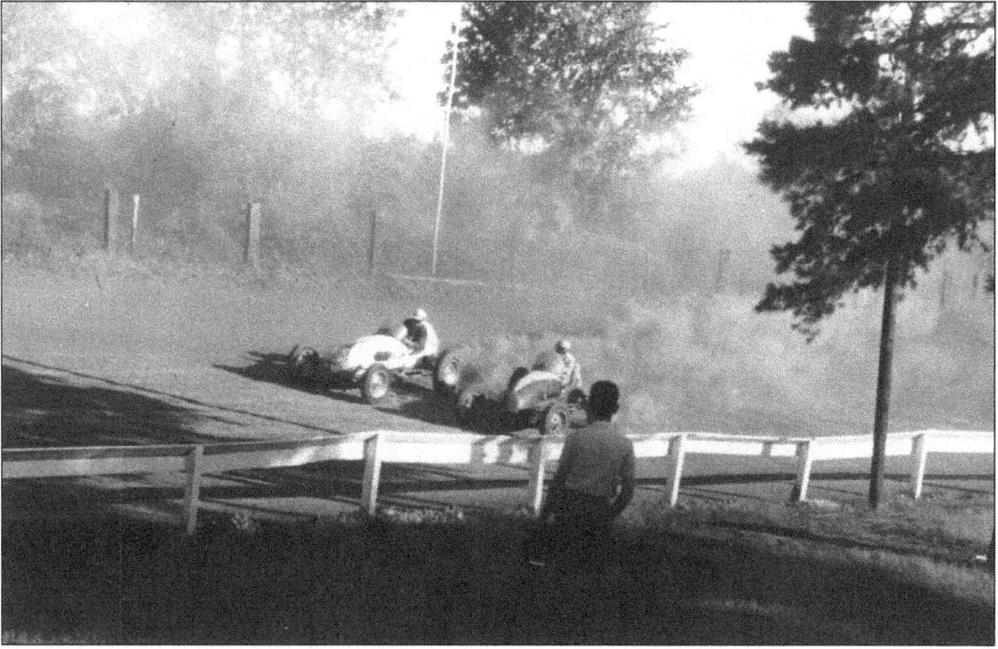

The competition was close, racing side by side in turn three. The red clay track had to be watered down regularly to minimize the clouds of dust.

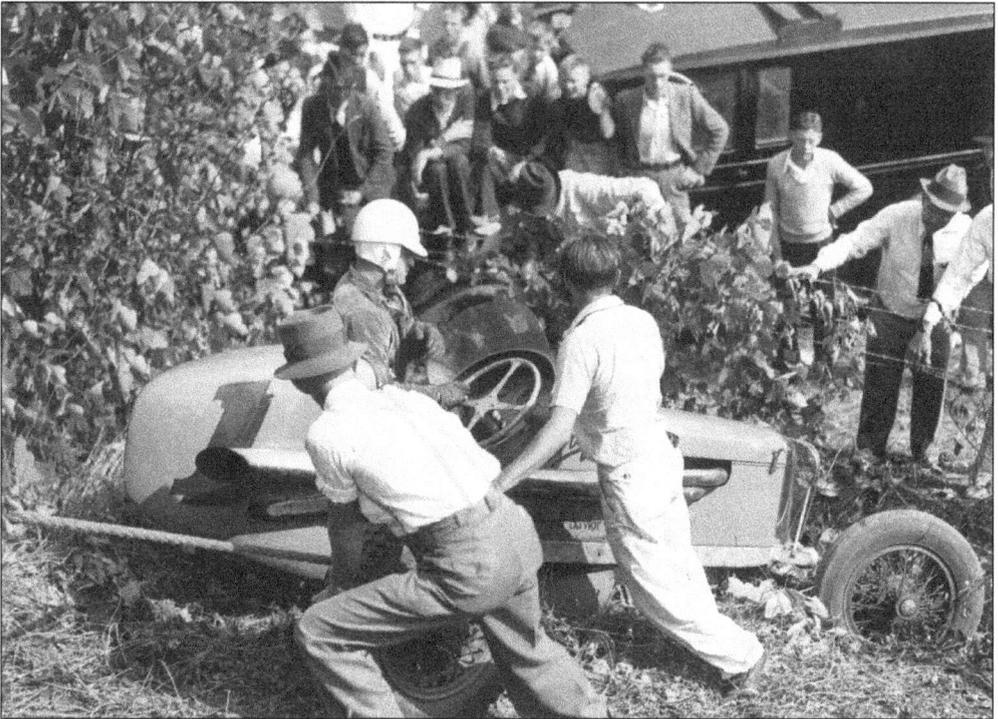

The race track did not always hold the competitors. As a precaution, the food stands along side turn one were closed during races.

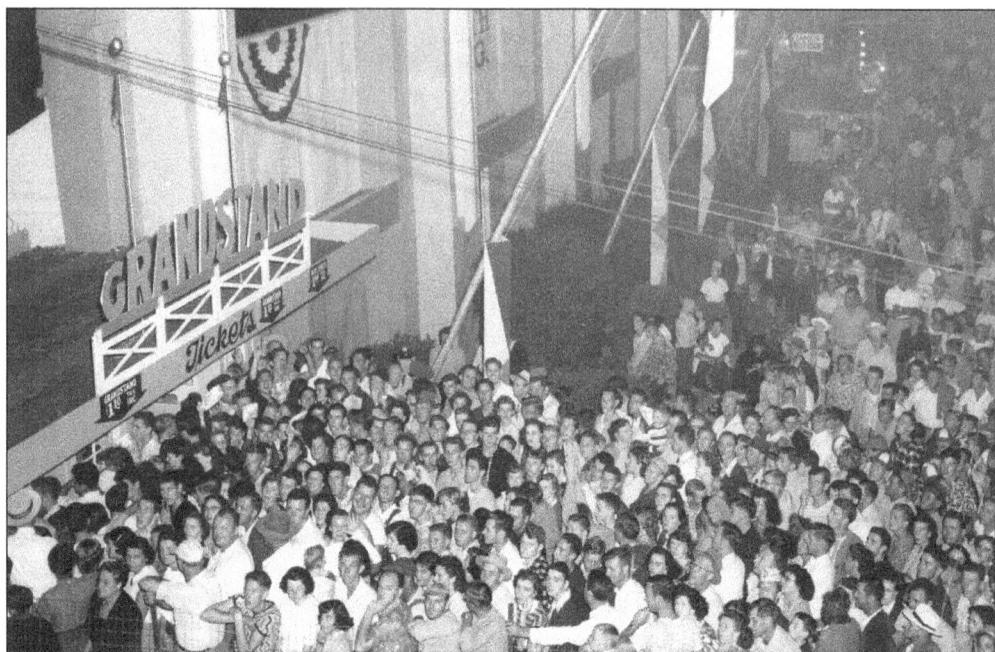

The crowd gathers at the entrance of the grandstand. From the Rockettes on tour from Radio City Music Hall in New York to rodeos from the Midwest, the fair has always provided a wide variety of entertainment.

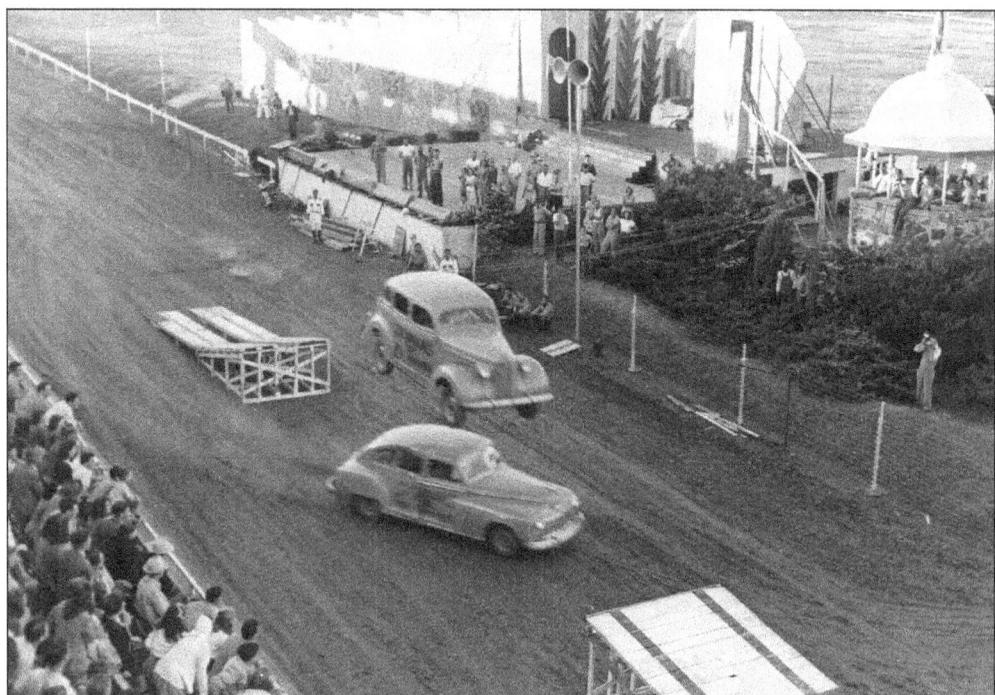

For many years stunt cars were a major attraction. Here the "Kochman Hell Drivers" thrill the fans with a crossover ramp jump. In the background the stage has been prepared for an upcoming show.

Fair promoter Dr. J.S. Dorton is shown greeting stunt driver Lucky Teeter. Teeter lost his life several years later in an unsuccessful ramp jump.

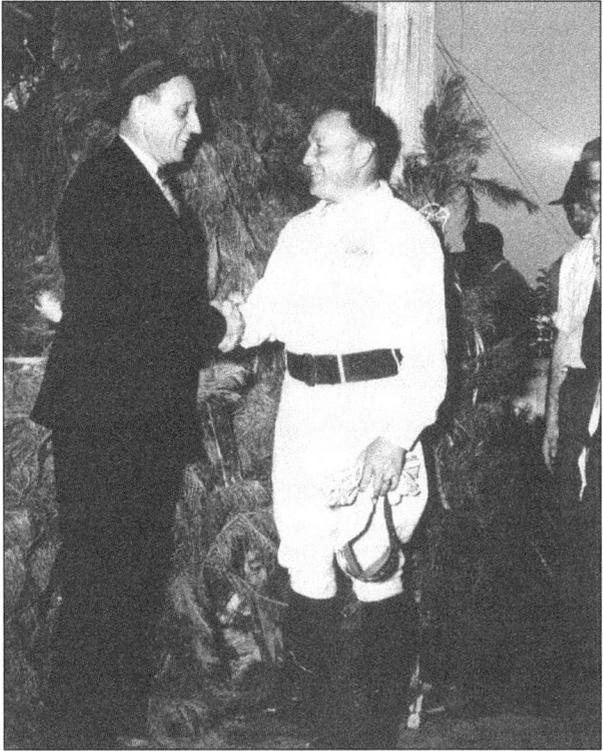

In the mid-1950s, convertible stock car races were a feature attraction. Joe Weatherly, Curtis Turner, and "Fireball" Roberts lead the field down the front stretch. The race was won by Curtis Turner. Nascar soon abandoned convertibles as race cars for safety concerns.

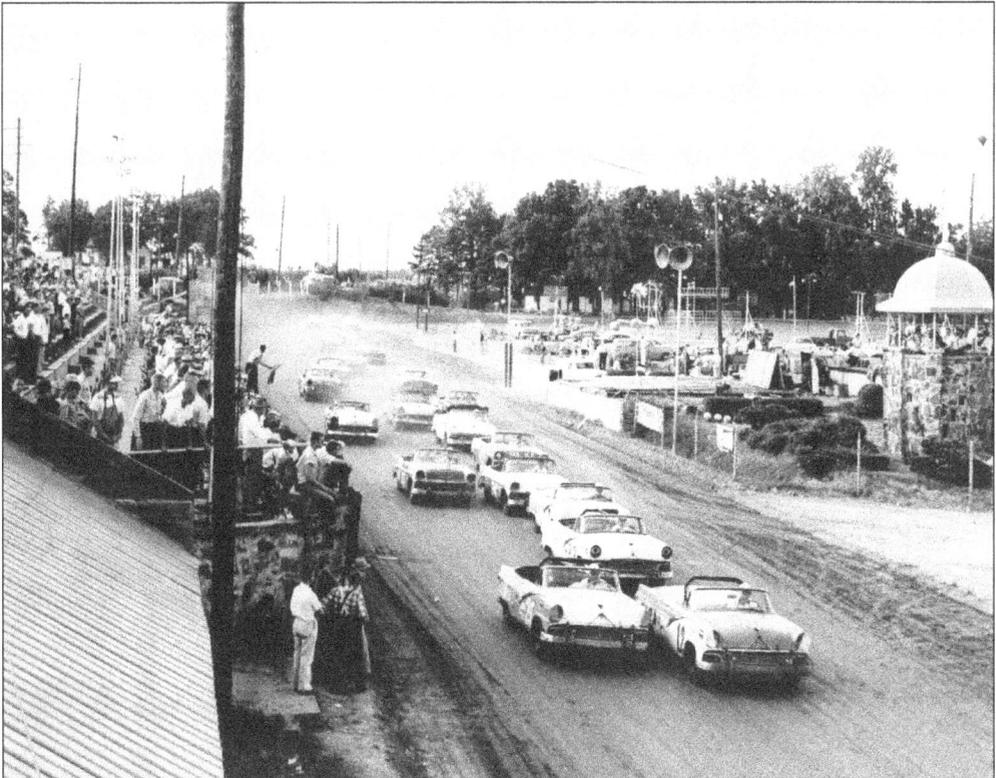

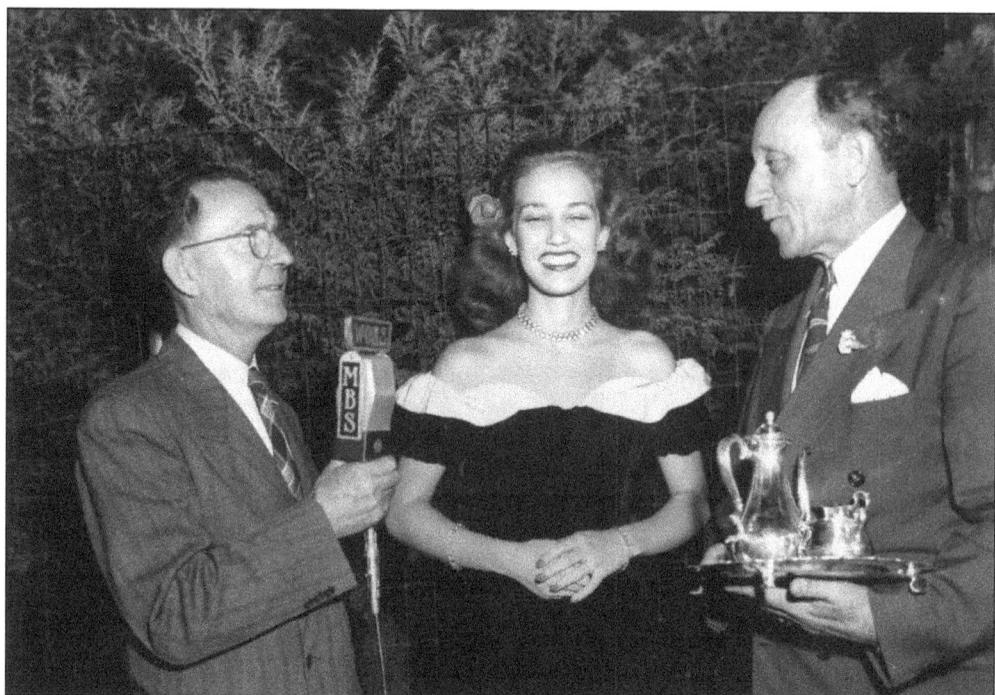

Assistant fair manager E.L. Weathers interviews the 1948 Apple Queen, Patty Osborne, along with Dr Dorton. Miss Osborne was later crowned Miss North Carolina.

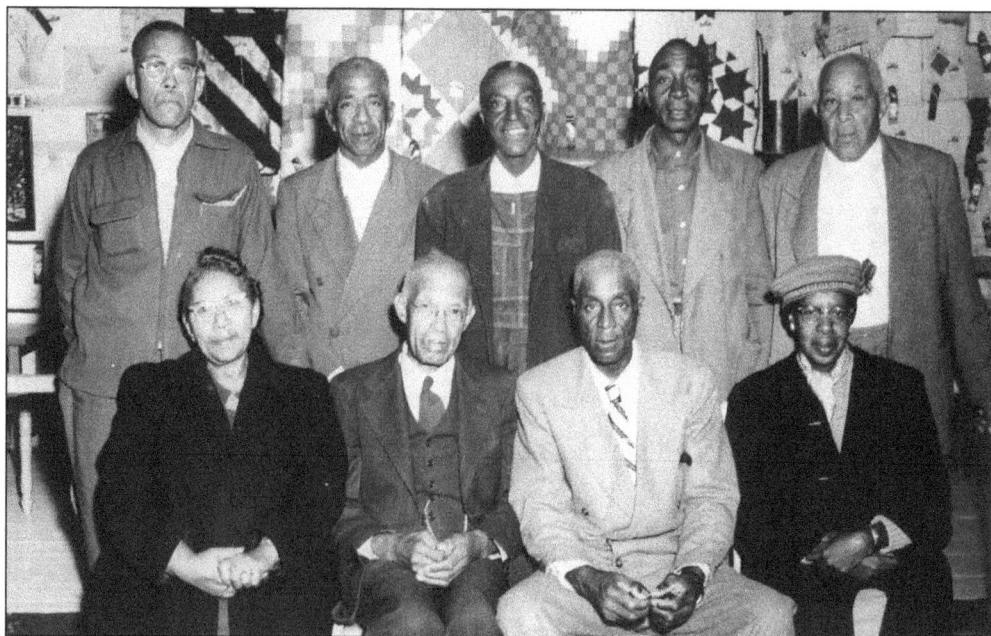

Before the days of integration, the African-American community held a separate fair. Members of the "Cleveland County Negro Fair" organizing committee are as follows, from left to right: (front row) Mrs. F. Camp, Mr. J. Camp. Reverend Foster, and Mrs. M Borders; (back row) Mr. Borders, Mr. D. Gill, Mr. Blanton, unidentified, and unidentified. (Courtesy of the Uptown Shelby Association.)

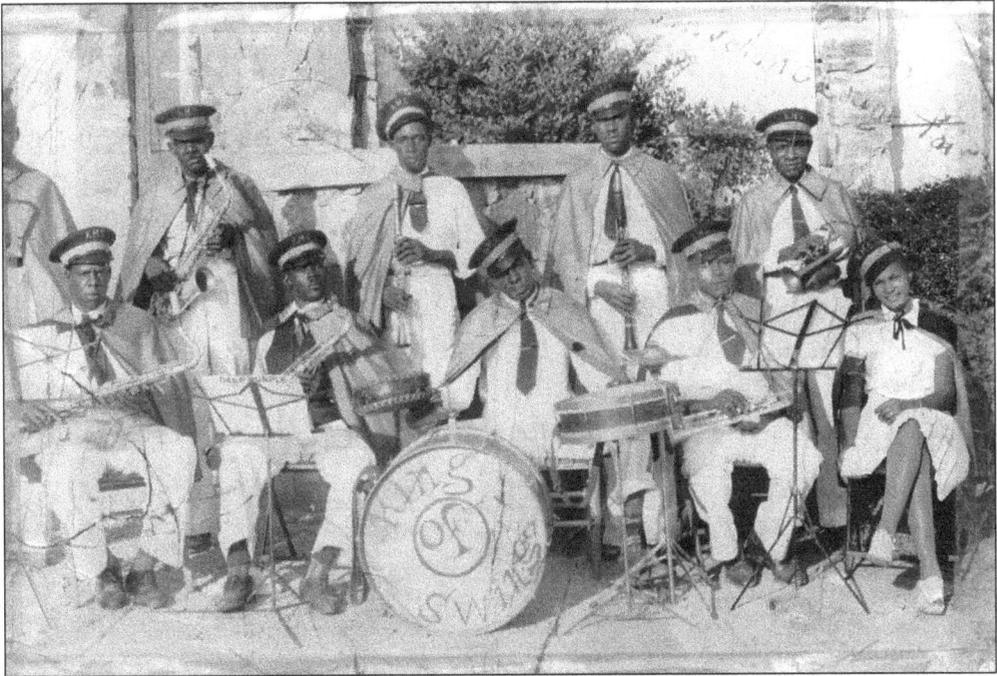

Local groups have always been a part of the fair's mix of entertainment. Shelt Feemster's band "The Kings of Swing" performed on the grandstand. (Courtesy of Tommy Forney.)

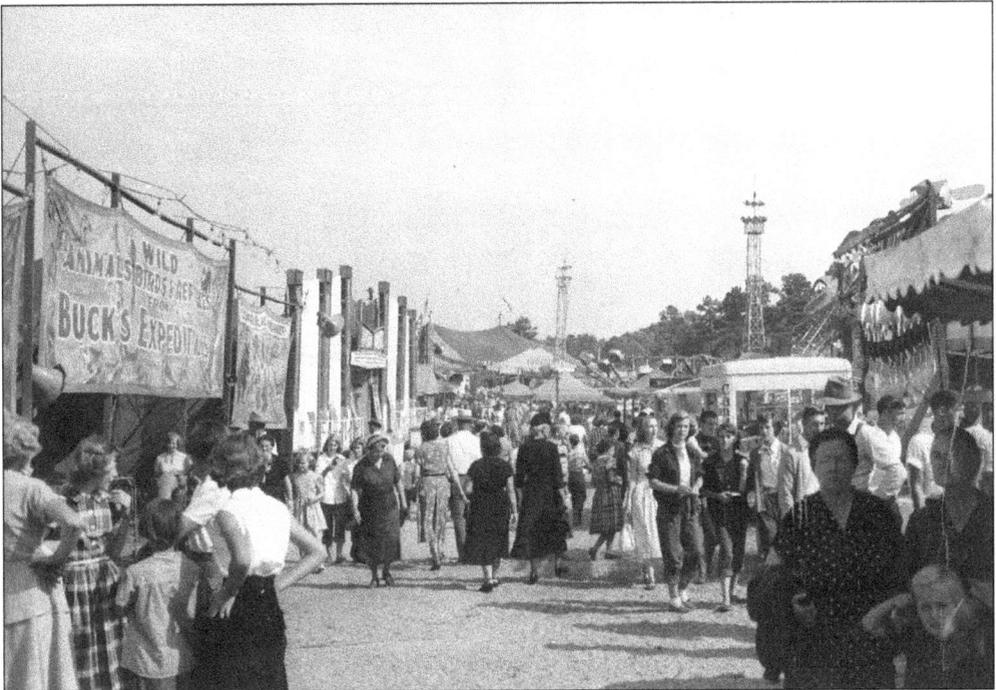

Crowds stroll through the mix of side shows and rides that make up the midway. Both local and traveling businesses set up booths selling cotton candy, candy apples, hot dogs, and lemonade. The walking paths on the midway were covered in sawdust.

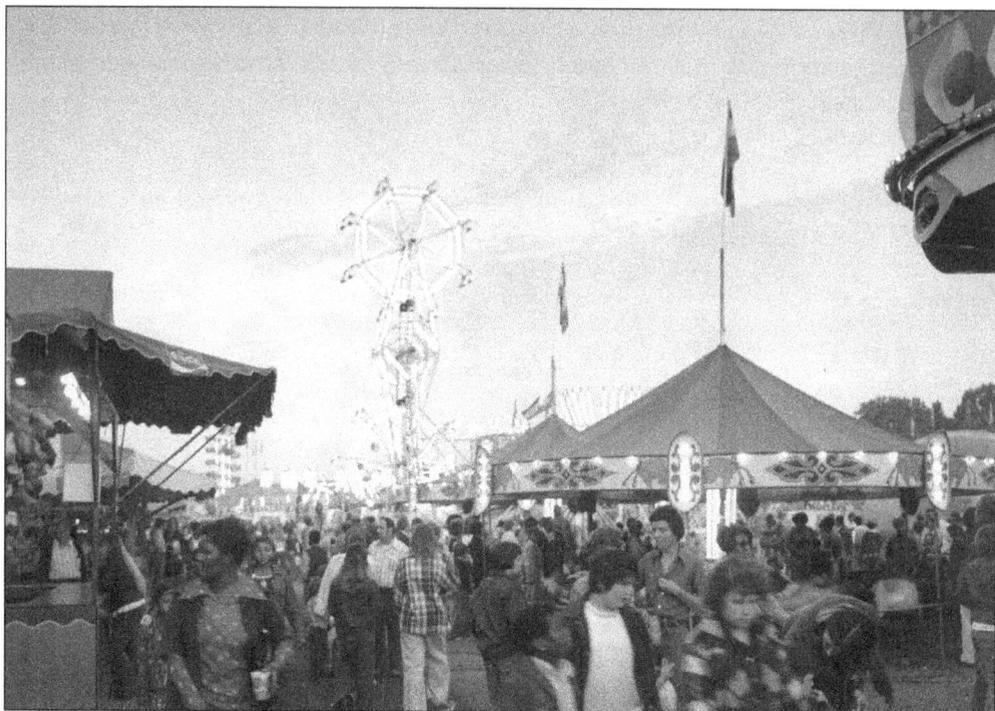

In the early 1960s the double Ferris wheel become a popular attraction on the midway. The diversification of attractions has been a part of the successful formula for the fair.

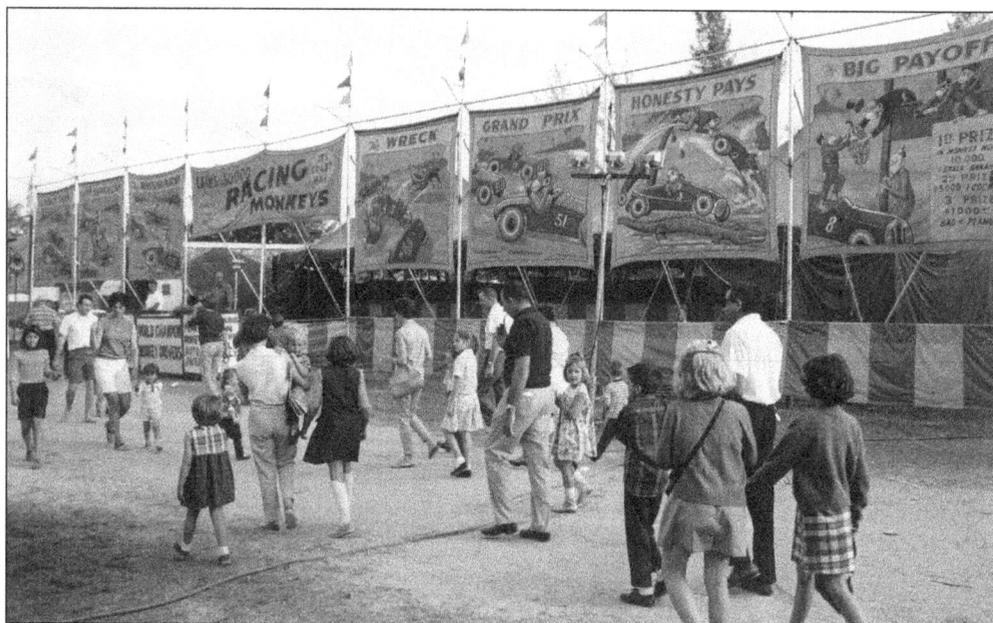

Entertaining side shows are also a part of fair's success. The racing monkeys entertained the young and young at heart. A crowd favorite was "mile-a-minute Murphy."

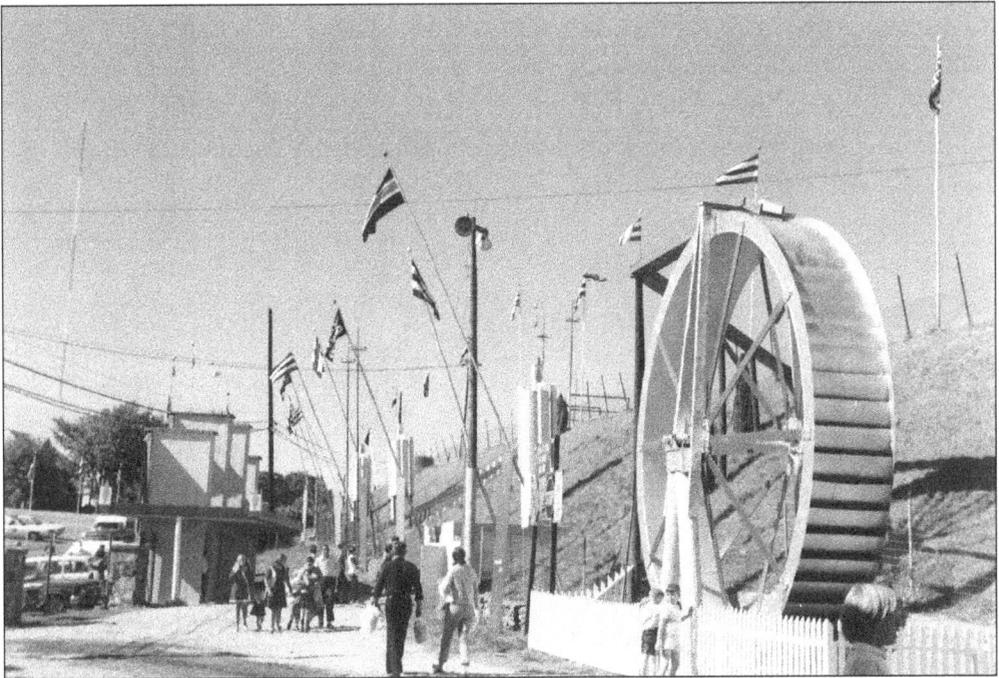

This photo from just inside the main gate shows the old bomb shelter in the center, and the water wheel to the right near the entrance to the grandstand. For a quarter you could have someone paged. "Meet me at the water wheel" was the standard call to meet a friend or family member.

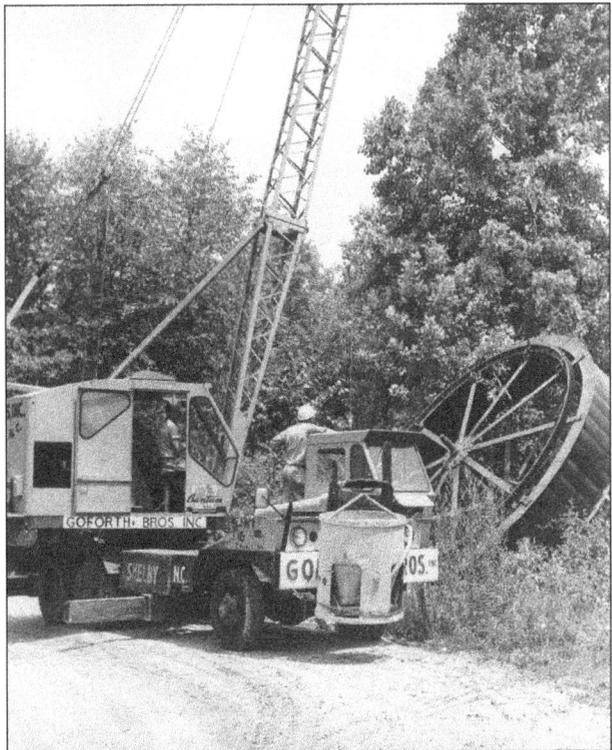

Ever wonder the origin of the water wheel? The Goforth Brothers crane lifts the wheel from the briars at the old Peelers Mill in Casar. The wheel had to be cut in two to be transported to the fairgrounds.

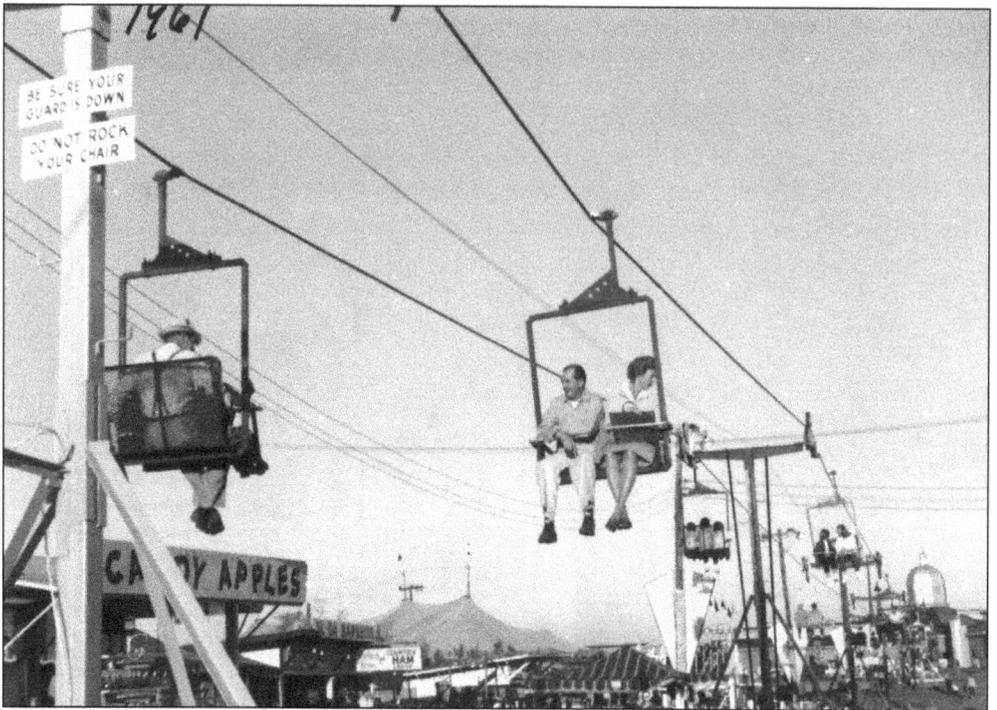

In 1961 a mobile chair lift, "The Skyliner," was added to the mix of rides. From the lift's vantage point one could view all the fair had to offer. The lift ran from the exhibit halls to the rear gate entrance to the grounds.

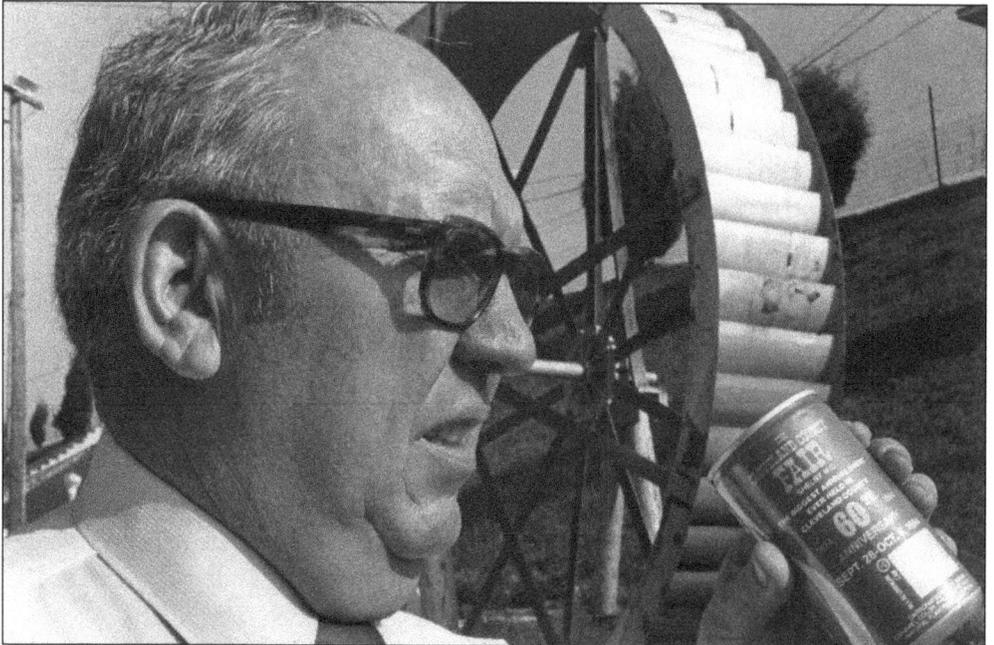

Current fair manager Joe Goforth is a walking history of the Cleveland County Fair. This chapter has only touched on the history of the counties largest continuing attraction. If you ever have the chance, stop and visit with Joe and he will be glad to share more of the story.